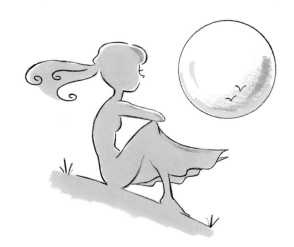

Draw 100 Things to Make You Happy

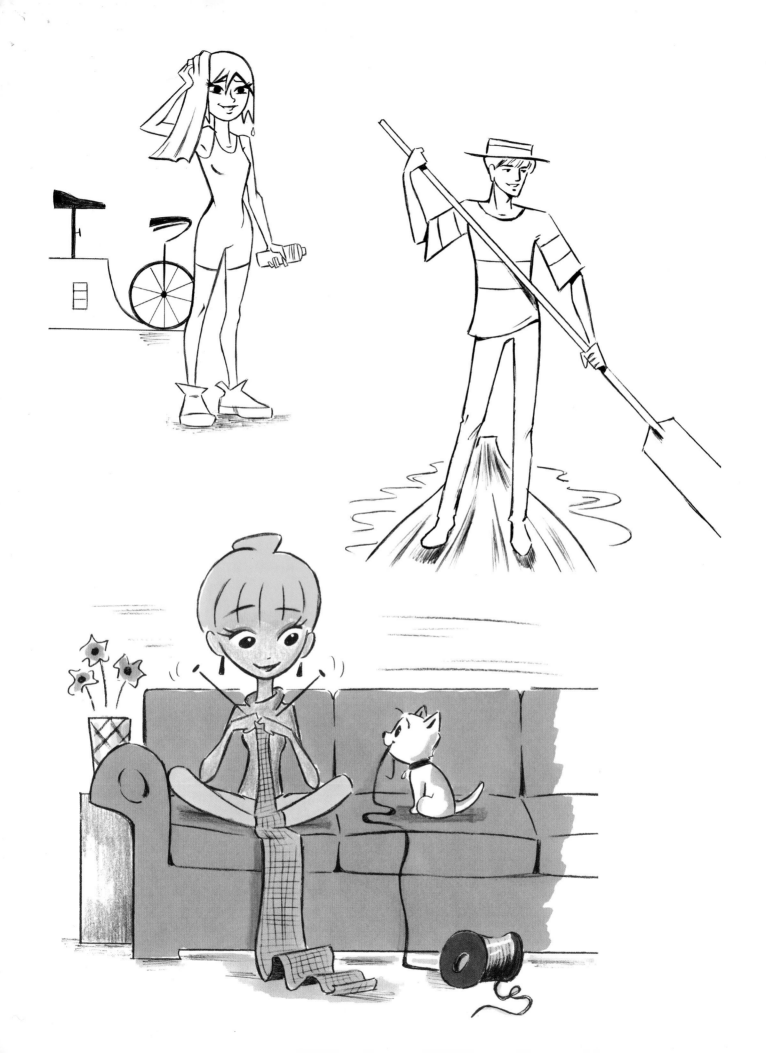

Draw 100 Things to Make You Happy

Step-by-Step Drawings to Nourish Your Creative Self

Mixed Media Resources
New York

DRAWING WITH Christopher Hart

An imprint of Mixed Media Resources
104 West 27th Street
New York, NY 10001

Editorial Director
JOAN KRELLENSTEIN

Senior Editor
MICHELLE BREDESON

Managing Editor
LAURA COOKE

Art Director
IRENE LEDWITH

Book Design
JULIE GRANT

Associate Editor
JACOB SEIFERT

Production
J. ARTHUR MEDIA

Vice President
TRISHA MALCOLM

Publisher
CAROLINE KILMER

Creative Director
DIANE LAMPHRON

Production Manager
DAVID JOINNIDES

President
ART JOINNIDES

Chairman
JAY STEIN

Names: Hart, Christopher
Title: Draw 100 things to make you happy : step-by-step drawings to nourish your creative self / Christopher Hart.
Other titles: Draw one hundred things to make you happy : step-by-step drawings to nourish your creative self
Description: First edition. | New York : Drawing with Christopher Hart, 2017.| Includes index.
Identifiers: LCCN 2017003742 | ISBN 9781942021865 (paperback)
Subjects: LCSH: Cartooning—Technique. | Drawing—Themes, motives. | BISAC: ART / Techniques / Drawing. | ART / Techniques / Cartooning.
Classification: LCC NC1320 .H36 2017 | DDC 741.5/1--dc23
LC record available at https://lccn.loc.gov/2017003742

Printed in China.

3 5 7 9 10 8 6 4

First Edition

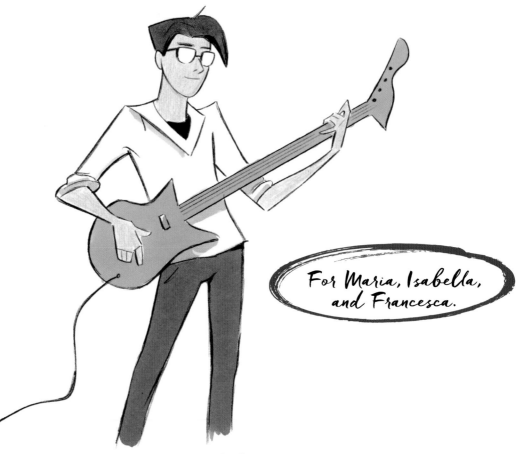

For Maria, Isabella, and Francesca.

christopherhartbooks.com
facebook.com/CARTOONS.MANGA

Contents

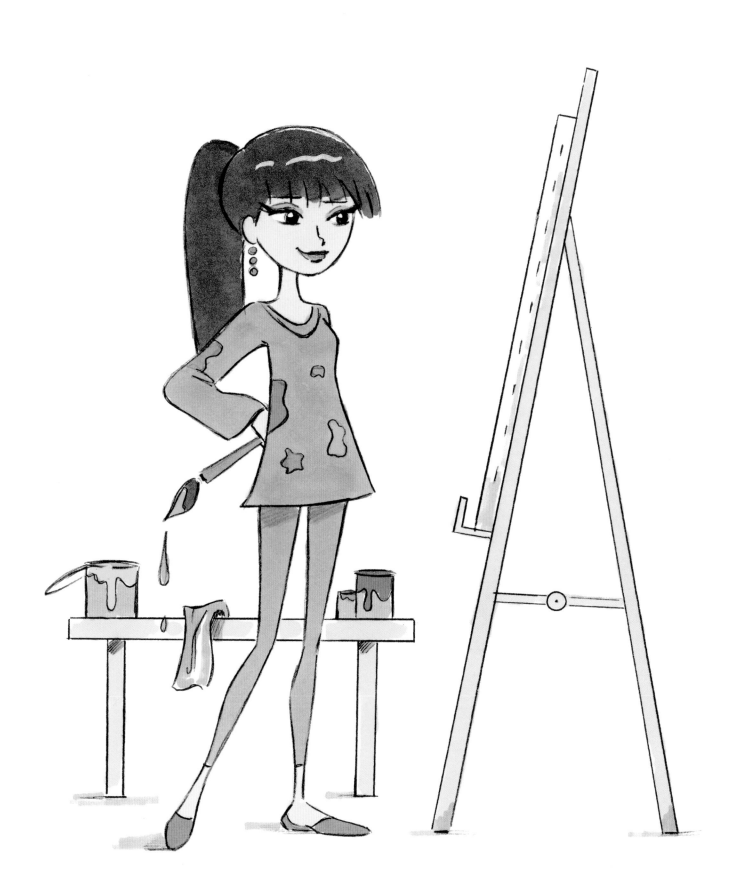

Introduction

Drawing makes your imagination smile!

What makes you happy? A beautiful fall day? A vacation in a tropical paradise? A lovable puppy? You can experience all of these joys, and more, with the magic of a pencil. With this book, I'll show you how you can draw yourself happy.

You'll create more than drawings. You'll be creating experiences. You'll feel an amazing sunset as you draw it. You'll feel the exhilaration of swimming with a dolphin or the enchantment of taking a boat ride down the Grand Canal in Venice. You'll unwind as you draw a yoga pose or a hammock on a beach. And you'll improve your drawing skills, because as you follow the step-by-step instructions, I'll be demonstrating many essential art principles, which you'll incorporate into your pictures.

Drawing is happiness. If you're ready to get into a good mood, grab a pencil and let's get started!

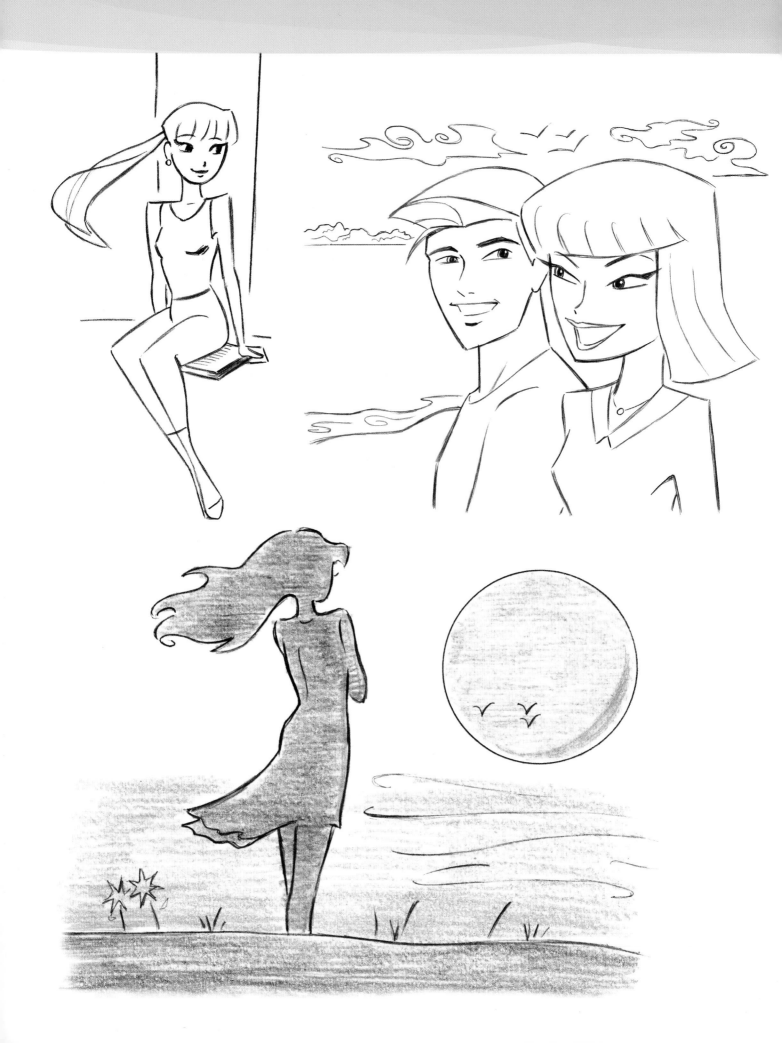

Simple Pleasures

So often we overlook the simple things in life. A cozy fire on a chilly night. Reconnecting with an old friend. And, of course, hanging up on a sales pitch. The last one is particularly fun. Does that make me a bad person? The point is that the small pleasures give us comfort and create smiles. And therefore make excellent subjects for drawings.

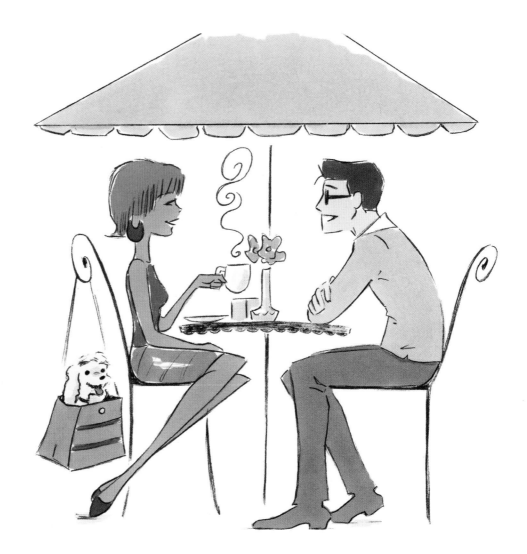

SO TALL!

If there's anything better than playing with your children, I haven't found it yet. I'm not sure why new dads feel it's essential to lift their kids way up over their heads. But it seems to make both of them happy! This drawing works because their attitudes contrast. The dad has an expression of delight, while his son has an inquisitive look. That must be one interesting nose!

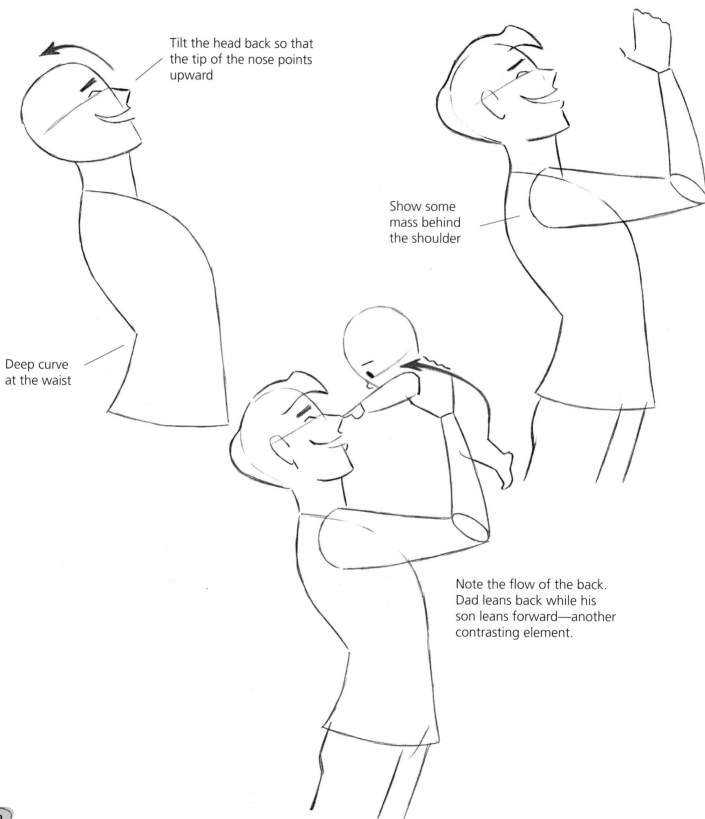

Tilt the head back so that the tip of the nose points upward

Show some mass behind the shoulder

Deep curve at the waist

Note the flow of the back. Dad leans back while his son leans forward—another contrasting element.

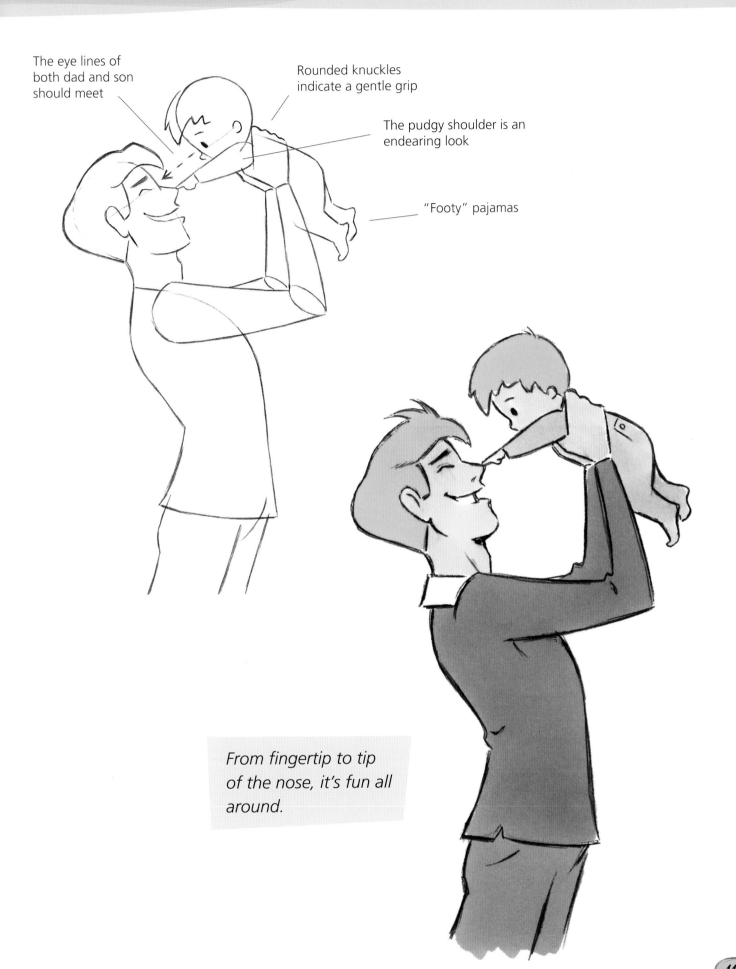

The eye lines of both dad and son should meet

Rounded knuckles indicate a gentle grip

The pudgy shoulder is an endearing look

"Footy" pajamas

From fingertip to tip of the nose, it's fun all around.

SHARING A SMILE

A shared smile between two characters creates a nice moment. But you don't have to stop the action in order to draw it. For example, in this scene, the couple is walking as the smile occurs. They glance at each other from the corner of their eyes, which gives it a flirtatious look.

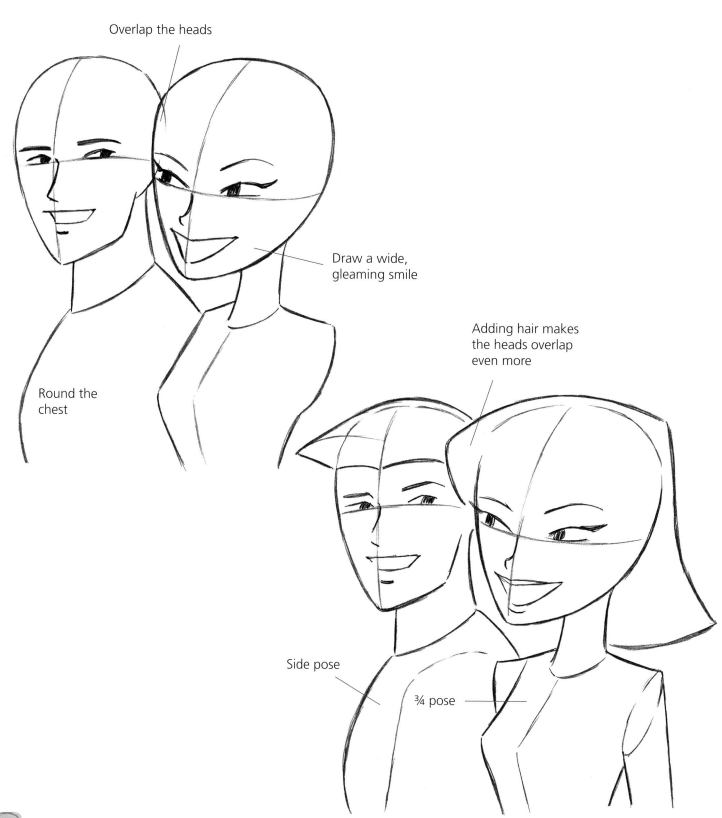

Overlap the heads

Draw a wide, gleaming smile

Round the chest

Adding hair makes the heads overlap even more

Side pose

¾ pose

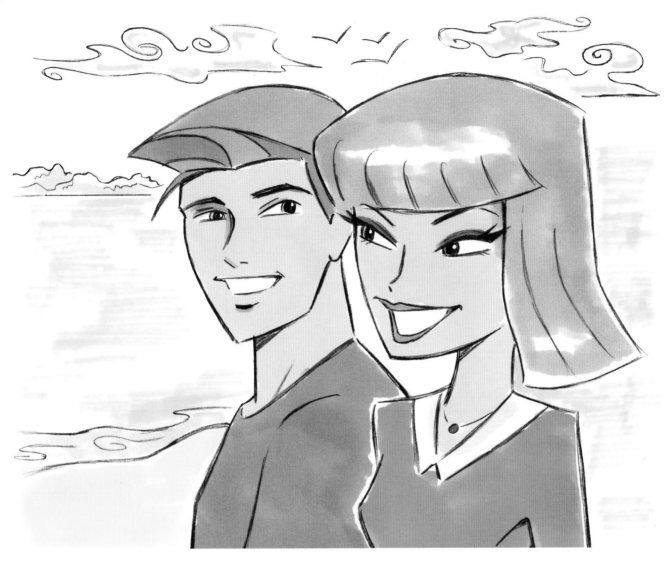

Staging Two Characters

It's intuitive to separate two characters, to give them a little breathing room. But this is actually less appealing. By overlapping them, you create a stronger visual relationship between the characters.

JUST OKAY
Characters are spaced apart from each other.

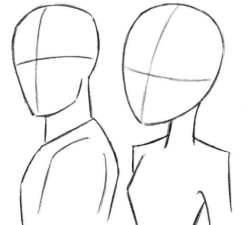

BETTER
Characters overlap each other.

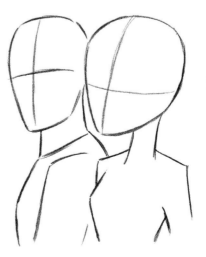

Tip

When drawing two people side by side, make the far character's head slightly smaller, due to perspective.

GETTING THAT PROMOTION

It feels great when you work hard for something and then get it. It could be a promotion at work or a personal goal. Those feelings of quiet pride are delicious. It's important to take a moment to enjoy them. Now, let's draw them, which will give you even more great feelings.

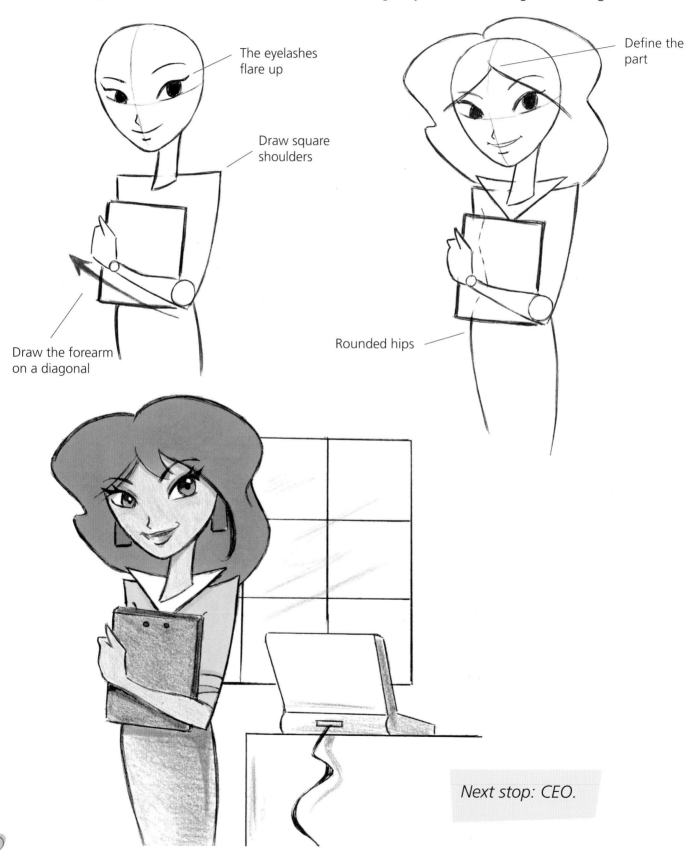

The eyelashes flare up

Draw square shoulders

Draw the forearm on a diagonal

Define the part

Rounded hips

Next stop: CEO.

URGENT BACK SCRATCH

Nothing feels better than an emergency back scratch. That's when the famous "backward lean into the edge of the desk" maneuver comes into play. Draw pursed lips to convey the sigh of relief. Bliss!

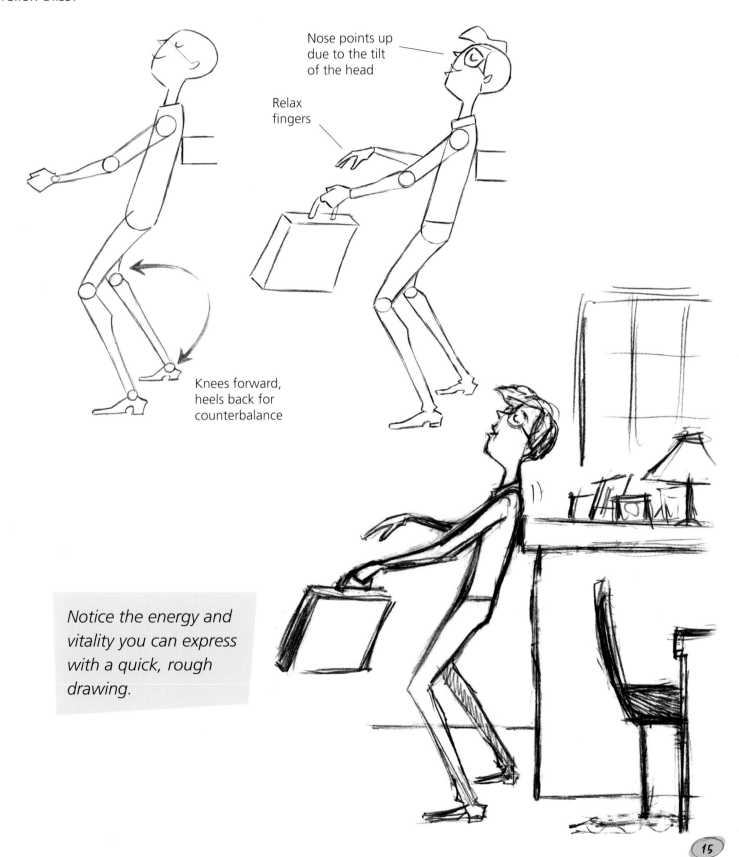

Nose points up due to the tilt of the head

Relax fingers

Knees forward, heels back for counterbalance

Notice the energy and vitality you can express with a quick, rough drawing.

THE COLORS OF FALL

Nothing beats those two weeks when New England's leaves come alive with spectacular colors. Cranberry red, bold orange, honey yellow . . . The autumn breeze scoops up the leaves and tosses them into the air. Coordinate them with your outfit for a stunning look.

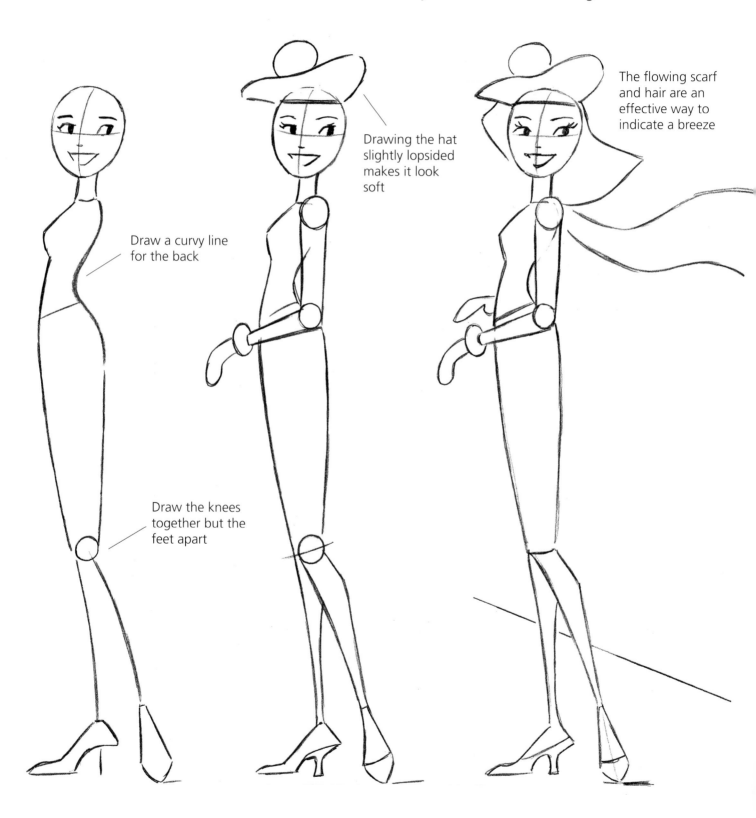

Draw a curvy line for the back

Draw the knees together but the feet apart

Drawing the hat slightly lopsided makes it look soft

The flowing scarf and hair are an effective way to indicate a breeze

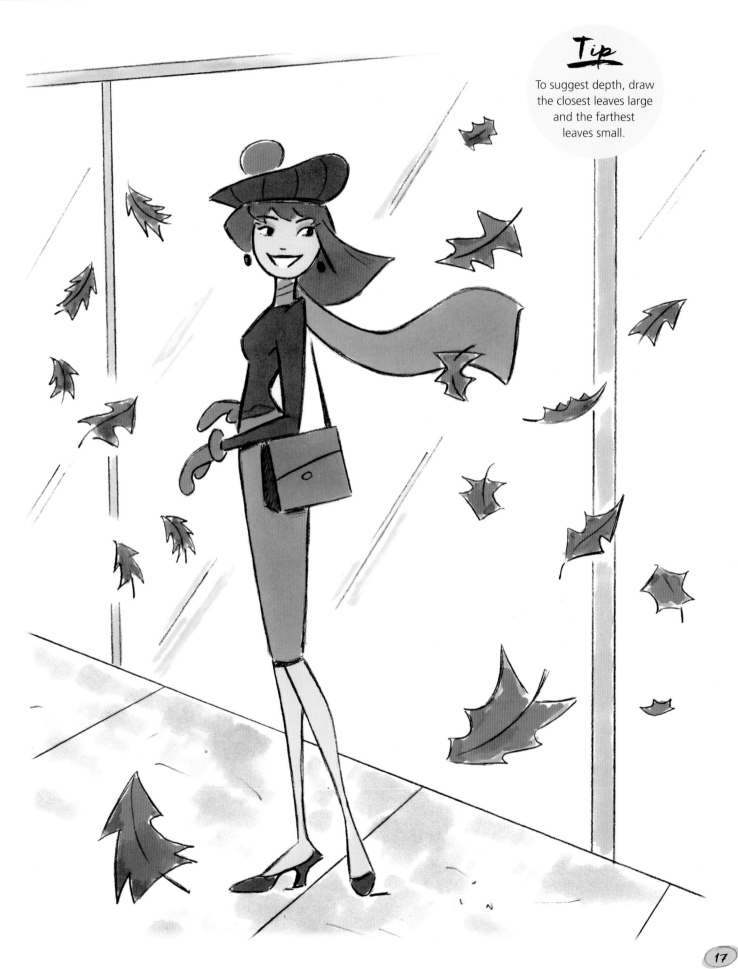

17

DOING SOMETHING NICE FOR THE PLANET

Everyone knows it's important to maintain your home. Well, the planet is a very big home, and it needs maintenance just as much as a four-bedroom Colonial does. If we do a kind act for the planet, it will thank us. And we'll feel good about it.

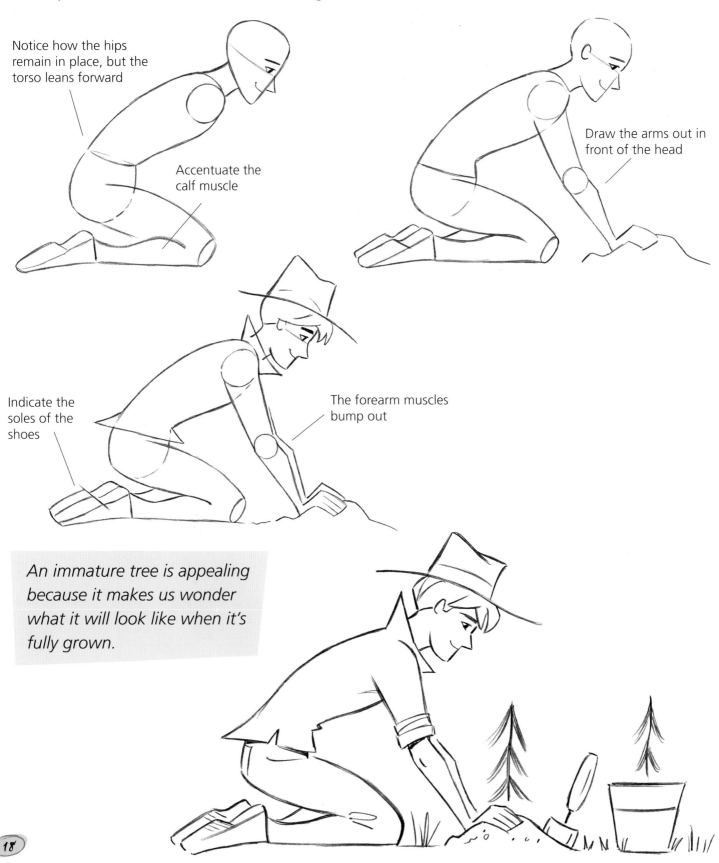

Notice how the hips remain in place, but the torso leans forward

Accentuate the calf muscle

Draw the arms out in front of the head

Indicate the soles of the shoes

The forearm muscles bump out

An immature tree is appealing because it makes us wonder what it will look like when it's fully grown.

RECEIVING A LETTER ACTUALLY WRITTEN ON PAPER

Technology is great, but it takes the human element out of everyday life. I remember when I used to get a sandwich from the refrigerator. Now I just download one. The charm and warmth of a letter penned by hand can't be matched by an email blast received simultaneously by 117 close friends.

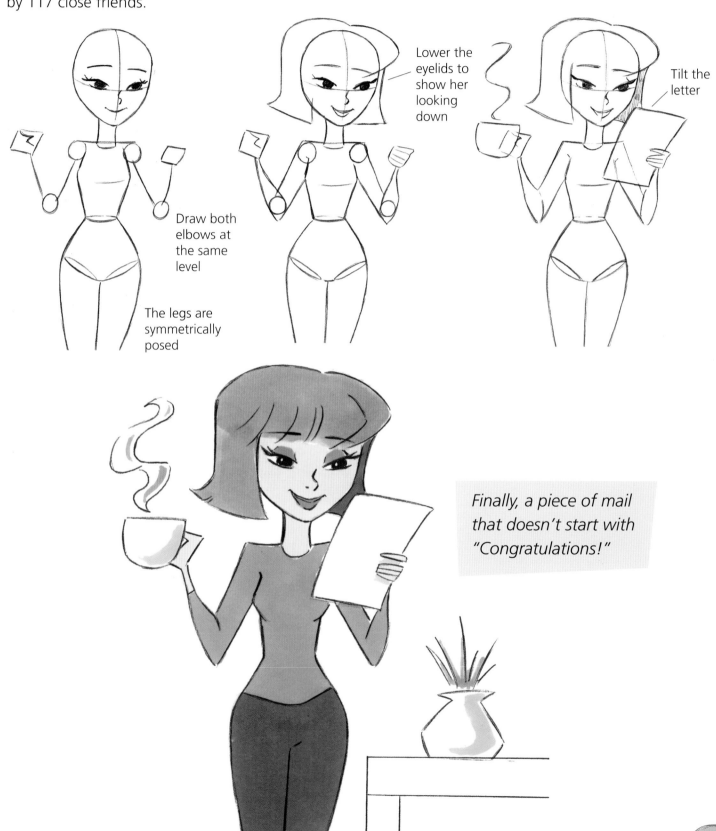

Lower the eyelids to show her looking down

Tilt the letter

Draw both elbows at the same level

The legs are symmetrically posed

Finally, a piece of mail that doesn't start with "Congratulations!"

A RADIANT SUNSET

At twilight, the sun is prominent but low in the sky. It's a visual homerun. In drawing this picture, I didn't want the figure in the scene to compete against the sunset. So how did I solve it? By drawing the figure in silhouette. The silhouette omits the details that would distract from the sunset.

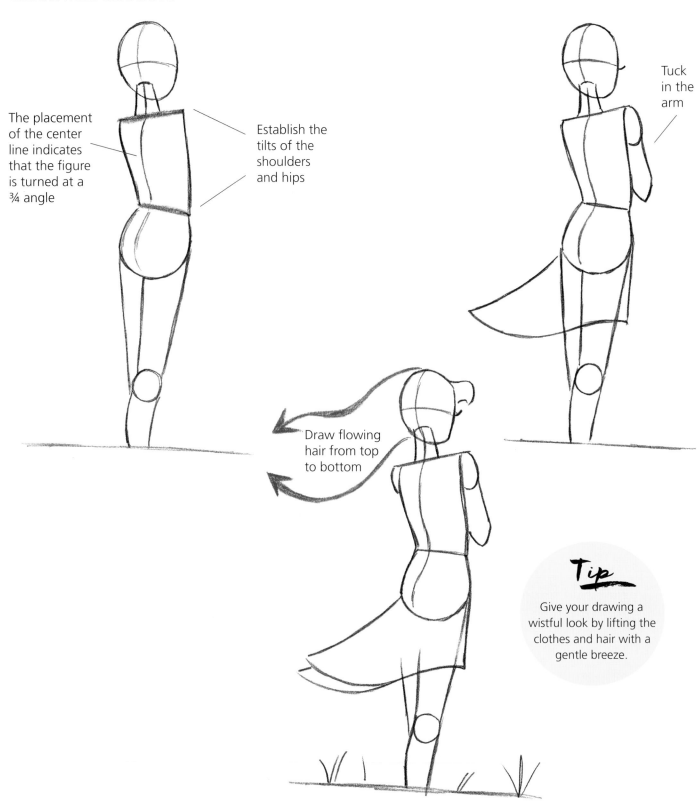

The placement of the center line indicates that the figure is turned at a ¾ angle

Establish the tilts of the shoulders and hips

Tuck in the arm

Draw flowing hair from top to bottom

Tip

Give your drawing a wistful look by lifting the clothes and hair with a gentle breeze.

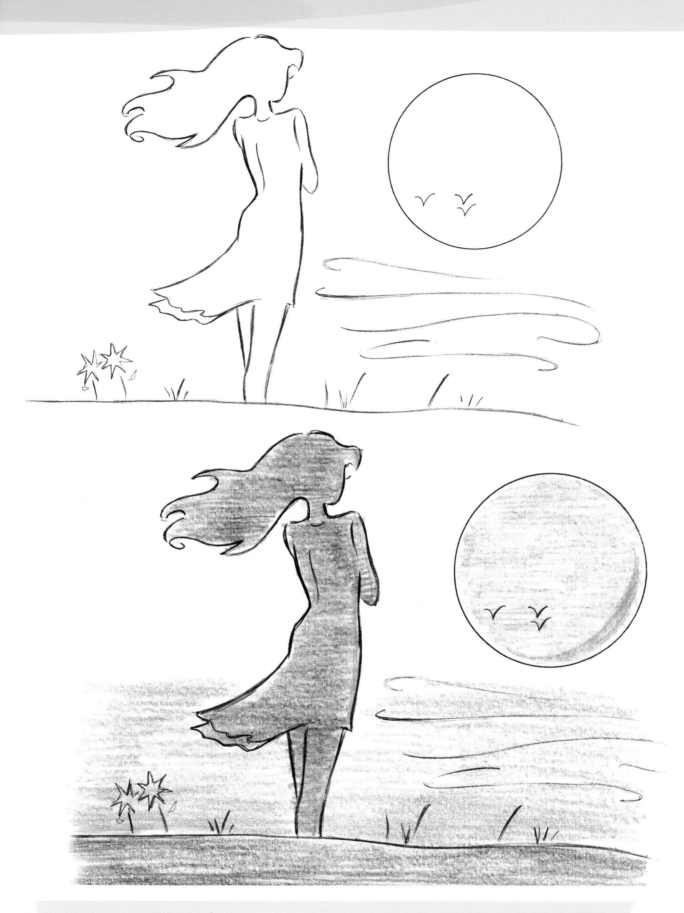

The back of the figure falls into shadow. I used purple because it's muted, but also colorful. Notice that I added a sliver of pink along the front of the figure to match the color of the sun.

VARIATION: Side View

A sunset also looks good in a side view, because this angle carves out a very clean silhouette. Here, as well as in the previous version, the sun is large and hangs low in the sky.

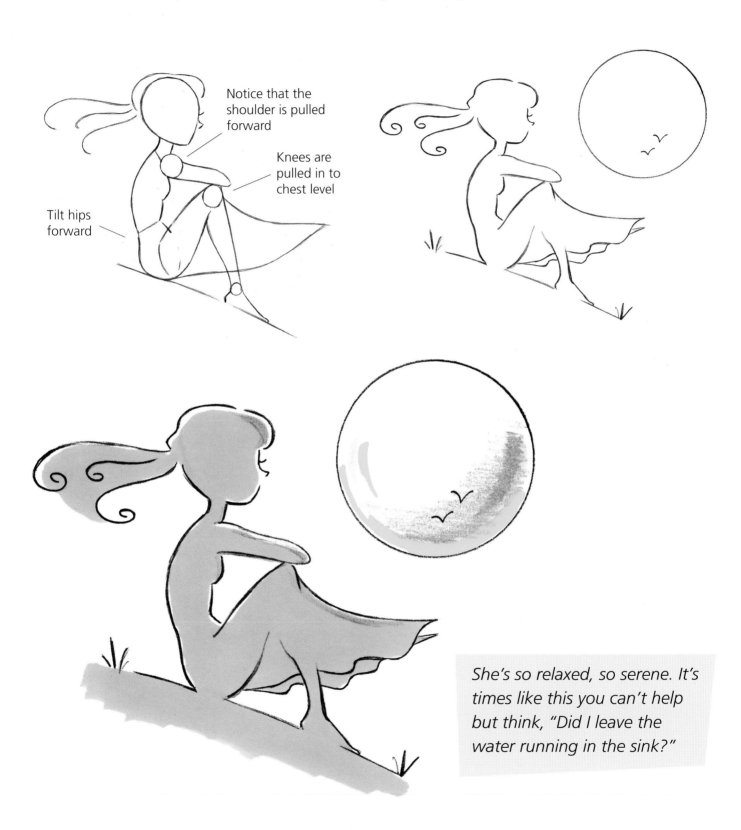

Notice that the shoulder is pulled forward

Knees are pulled in to chest level

Tilt hips forward

She's so relaxed, so serene. It's times like this you can't help but think, "Did I leave the water running in the sink?"

A GREAT FIRST DATE

These two must have used the perfect dating app. You can sense a quiet energy between them. It's a happy scene. Two people, at a café, getting to know each other. Notice that they are both drawn in profile to make the communication between them clear. Will there be a second date? The puppy obviously approves, so yes.

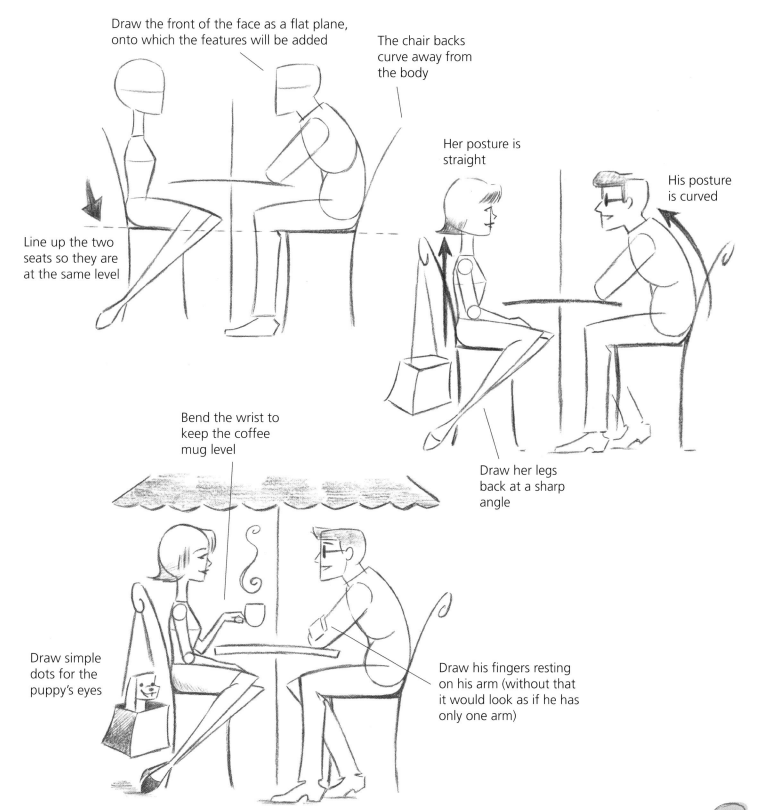

Draw the front of the face as a flat plane, onto which the features will be added

The chair backs curve away from the body

Her posture is straight

His posture is curved

Line up the two seats so they are at the same level

Bend the wrist to keep the coffee mug level

Draw her legs back at a sharp angle

Draw simple dots for the puppy's eyes

Draw his fingers resting on his arm (without that it would look as if he has only one arm)

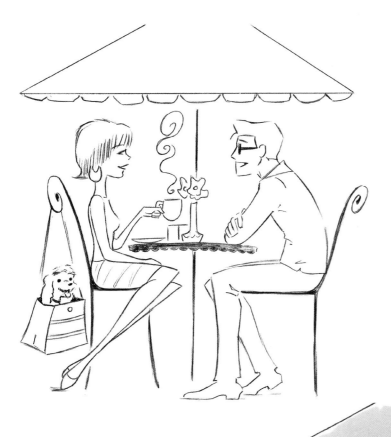

Color Cues

Color can be used to express feelings, but it can also be used to create a stronger image. This color drawing demonstrates a few helpful concepts you can use in your color work.

- The largest object in the picture is the canopy of the umbrella. I've given it a neutral color that won't overpower the figures.
- Her skirt and his pants are both gray—a visual cue that they share something in common.
- The woman's hair and bright top are used to enliven the scene.

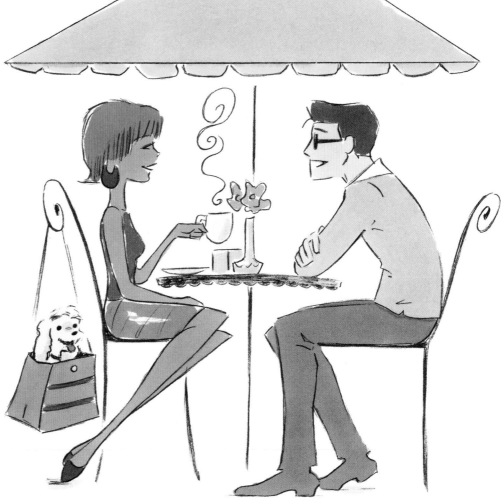

VARIATION: Expanded Scene

To emphasize our couple, de-emphasize the other pair in the scene by placing them off center and slightly back. Draw them smaller due to perspective.

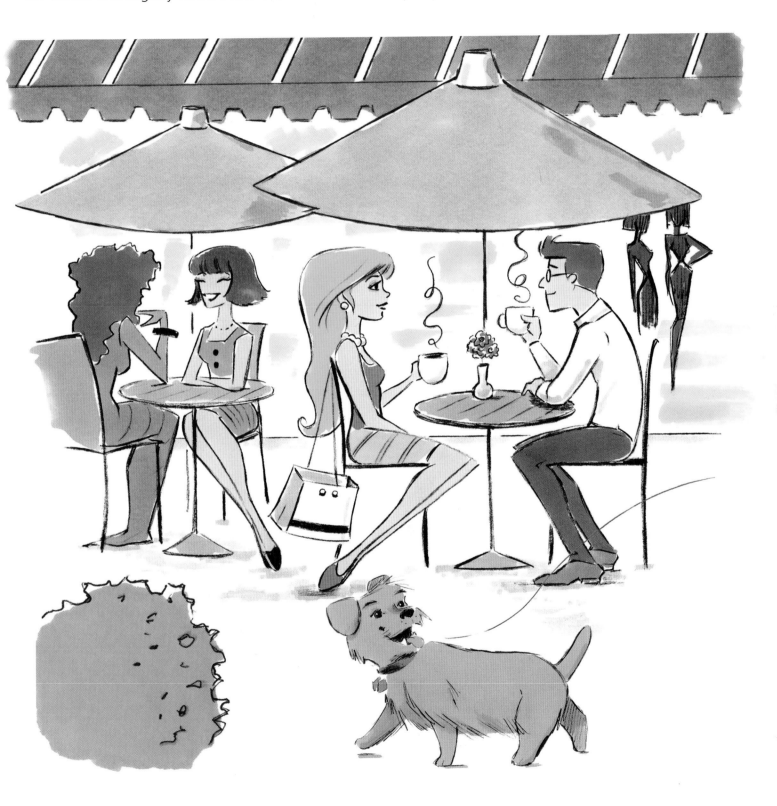

UNDER THE WILLOW TREE

The weeping willow tree is a magical canopy under which many stories have unfolded. The tall swing, the leafy tendrils, and the wishing well set up a charming scene. But let's not overlook the contribution of the pose, which is petite and composed.

Her head turns one direction, while her body turns the other way

The leg flattens against the seat of the swing

Draw the knees and toes together

Arch the back for an appealing posture

Indicate thickness of the seat

The far leg extends past the near leg

Charming Landscapes

In order to create a pleasing landscape, draw the figure at a medium or small size. That way, she'll appear to be an element in a larger scene. And here's another tip: The hanging branches and the tree trunk establish a vertical layout. To offset the verticals, draw a curved horizon.

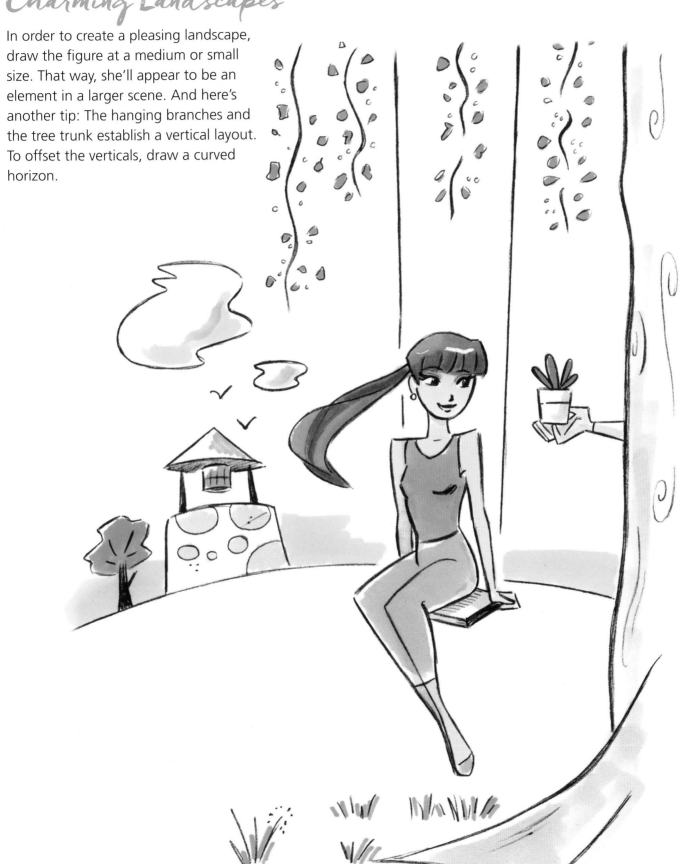

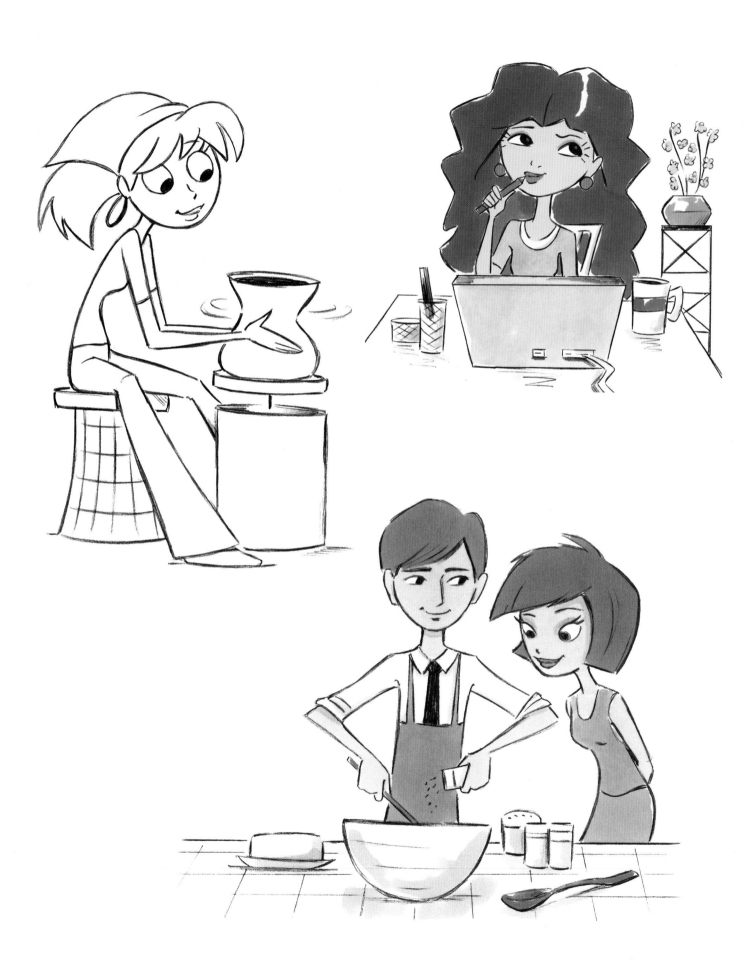

Getting Creative

Creativity is a basic human drive. The impulse to create goes way back. The Middle Ages was famous for its artists and, less admirably, for bleeding anyone with a head cold. Today, we still don't have a cure for the head cold, but we continue to paint, draw, write, and play music. The theme of this chapter is creativity itself. A person in the midst of a creative endeavor is passionate and alive with feeling, which makes them an appealing subject to draw.

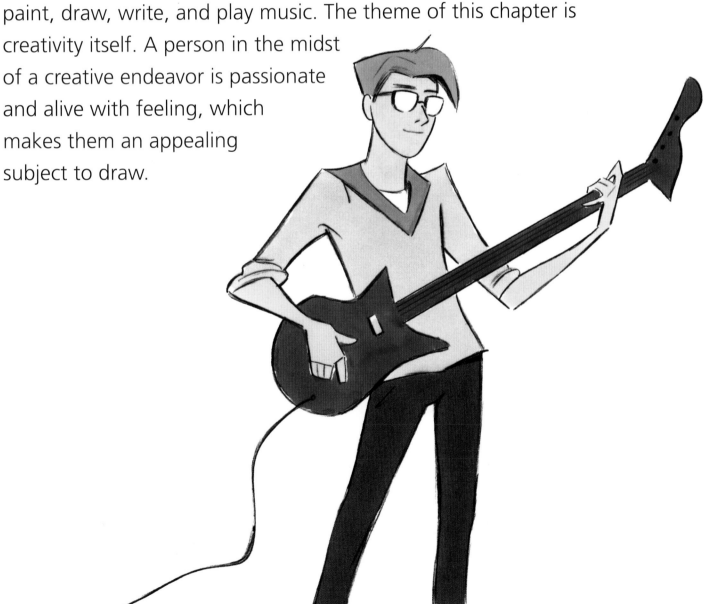

SITTING & KNITTING

I find it amazing that an experienced knitter can take a simple ball of yarn and stitch together a sweater, a throw, slippers, pillows . . . My grandmother made me a knit sweater once. Took me 45 minutes to pull my head out of the sleeve hole. When a person knits, the hands are close together and centered under the head. Therefore, we position our subject the same way.

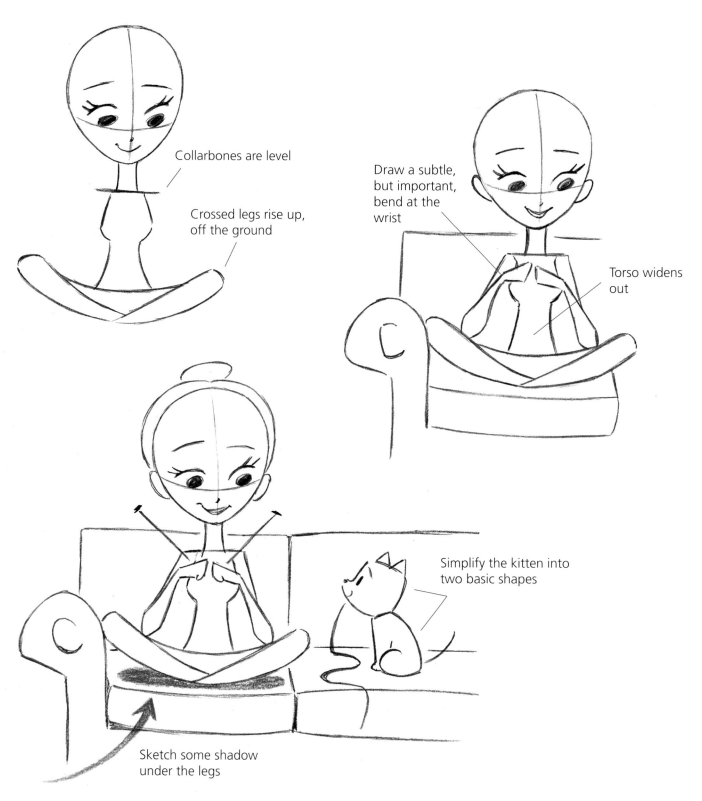

Collarbones are level

Crossed legs rise up, off the ground

Draw a subtle, but important, bend at the wrist

Torso widens out

Simplify the kitten into two basic shapes

Sketch some shadow under the legs

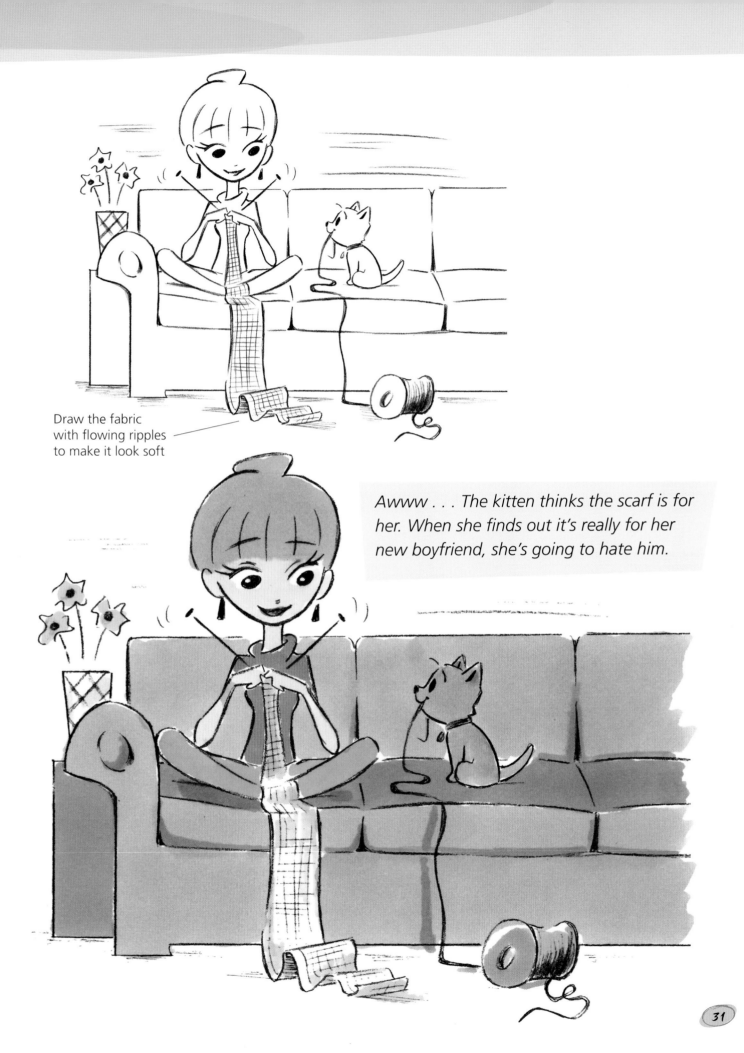

Draw the fabric
with flowing ripples
to make it look soft

Awww . . . The kitten thinks the scarf is for her. When she finds out it's really for her new boyfriend, she's going to hate him.

WRITING YOUR NOVEL

Everyone has a novel in them. Many people have interesting ideas and big dreams of someday being published. If you've ever had an idea for a story or a screenplay, use that inspiration to create this illustration. Perhaps it's a version of yourself!

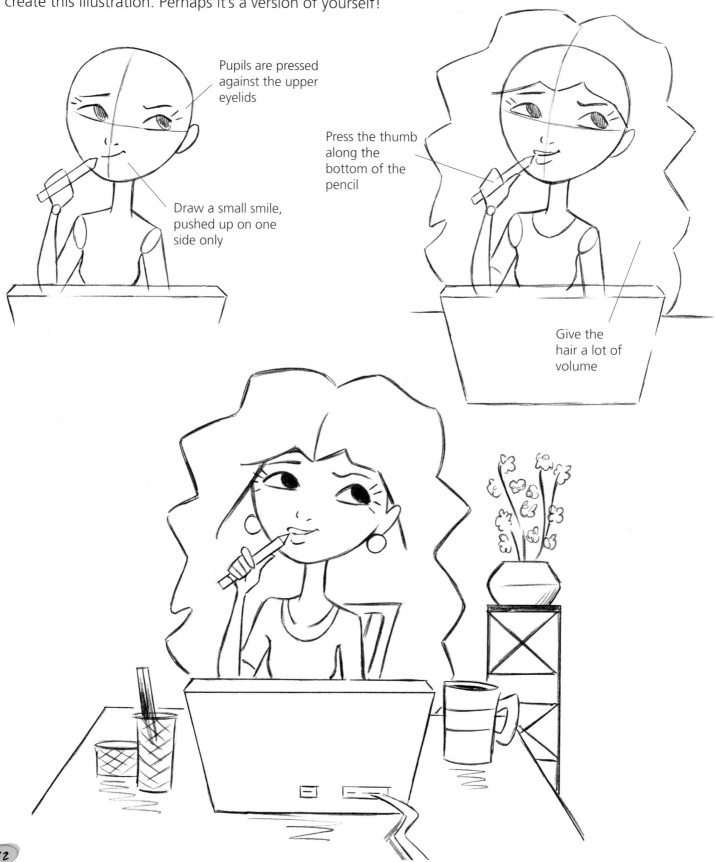

Pupils are pressed against the upper eyelids

Press the thumb along the bottom of the pencil

Draw a small smile, pushed up on one side only

Give the hair a lot of volume

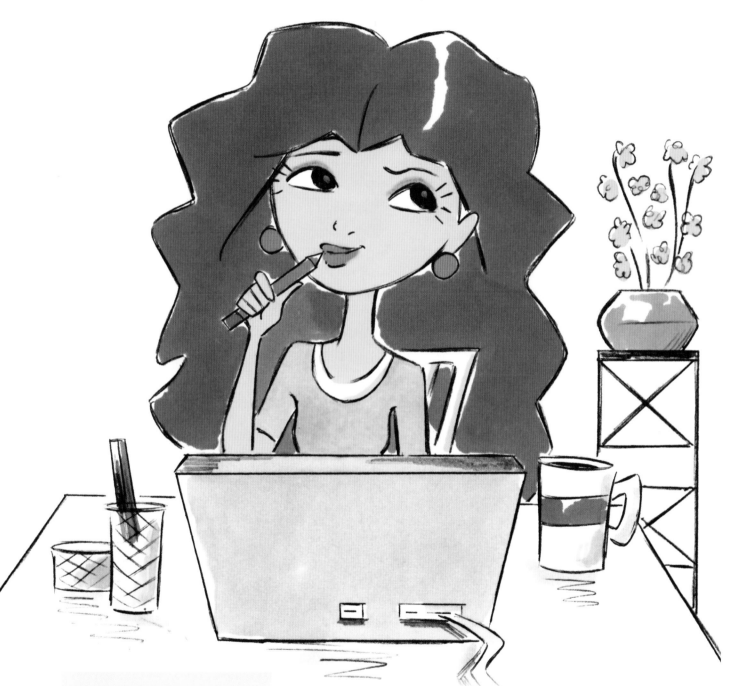

Looks like the ideas are beginning to percolate!

LEARNING AN INSTRUMENT

It's fun to learn an instrument. As a teenager, I played rock songs on the air guitar. But as I matured, I left all that behind. Now I play classical music on the air violin. When drawing someone playing the guitar or electric bass, draw the pose to accommodate the position of the instrument. For example, this fellow's hips are pushed slightly forward to create a platform on which the instrument rests.

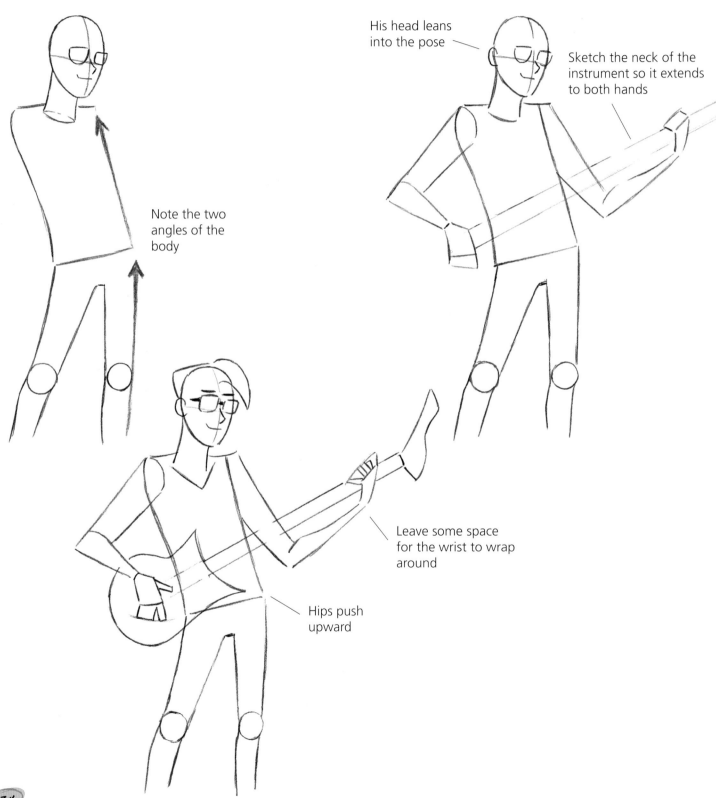

Note the two angles of the body

His head leans into the pose

Sketch the neck of the instrument so it extends to both hands

Leave some space for the wrist to wrap around

Hips push upward

34

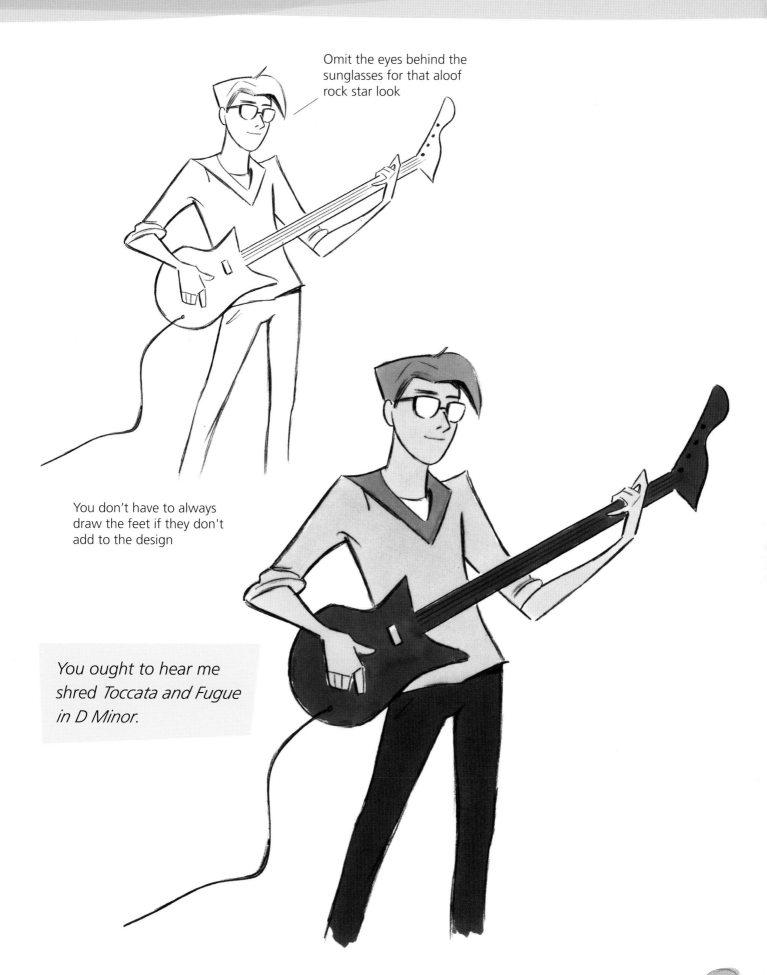

Omit the eyes behind the sunglasses for that aloof rock star look

You don't have to always draw the feet if they don't add to the design

You ought to hear me shred Toccata and Fugue in D Minor.

35

IN THE POTTERY STUDIO

Whenever I walk into an art studio, the smell of the clay makes me feel good. There's stuff being created. I still have fond memories of art class in elementary school. Math class, less so. But the hands-on experience of creating art remains uplifting.

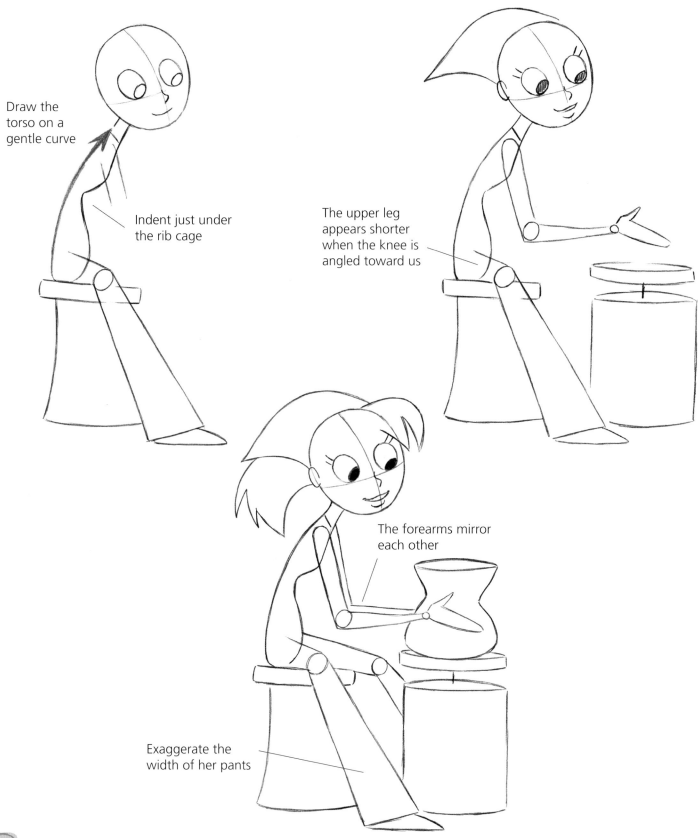

Draw the torso on a gentle curve

Indent just under the rib cage

The upper leg appears shorter when the knee is angled toward us

The forearms mirror each other

Exaggerate the width of her pants

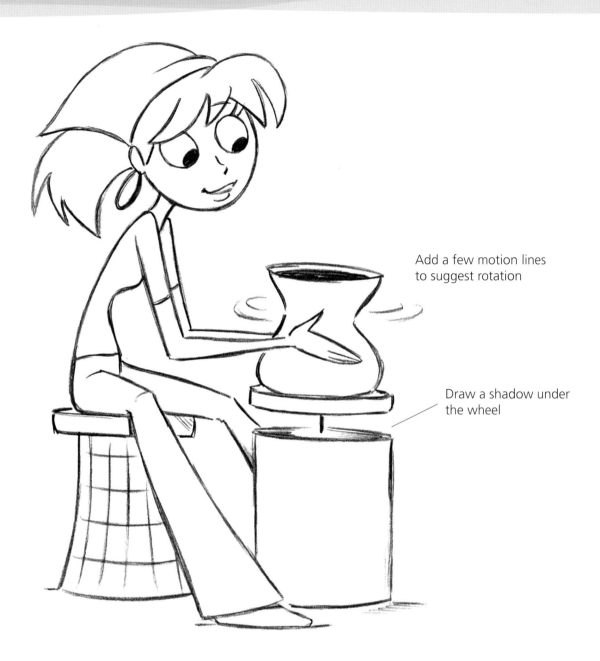

Add a few motion lines to suggest rotation

Draw a shadow under the wheel

Pottery Swap

Don't be afraid to change details in a drawing to personalize it. Here are a few more pottery pieces you can swap with the vase. Or you can use them to fill out a larger scene.

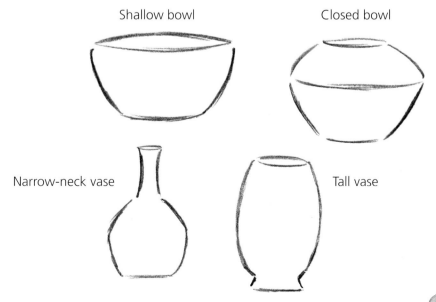

Shallow bowl

Closed bowl

Narrow-neck vase

Tall vase

PAINTING YOUR MASTERPIECE

Drawing a large canvas creates an engaging scene. That's because a large canvas causes the viewer to wonder what's on the other side. When drawing this artist painting, indicate a few splotches of paint on her smock or clothing. No one will mind if she gets a little messy.

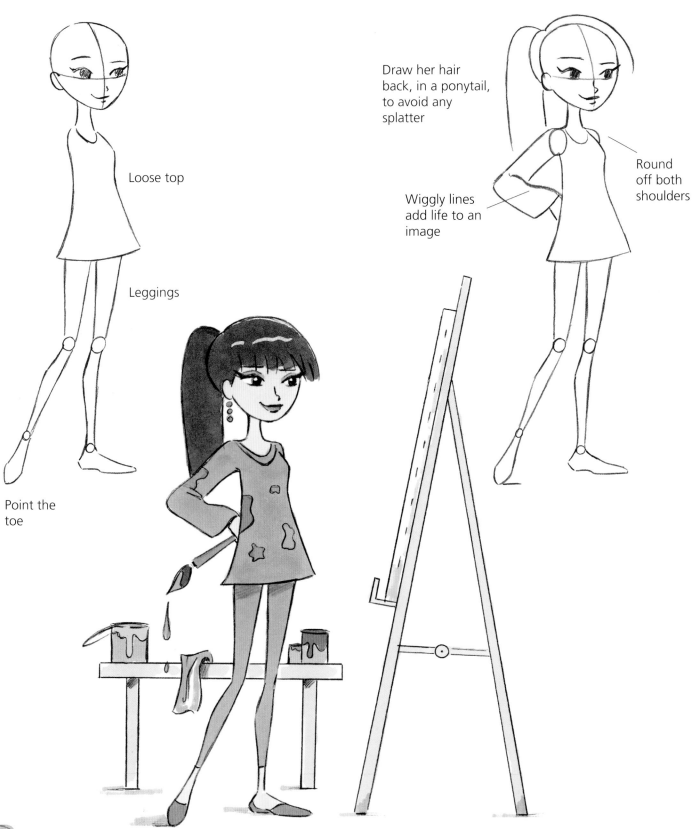

Loose top

Leggings

Point the toe

Draw her hair back, in a ponytail, to avoid any splatter

Wiggly lines add life to an image

Round off both shoulders

SAND ART

Some sand castles are so amazing that they make you want to throw your body in front of them to block the tide. It takes an afternoon to build a world-class sand castle. It takes even longer at the beach in our neighborhood, mainly because of all the zoning permits required. Each sand castle must be equipped with solar panels.

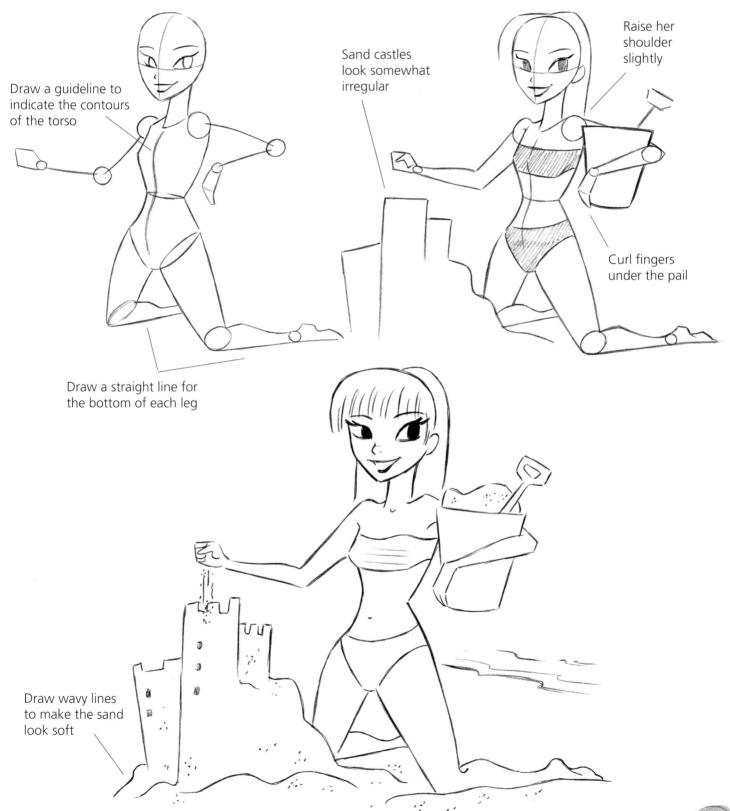

Draw a guideline to indicate the contours of the torso

Draw a straight line for the bottom of each leg

Sand castles look somewhat irregular

Raise her shoulder slightly

Curl fingers under the pail

Draw wavy lines to make the sand look soft

CREATING A GREAT DISH

A dash of this, a sprinkle that—and voilà—Pasta à la Dave. We all love to taste inventive dishes. But there's a creative plateau beyond which you're pushing it. I went to Miami with my family a few years back. Our curiosity was stirred when we saw a licorice-flavored salmon dish listed on the menu. It took two days of gargling to get rid of the taste. But the cook featured on this page is not quite so adventurous. Which is a good thing for his guest.

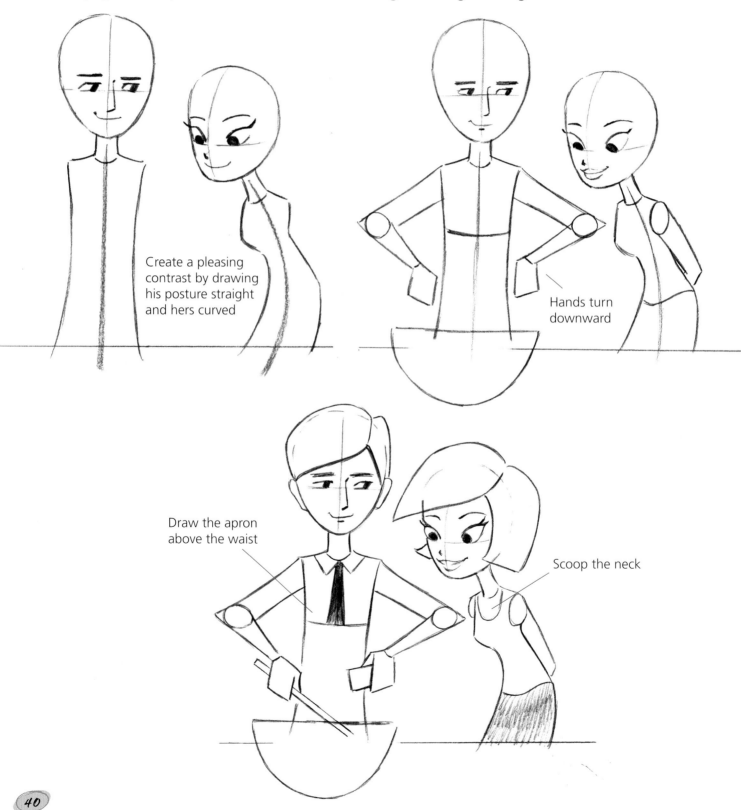

Create a pleasing contrast by drawing his posture straight and hers curved

Hands turn downward

Draw the apron above the waist

Scoop the neck

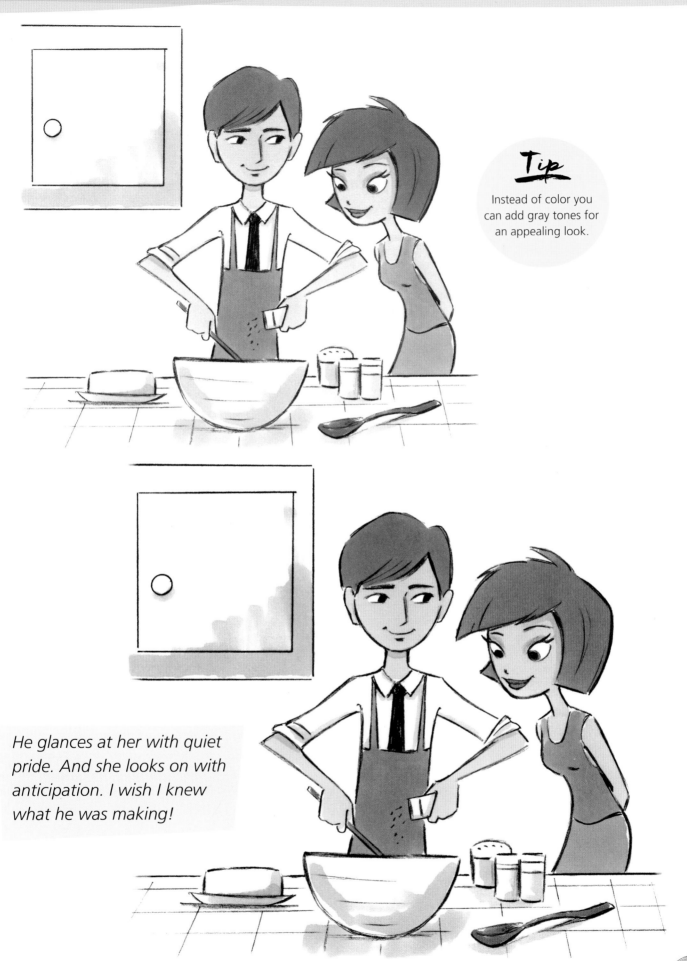

Tip

Instead of color you can add gray tones for an appealing look.

He glances at her with quiet pride. And she looks on with anticipation. I wish I knew what he was making!

MAKING JEWELRY

Many creative types enjoy making their own jewelry. There are craft shows and stores that offer one-of-a-kind, handmade earrings. It's the only type of artwork you can (or should!) display by hanging it from your ears!

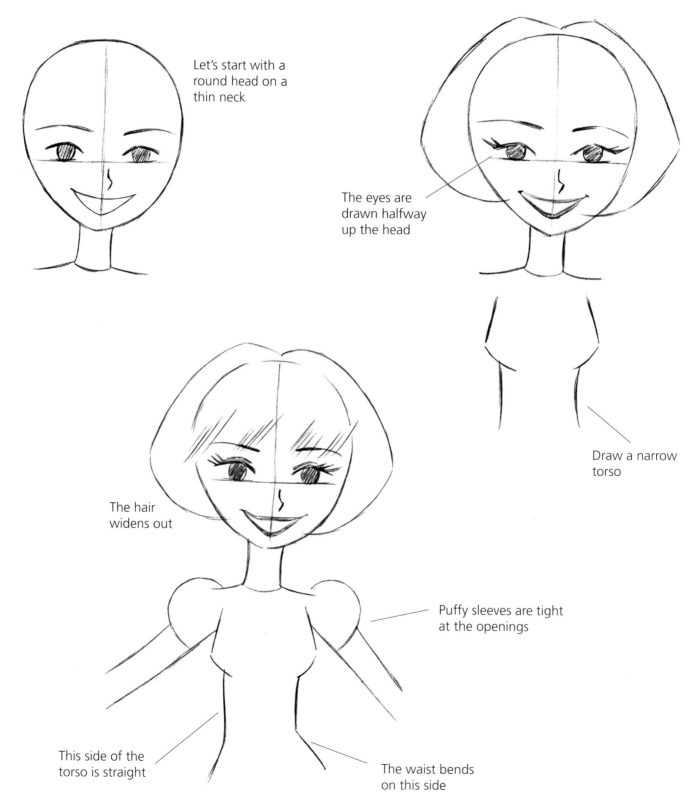

Let's start with a round head on a thin neck

The eyes are drawn halfway up the head

Draw a narrow torso

The hair widens out

Puffy sleeves are tight at the openings

This side of the torso is straight

The waist bends on this side

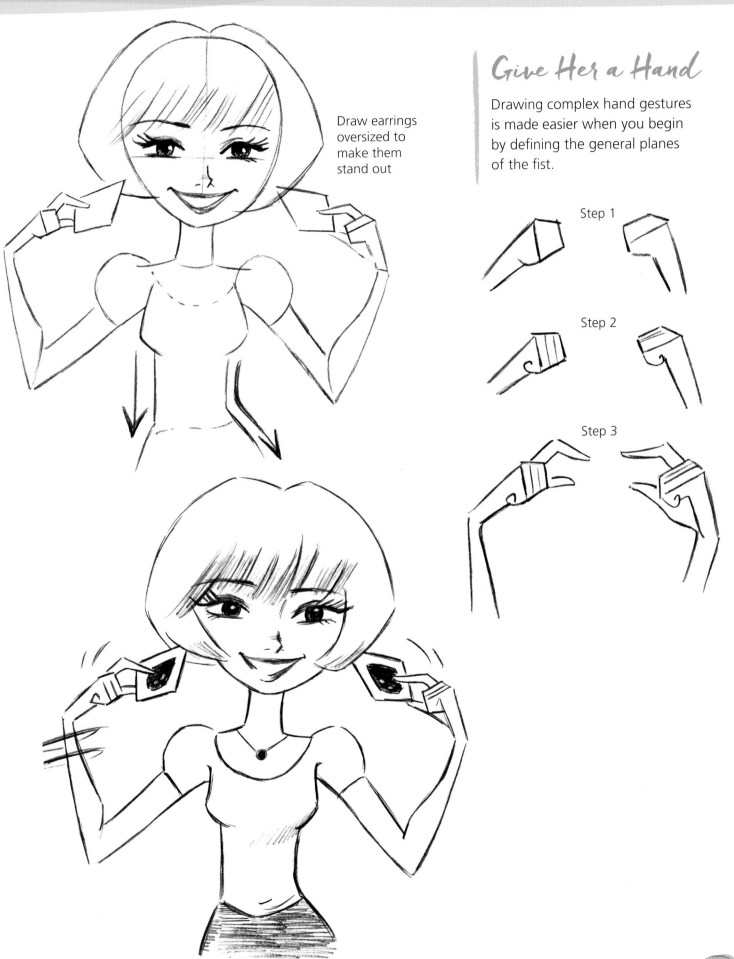

Draw earrings oversized to make them stand out

Give Her a Hand

Drawing complex hand gestures is made easier when you begin by defining the general planes of the fist.

Step 1

Step 2

Step 3

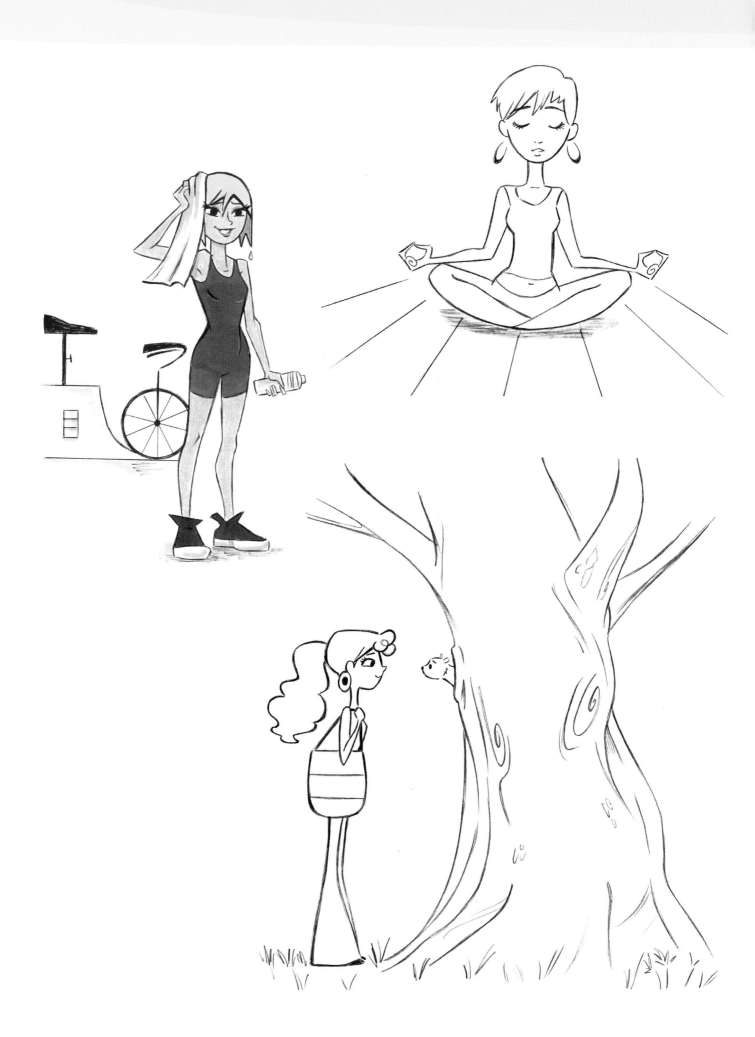

Just for You

Are you always busy doing nice things for others but not for yourself? Hit the "pause" button on your life. This chapter has just what you need. You'll enjoy sketching things that make you feel restored. These are delicious scenes you can sink into as an artist. If you still feel guilty about doing something nice for yourself, I'll write you a note: "Dear Conscience, my reader will be taking a break today to enjoy drawing. Hold all calls."

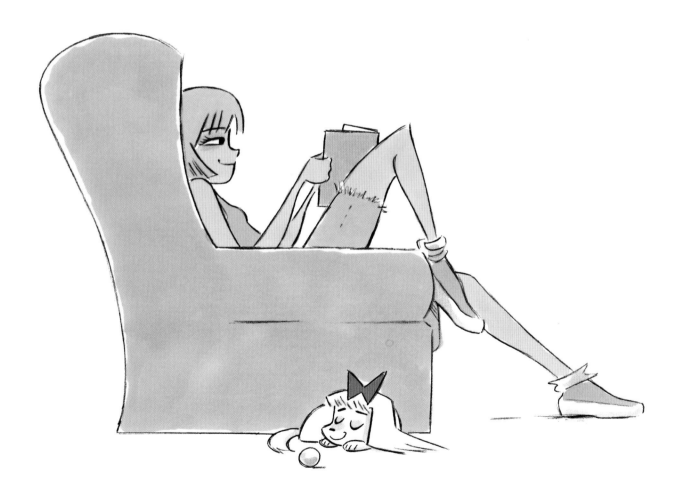

A CHALLENGING WORKOUT

When you get a good workout, you feel good for the rest of the day. Draw a few props to flesh out the scene, such as the towel, water bottle, and spin cycle. I bought a top-of-the line spin cycle last year. And someday I may even unwrap it.

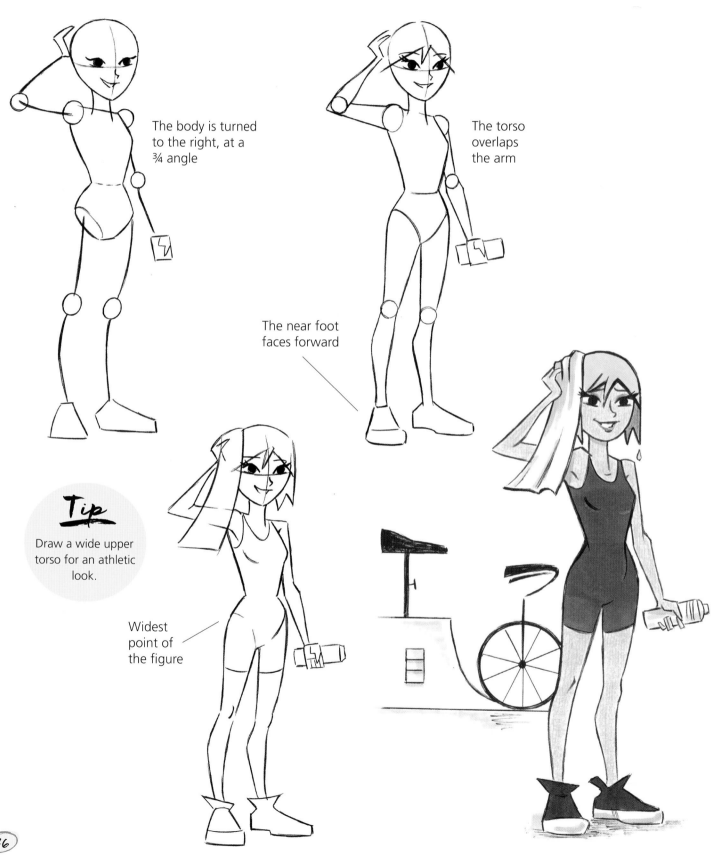

The body is turned to the right, at a ¾ angle

The torso overlaps the arm

The near foot faces forward

Tip

Draw a wide upper torso for an athletic look.

Widest point of the figure

46

GETTING TO SLEEP LATE

In case you don't recognize what's going on here, it's a picture of someone sleeping late. The concept is that some people actually slow down on weekends. Really, people actually do this. Just turn off your alarm clock and sleep until you feel like getting up. Insane, right?

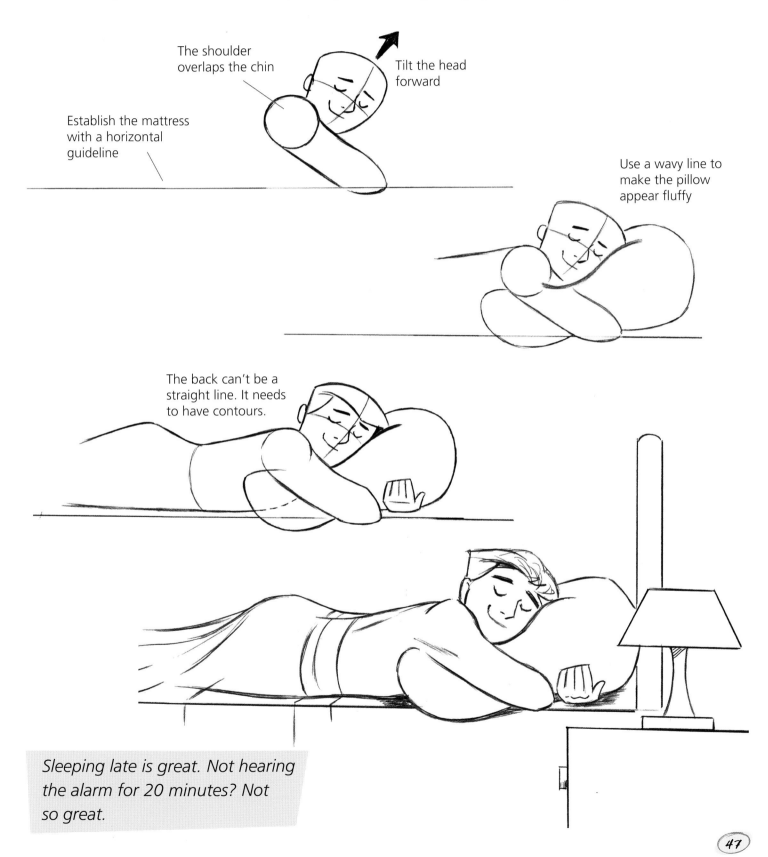

The shoulder overlaps the chin

Tilt the head forward

Establish the mattress with a horizontal guideline

Use a wavy line to make the pillow appear fluffy

The back can't be a straight line. It needs to have contours.

Sleeping late is great. Not hearing the alarm for 20 minutes? Not so great.

FAVORITE FOODS FROM CHILDHOOD

Half of the people you see drinking kale smoothies at juice bars are secretly slurping chocolate corn cereal chunks before they go to work. The way she holds her spoon shows that she has paused to read the cartoons on the back of the cereal box. Small gestures like these add humor to the scene.

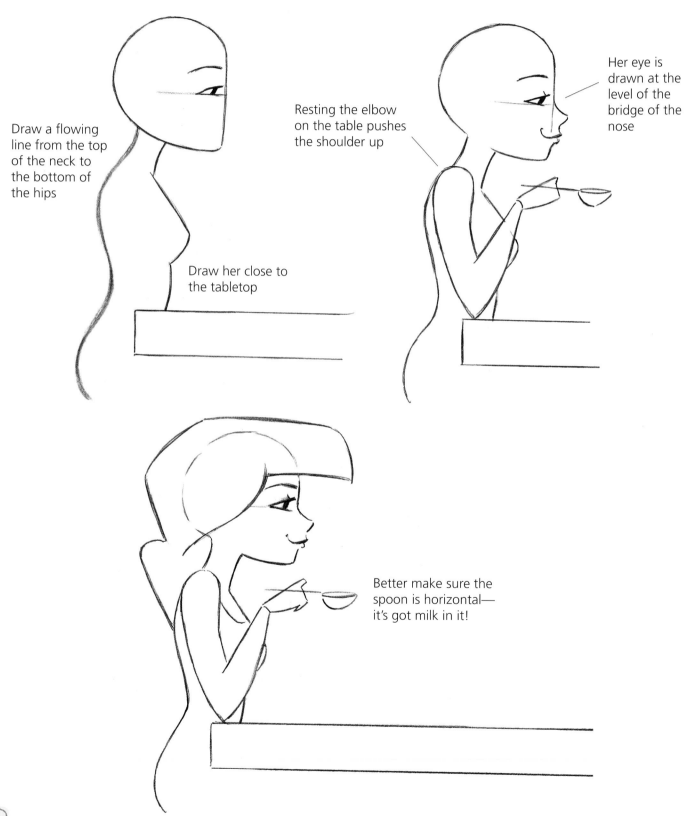

Draw a flowing line from the top of the neck to the bottom of the hips

Draw her close to the tabletop

Resting the elbow on the table pushes the shoulder up

Her eye is drawn at the level of the bridge of the nose

Better make sure the spoon is horizontal— it's got milk in it!

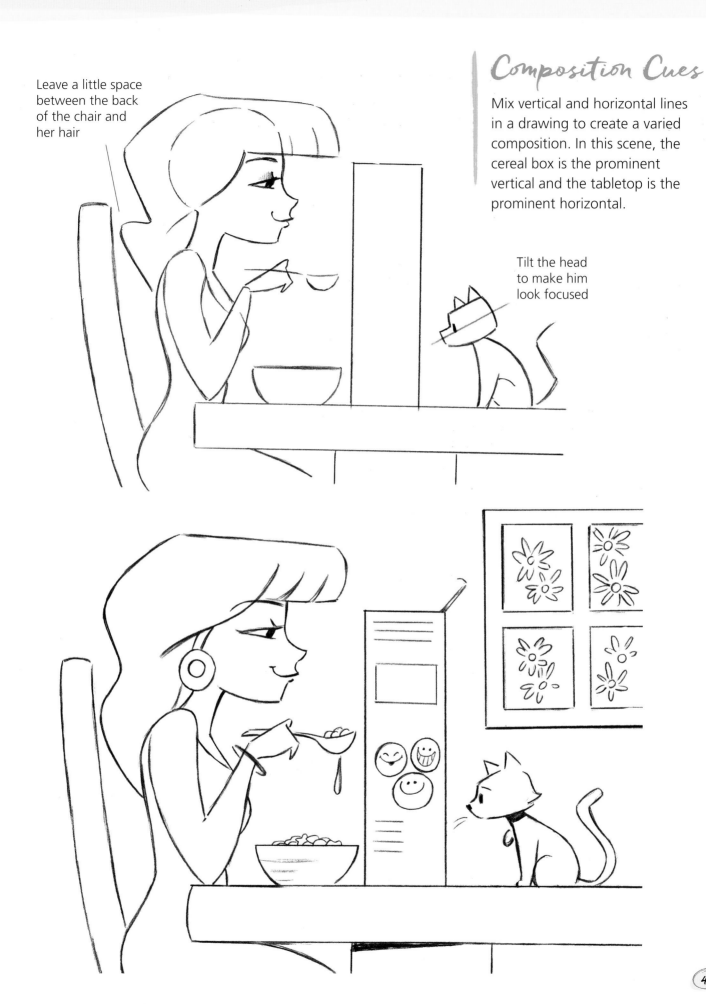

Leave a little space between the back of the chair and her hair

Composition Cues

Mix vertical and horizontal lines in a drawing to create a varied composition. In this scene, the cereal box is the prominent vertical and the tabletop is the prominent horizontal.

Tilt the head to make him look focused

SINKING INTO A GOOD BOOK

It's cozy to curl up in an easy chair with a good book and escape from the demands of the day. It's "me time." And you deserve it!

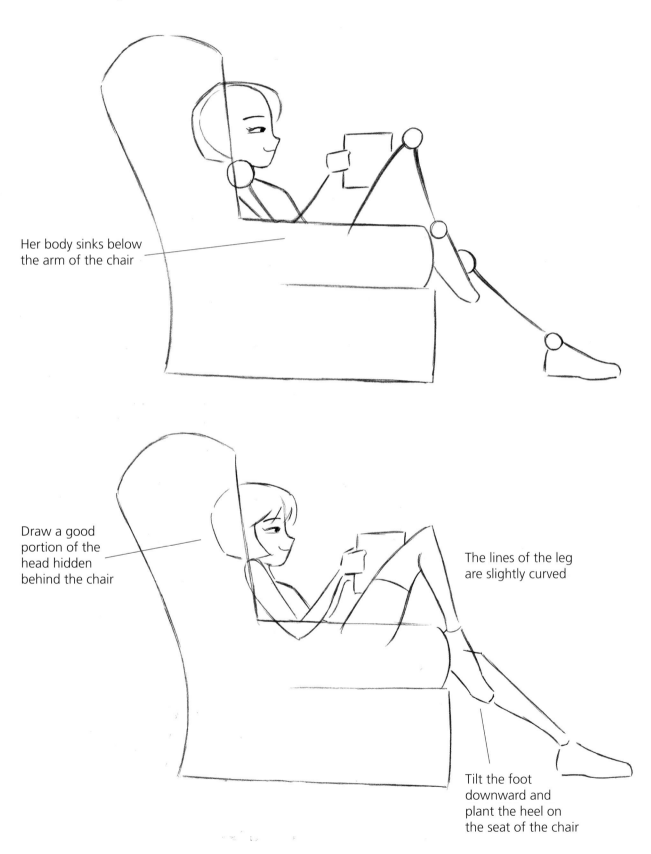

Her body sinks below the arm of the chair

Draw a good portion of the head hidden behind the chair

The lines of the leg are slightly curved

Tilt the foot downward and plant the heel on the seat of the chair

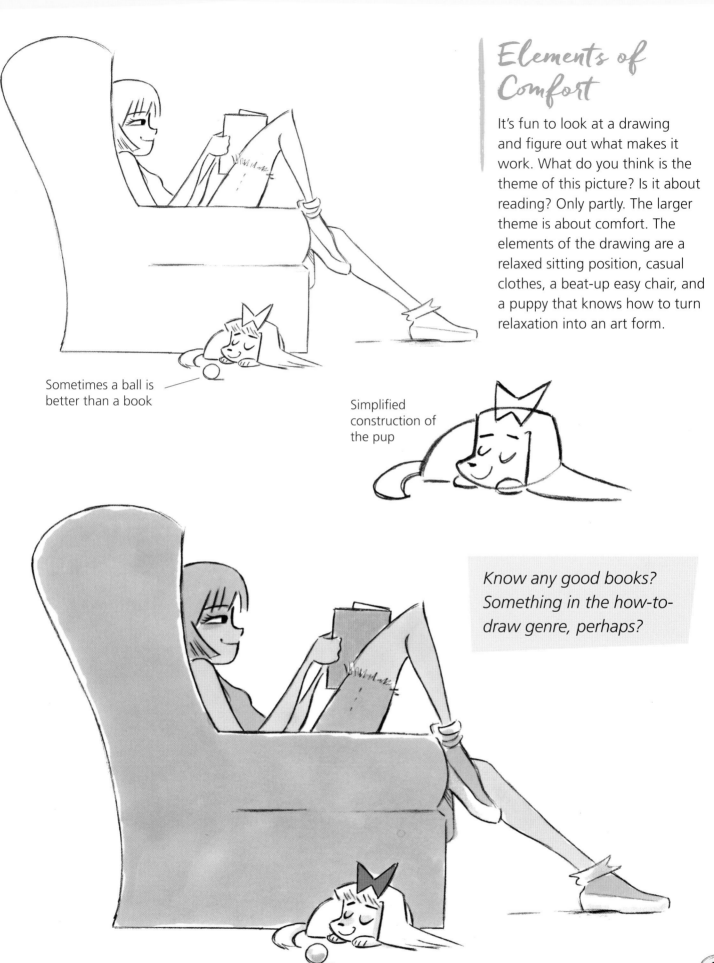

Elements of Comfort

It's fun to look at a drawing and figure out what makes it work. What do you think is the theme of this picture? Is it about reading? Only partly. The larger theme is about comfort. The elements of the drawing are a relaxed sitting position, casual clothes, a beat-up easy chair, and a puppy that knows how to turn relaxation into an art form.

Sometimes a ball is better than a book

Simplified construction of the pup

Know any good books? Something in the how-to-draw genre, perhaps?

TIME TO UNWIND

It's easy to get tense when you're caught in traffic, but not so easy when you're lying on a hammock. Add the Caribbean Sea, and you'll quickly become the most agreeable person on the planet. This transformation instantly wears off when you return home. However, you can still conjure up those soothing feelings as you draw this scene!

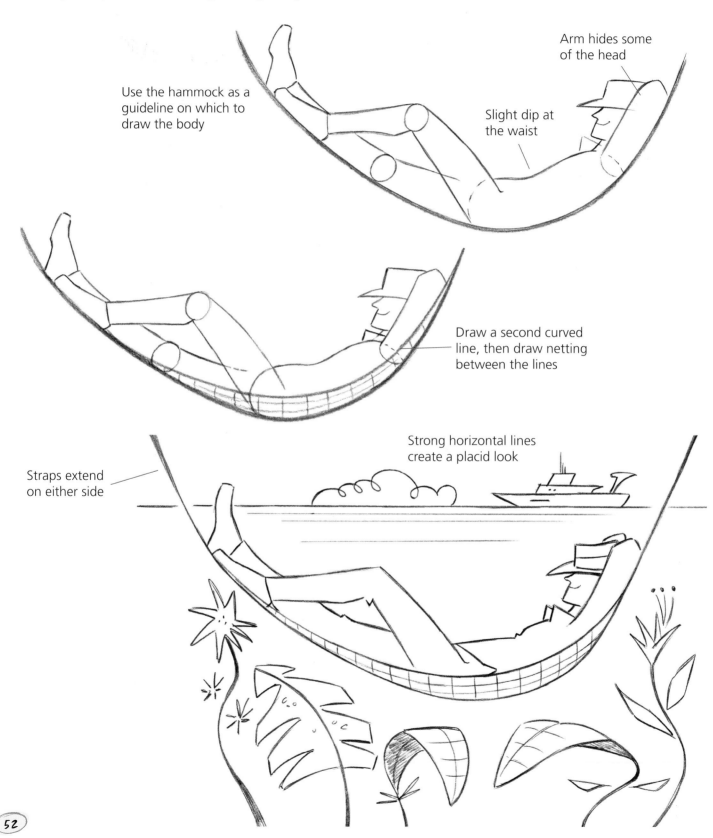

Arm hides some of the head

Use the hammock as a guideline on which to draw the body

Slight dip at the waist

Draw a second curved line, then draw netting between the lines

Straps extend on either side

Strong horizontal lines create a placid look

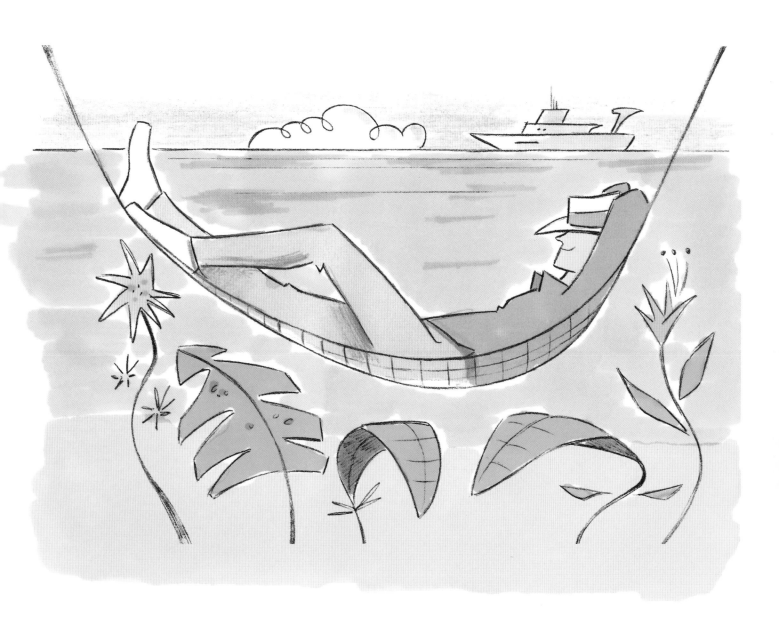

I could have lifted the shoreline (the sandy part) higher so that he overlaps it, but I find it more appealing to frame him within a band of blue, tropical sea.

APPRECIATING THE LITTLE THINGS

Everything moves so fast. People rush to their yoga classes. They answer texts while doing tai chi. Instead of driving yourself crazy, why not pause—just for a moment—and notice the little things right in front of you. And when you do, you can draw what you find and share it with others.

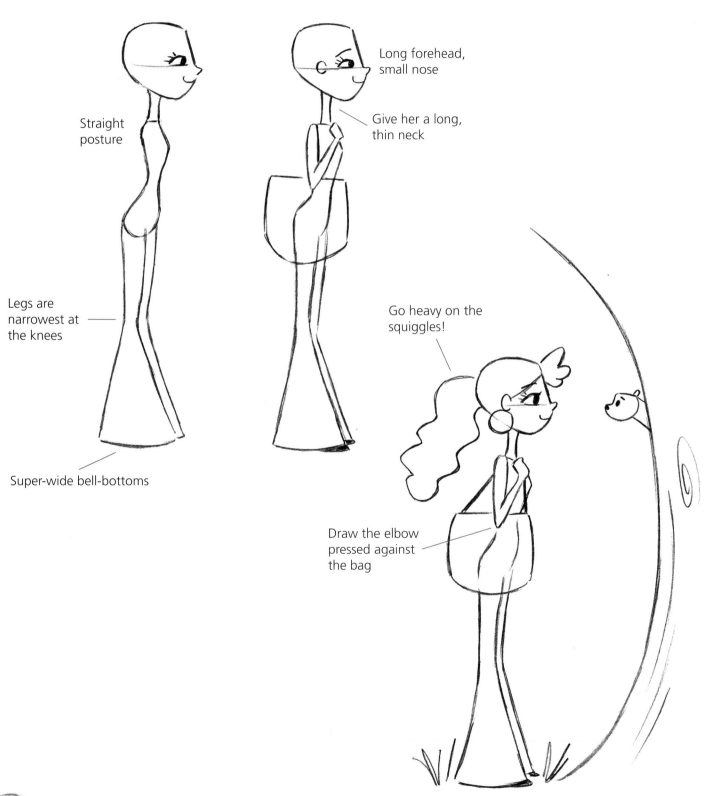

Long forehead, small nose

Give her a long, thin neck

Straight posture

Legs are narrowest at the knees

Super-wide bell-bottoms

Go heavy on the squiggles!

Draw the elbow pressed against the bag

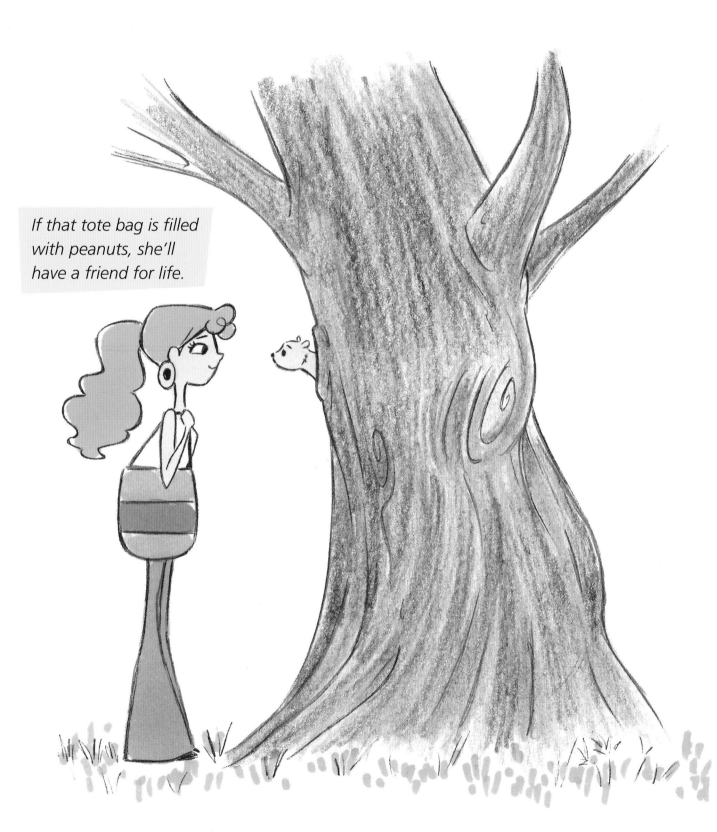

If that tote bag is filled with peanuts, she'll have a friend for life.

PRACTICING YOGA

The sukhasana is the most famous position in yoga. The second most famous position is sitting in front of the TV with an ice pack pressed against your hamstring. But if you can withstand the rigors of enforced relaxation (I'm talking to all you type As out there), then you'll emerge with a wonderful feeling of calm. Yoga is about balance so your drawing needs to be symmetrical. In "artist's speak" that means that the left side and right side need to match up.

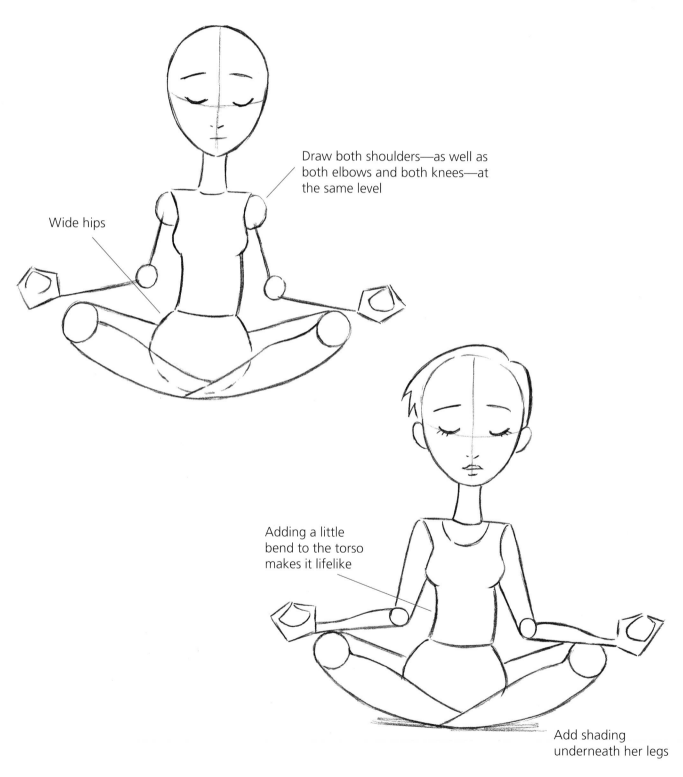

Draw both shoulders—as well as both elbows and both knees—at the same level

Wide hips

Adding a little bend to the torso makes it lifelike

Add shading underneath her legs

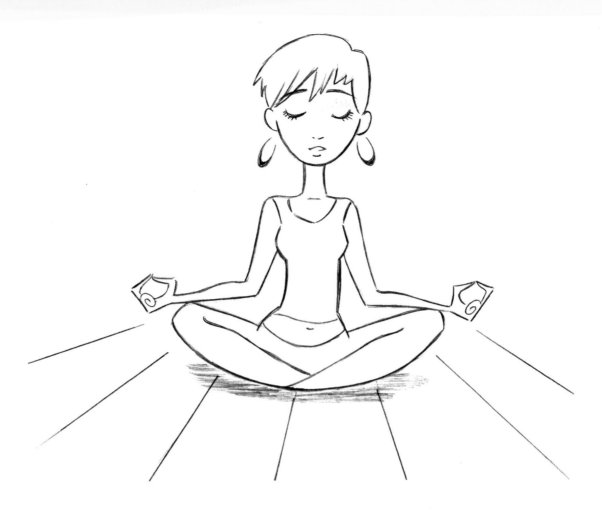

VARIATION: Standing Pose

This is called the "tree" pose in yoga. It's for people who enjoy standing poses, and for those who have never seen what a tree looks like. In order to maintain balance, follow these steps and avoid a strong breeze.

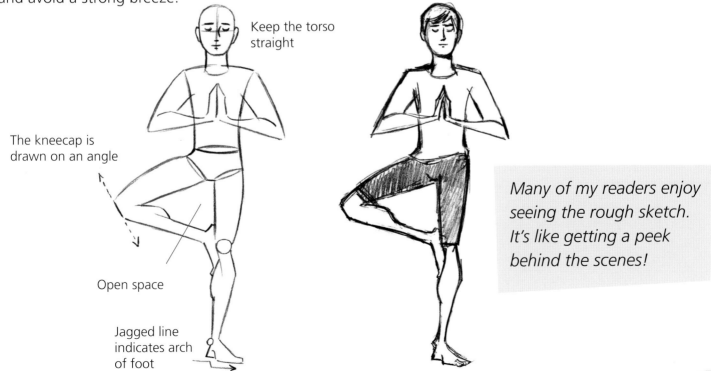

Keep the torso straight

The kneecap is drawn on an angle

Open space

Jagged line indicates arch of foot

Many of my readers enjoy seeing the rough sketch. It's like getting a peek behind the scenes!

TREAT YOURSELF

It's never easy to acknowledge your own self-worth. But it's important. You work hard. You deserve to reward yourself. Is there something special you've had your eye on? Give yourself permission to get it. Get it this week. Mark it down on your agenda. And while you're at it, pick up a little something for me, too.

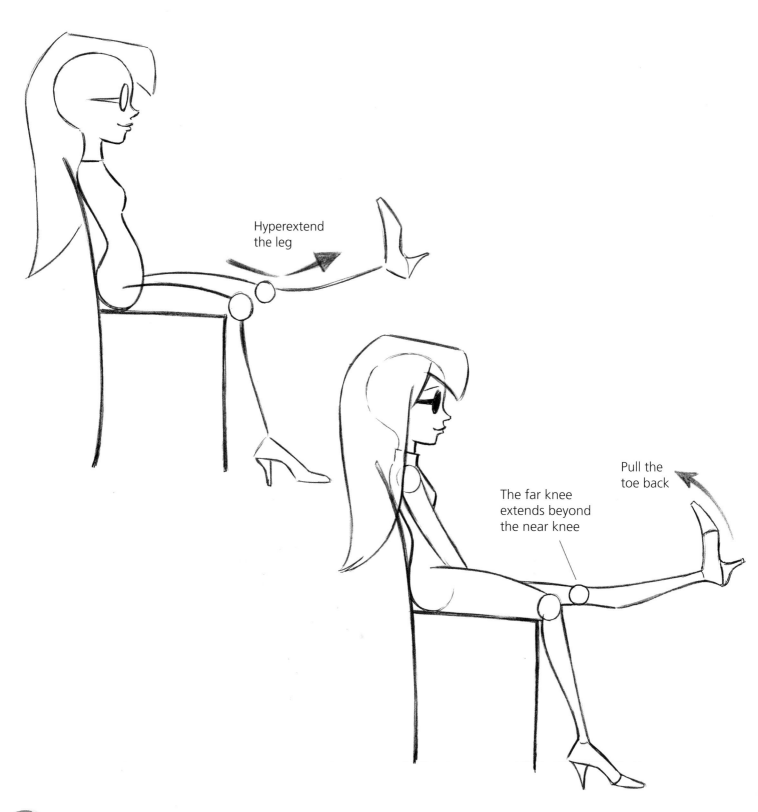

Hyperextend the leg

The far knee extends beyond the near knee

Pull the toe back

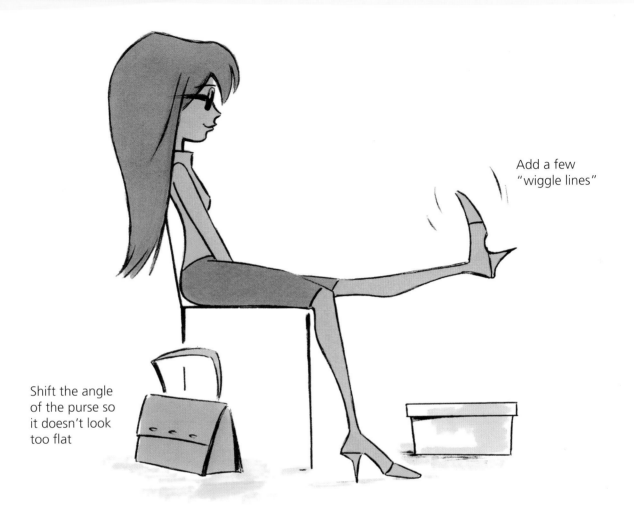

Add a few "wiggle lines"

Shift the angle of the purse so it doesn't look too flat

Shoe Styles

If high heels aren't what makes you happy, feel free to design your own shoes. Here are a few ideas.

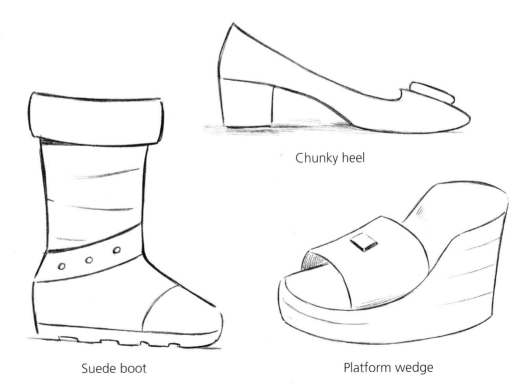

Chunky heel

Suede boot

Platform wedge

WAKE UP & SMELL THE COFFEE

I created this illustration in a whimsical, cartoony style, which is fun to draw. It combines the sharp angles of the nose and chin with the flat plane of the forehead. And although the face has been drawn in a profile, both eyes appear on the same side of the face—a humorous detail.

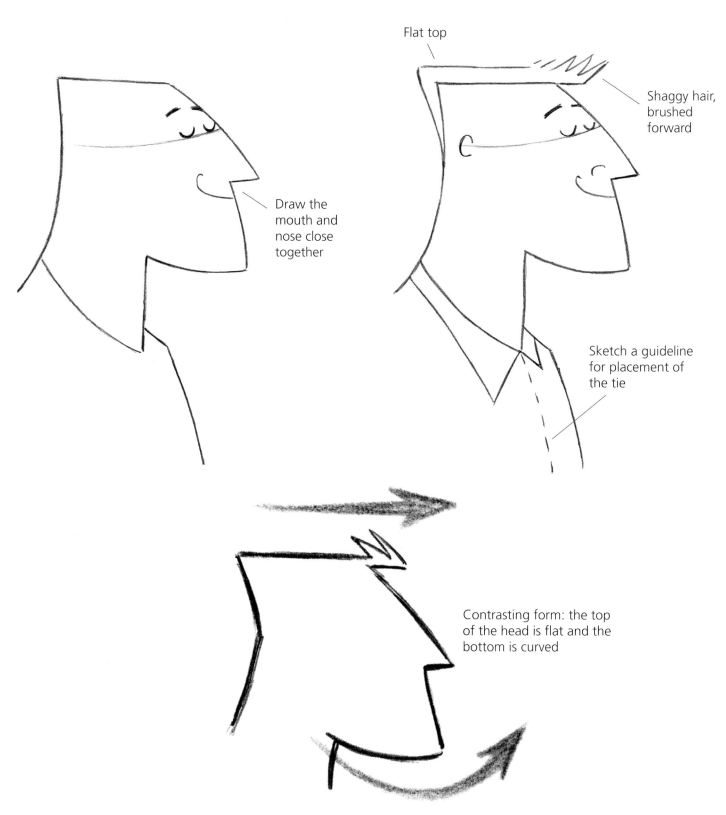

Flat top

Shaggy hair, brushed forward

Draw the mouth and nose close together

Sketch a guideline for placement of the tie

Contrasting form: the top of the head is flat and the bottom is curved

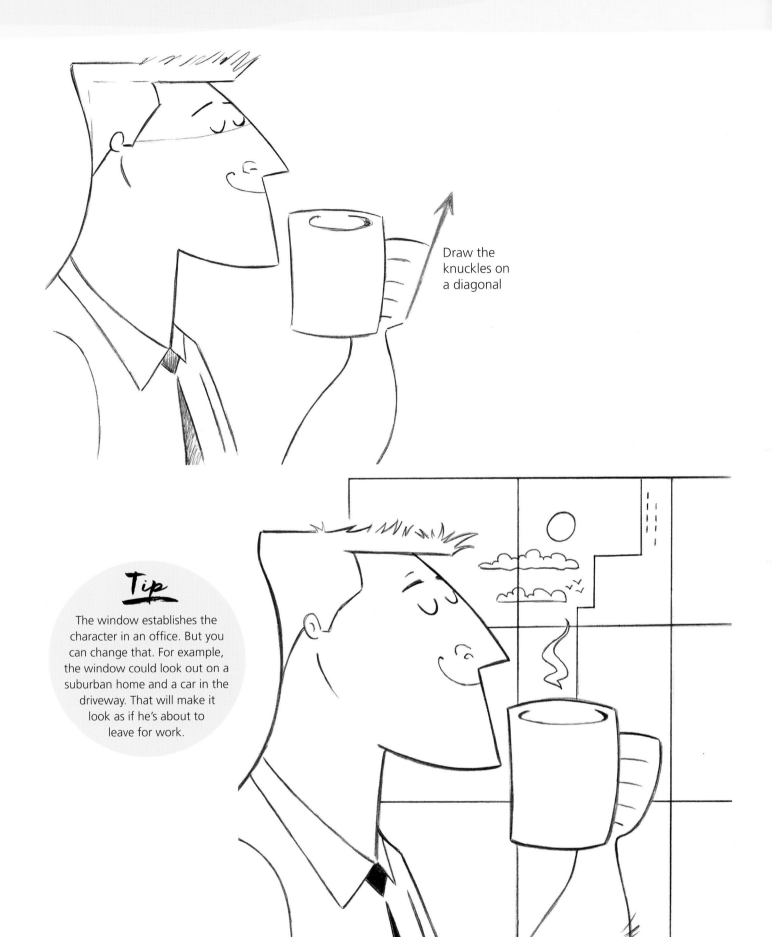

Draw the knuckles on a diagonal

Tip

The window establishes the character in an office. But you can change that. For example, the window could look out on a suburban home and a car in the driveway. That will make it look as if he's about to leave for work.

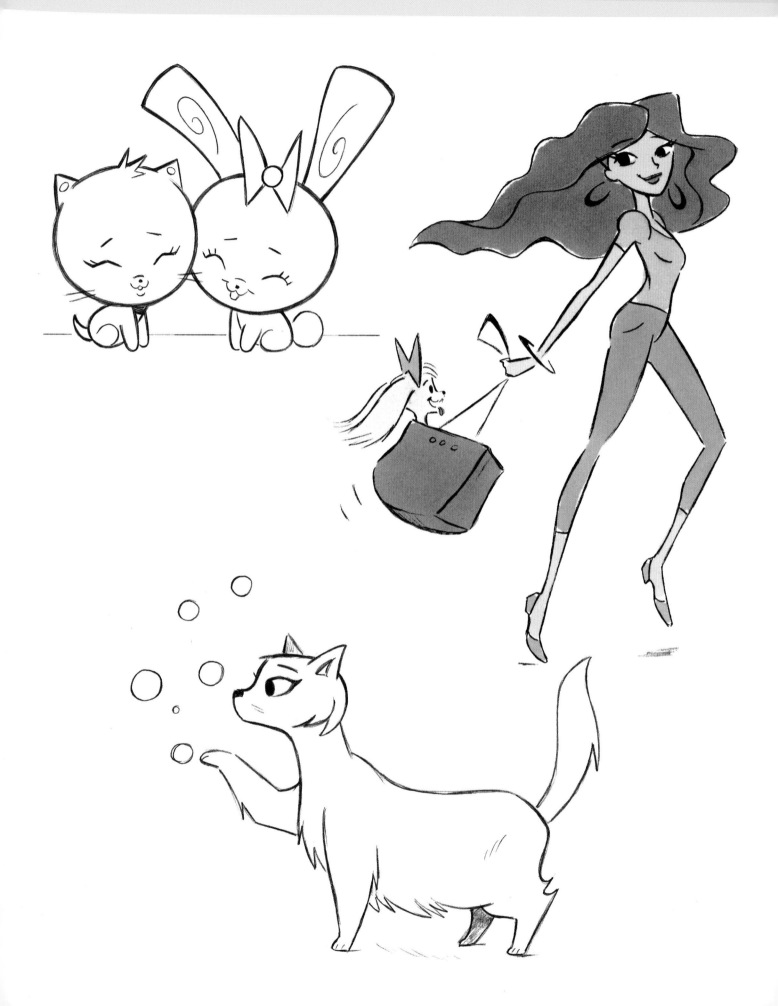

Pets & Other Fun Animals

We love our pets unconditionally. They can get us to do anything, from tossing a ball to sneaking a morsel of food to them under the table. We don't even get mad when they shred our socks or play tug of war with our ties. Especially a tie that was a gift from an in-law. Anyway, in this chapter, I'll share the joys of drawing pets and a few other animals, too.

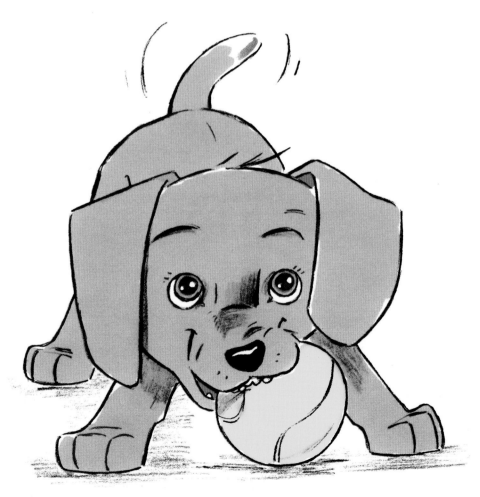

SOMEONE TO TALK TO

Have you never needed someone to talk to? Someone who was a good listener? That person might be right in front of you. And it might not exactly be a person. I like to think of dogs as furry little counselors. They won't understand a word you're saying, but they know exactly how you're feeling. And after 50 minutes of talking, they won't tell you your time is up.

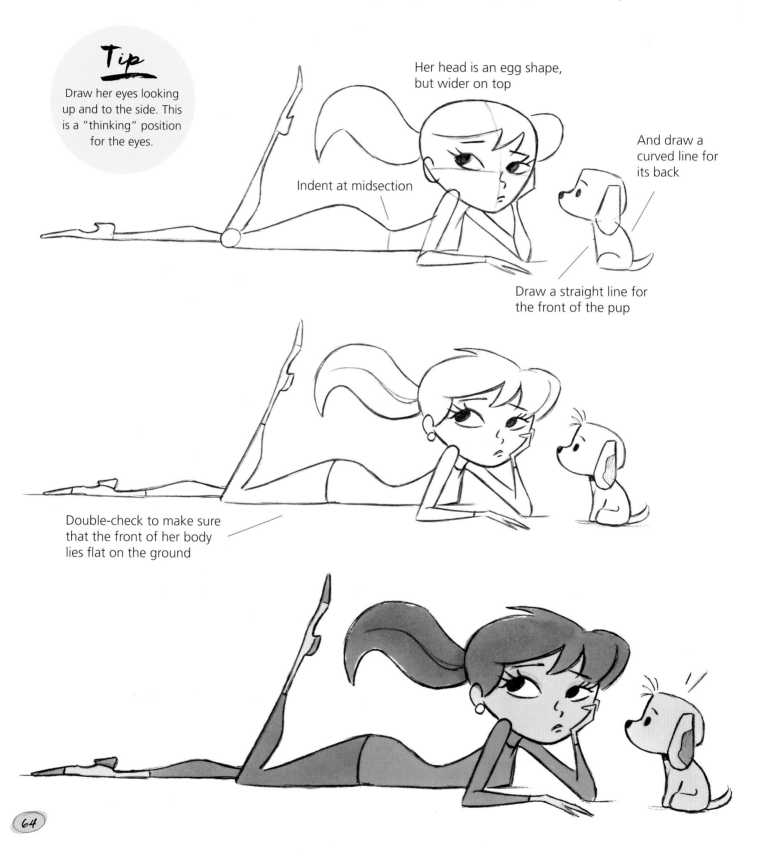

Tip

Draw her eyes looking up and to the side. This is a "thinking" position for the eyes.

Her head is an egg shape, but wider on top

And draw a curved line for its back

Indent at midsection

Draw a straight line for the front of the pup

Double-check to make sure that the front of her body lies flat on the ground

RUB-A-DUB-DUB

I know, you feel guilty because you find your dog's hatred of baths so adorable! So try to hide your smile while you pretend to sympathize with his situation. It works for me.

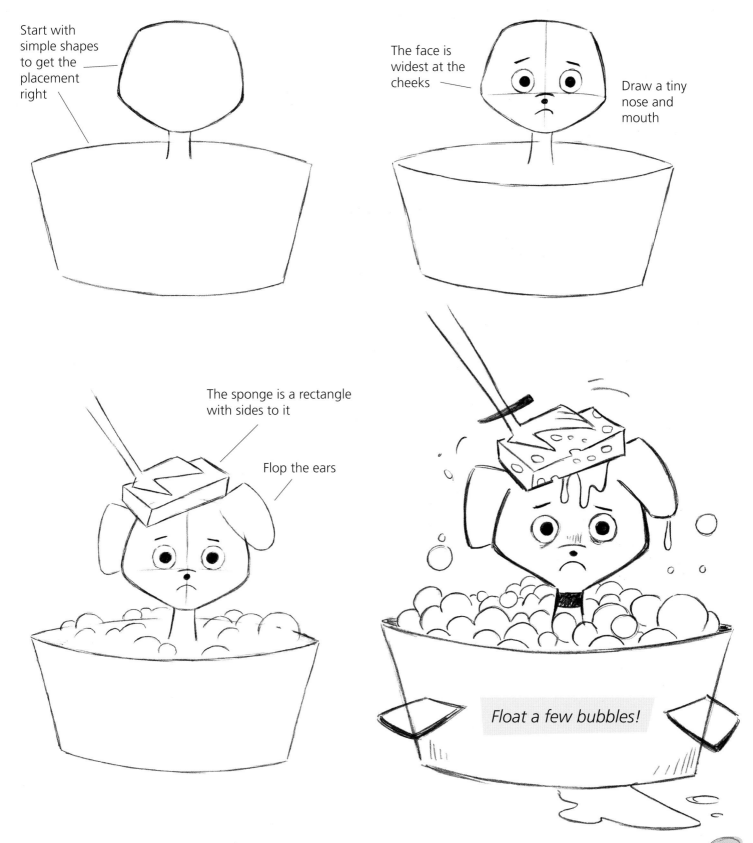

Start with simple shapes to get the placement right

The face is widest at the cheeks

Draw a tiny nose and mouth

The sponge is a rectangle with sides to it

Flop the ears

Float a few bubbles!

LET'S PLAY!

"All efforts to resist playing with me are futile," said the puppy. This stance can turn the most strong-willed human into a wiggly pile of goo. Puppies always get their way.

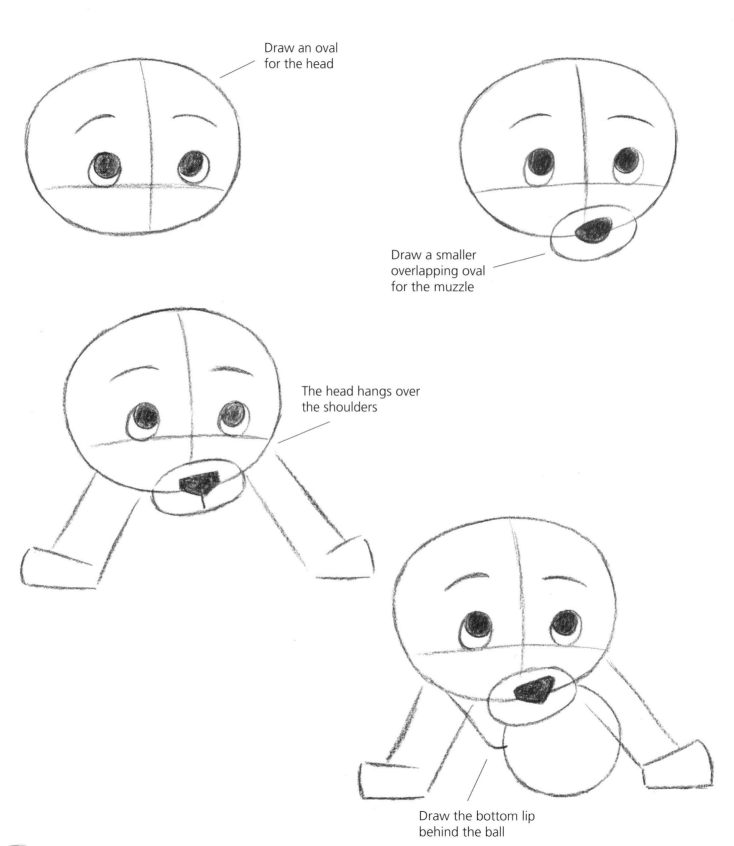

Draw an oval for the head

Draw a smaller overlapping oval for the muzzle

The head hangs over the shoulders

Draw the bottom lip behind the ball

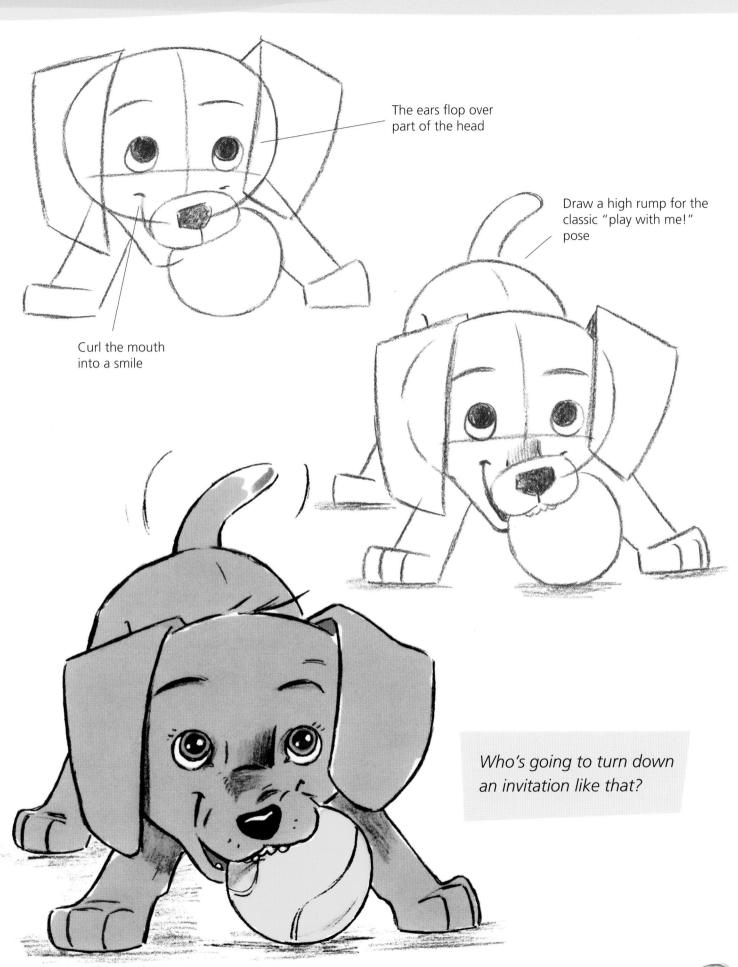

The ears flop over part of the head

Curl the mouth into a smile

Draw a high rump for the classic "play with me!" pose

Who's going to turn down an invitation like that?

VARIATION: Alternate Pose

This pup is saying, "Please try to take this ball from me!" So you go for it. But no matter how hard you try, you can't quite reach it. Why not? Because you love him. You're such a softy.

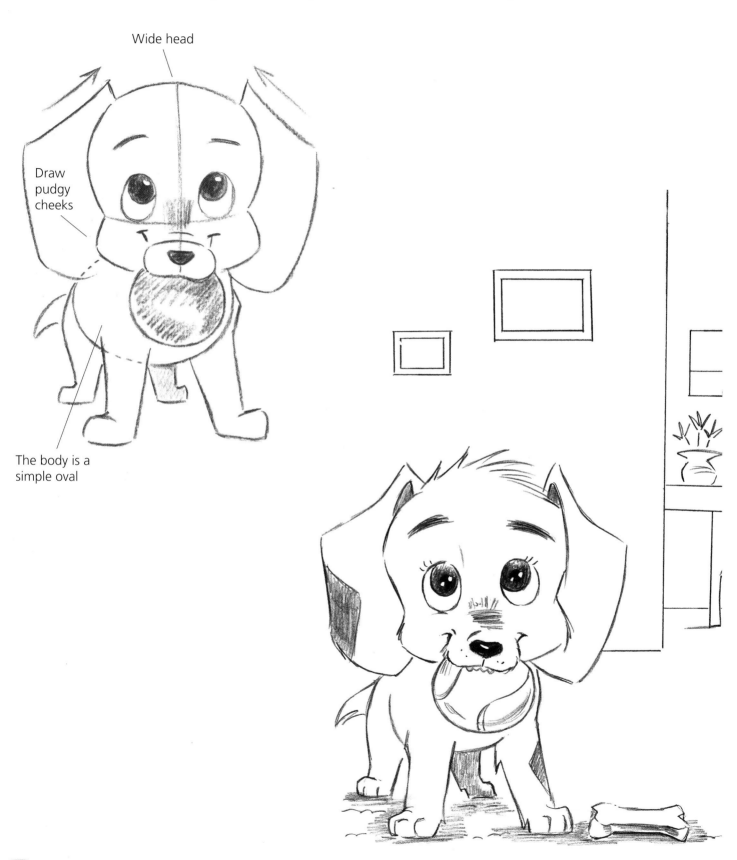

Wide head

Draw pudgy cheeks

The body is a simple oval

BASKET OF PUPPIES

Here's an adorable picture for you to try. Although it's crowded with puppies, the picture has been laid out in such a way as to keep the various elements clear. I'll show you some of the principles that helped create a pleasing composition.

The back row is organized along an ascending straight line

For contrast, the front row is organized along a wavy horizontal line

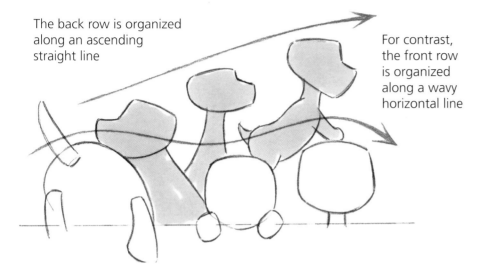

Space

Space

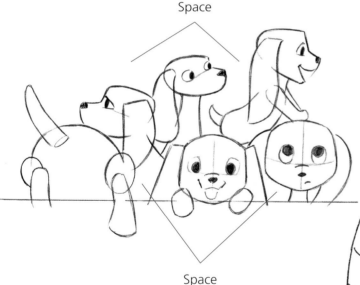

Composition Cues

Depth is depicted by creating two distinct rows of puppies. The puppies in blue are the back row. The puppies without color are the front row. But perhaps the most important tip is about clarity. Even in a crowded picture, it's important to leave a bit of space between the characters to let them "breathe."

It's a good thing I've never actually come across a basket of puppies. If I did, I'd have to buy them all.

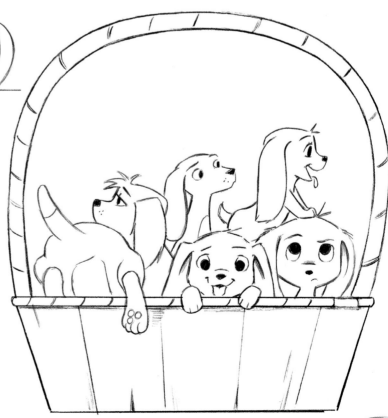

ARE THOSE BUBBLES FOR ME?

Cats are easily mesmerized. Anything that moves takes priority. A belt from a bathrobe, dragging across the floor, is riveting. So, it's fun to draw cats as they watch little things that others would hardly notice, such as a butterfly or an errant bubble from a bubble bath.

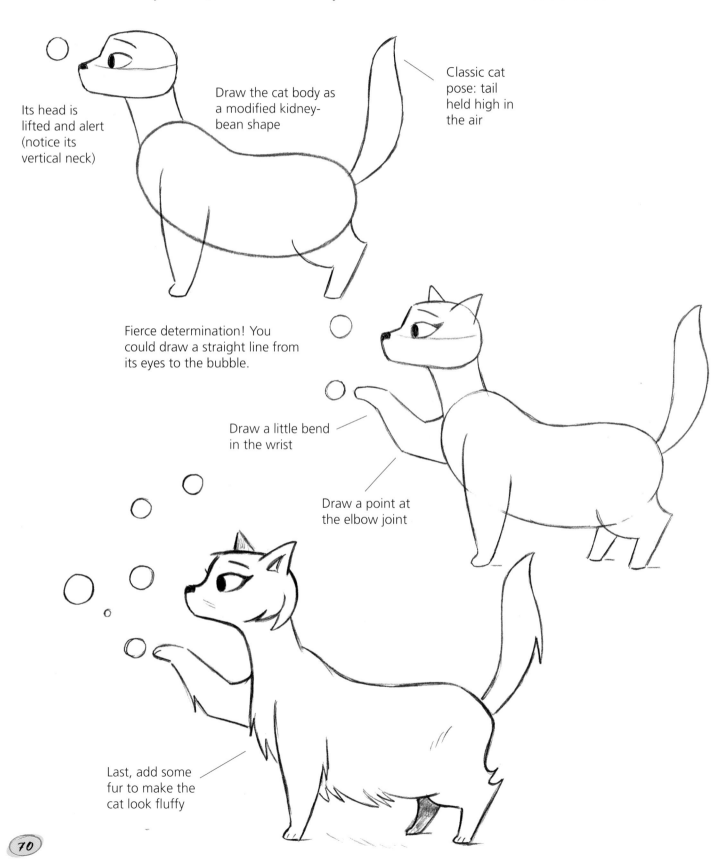

Its head is lifted and alert (notice its vertical neck)

Draw the cat body as a modified kidney-bean shape

Classic cat pose: tail held high in the air

Fierce determination! You could draw a straight line from its eyes to the bubble.

Draw a little bend in the wrist

Draw a point at the elbow joint

Last, add some fur to make the cat look fluffy

UNLIKELY FRIENDS

What could be cuter than a kitten and a bunny snuggling? Drawing two different types of animal buddies together creates a happy picture. Although they're different species, the drawing style is the same for each—and that's the key to creating a visual bond between them. Keep the head and body shapes simple, the features simple, and the poses simple as well.

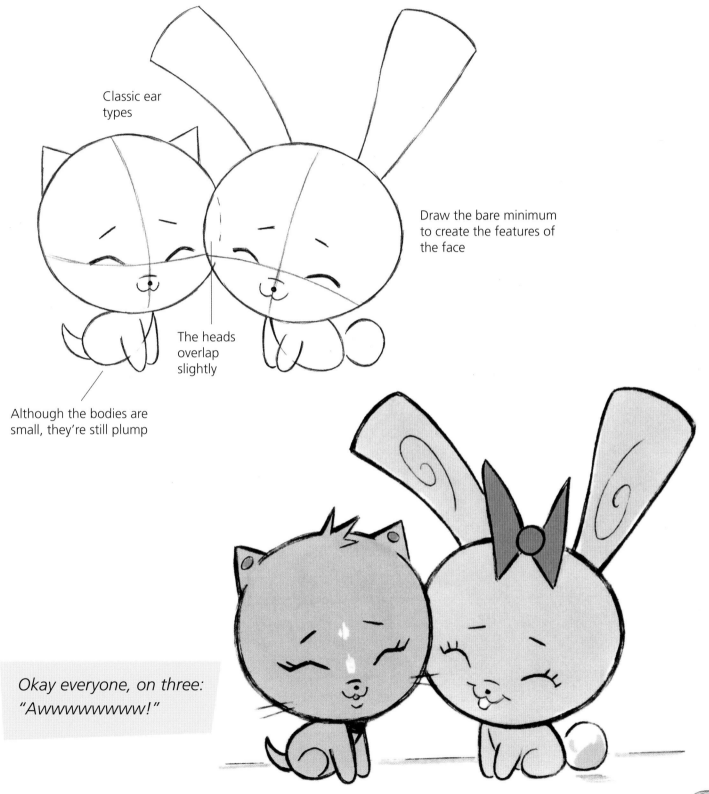

Classic ear types

Draw the bare minimum to create the features of the face

The heads overlap slightly

Although the bodies are small, they're still plump

Okay everyone, on three: "Awwwwwwwww!"

BEST FRIENDS

Dogs are not only best friends, but they also make excellent pillows. The unplanned nature of this nap makes it all the more charming. Kids and dogs have a lot in common. They're curious, adventurous, and they leave everything a mess when they're done playing.

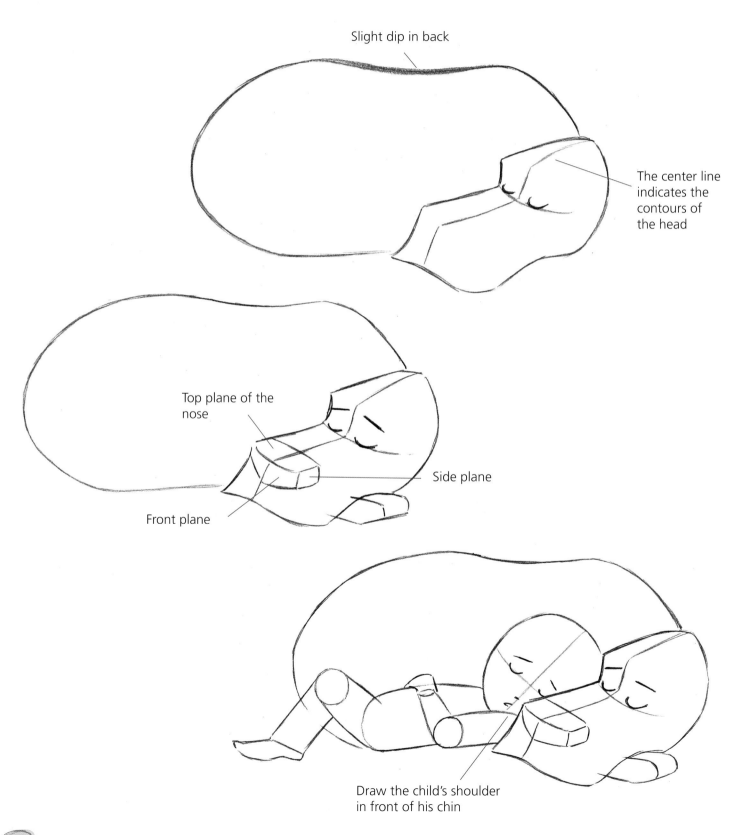

Slight dip in back

The center line indicates the contours of the head

Top plane of the nose

Front plane

Side plane

Draw the child's shoulder in front of his chin

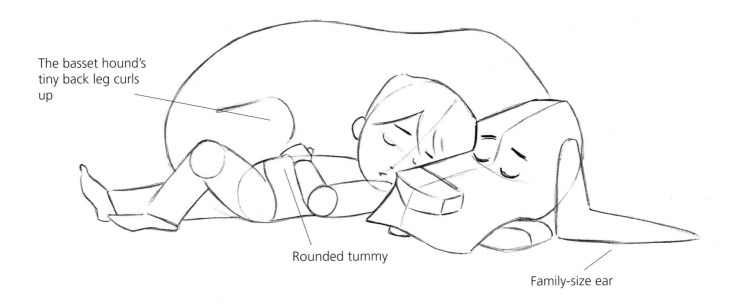

The basset hound's tiny back leg curls up

Rounded tummy

Family-size ear

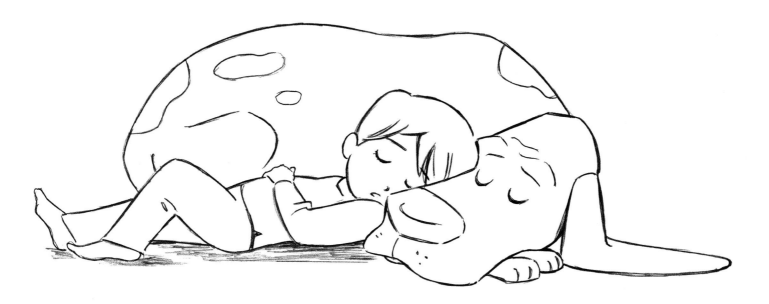

Have you ever heard a basset hound snore? It's surreal. You've got to remove the glassware from the room. However, nothing can disturb these two buddies.

WHO'S THE OWNER?

Even when your pet displays an incredibly entitled attitude, you think it's adorable. And you know what? You're right! Let's put pencil to paper and draw a cat who feels that you've fallen behind in your schedule.

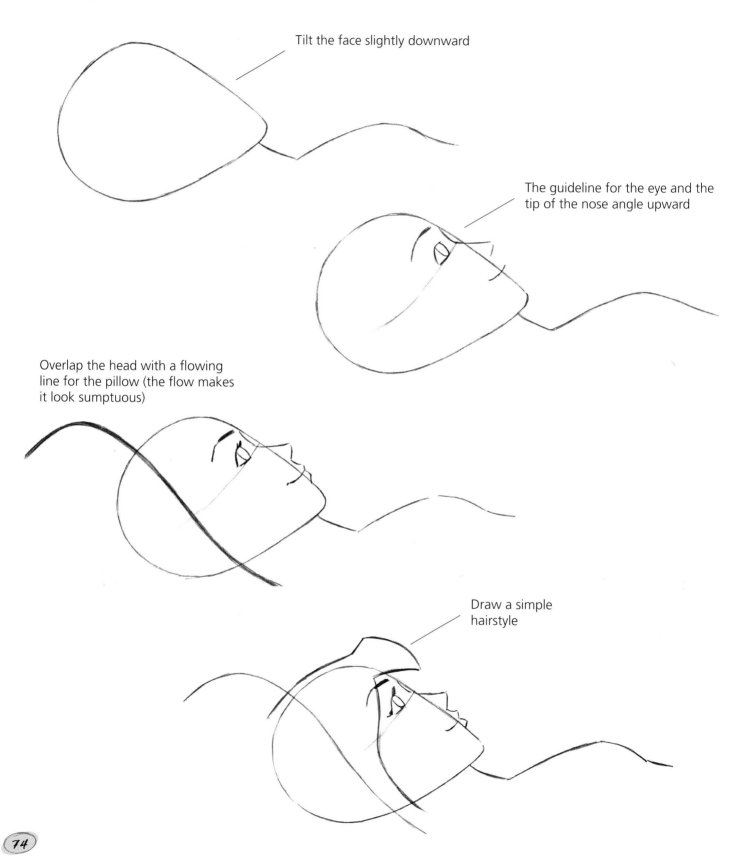

Tilt the face slightly downward

The guideline for the eye and the tip of the nose angle upward

Overlap the head with a flowing line for the pillow (the flow makes it look sumptuous)

Draw a simple hairstyle

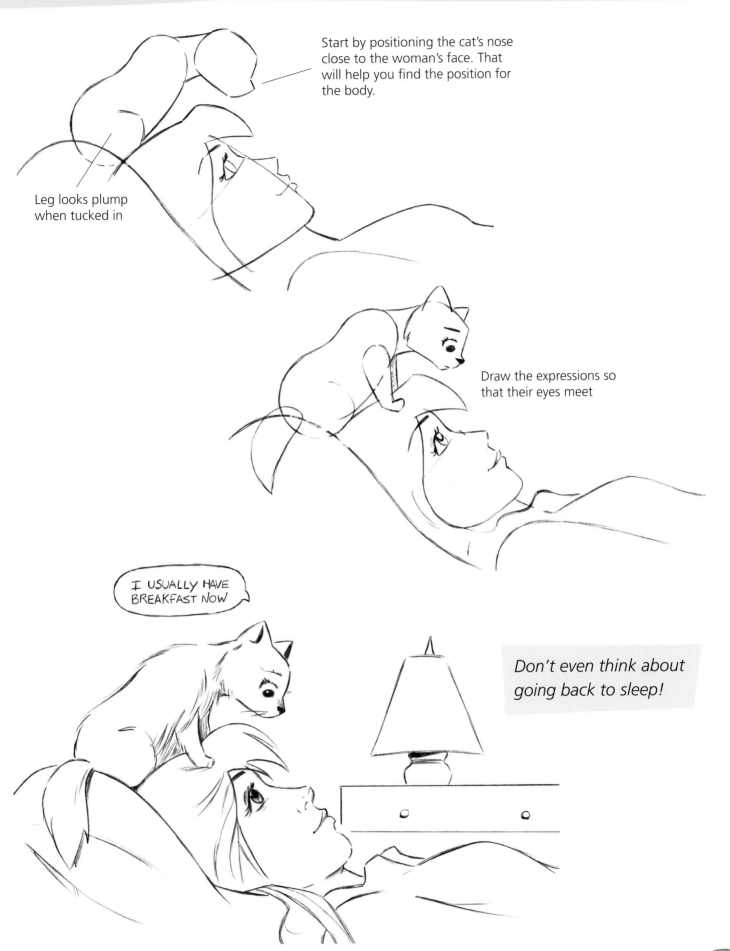

Start by positioning the cat's nose close to the woman's face. That will help you find the position for the body.

Leg looks plump when tucked in

Draw the expressions so that their eyes meet

I USUALLY HAVE BREAKFAST NOW

Don't even think about going back to sleep!

A LITTLE COMPANY

Put away the leash and bring the tote bag with a friend inside. Although a pet can't offer an opinion, it rarely stops people from soliciting one. The one-way conversation usually goes something like this:

WOMAN: *Do you think I should get the yellow blouse?*
DOG:
WOMAN: *I see. But does it go with my shoes?*
DOG:
WOMAN: *I agree. We'll go with cream-colored one instead.*

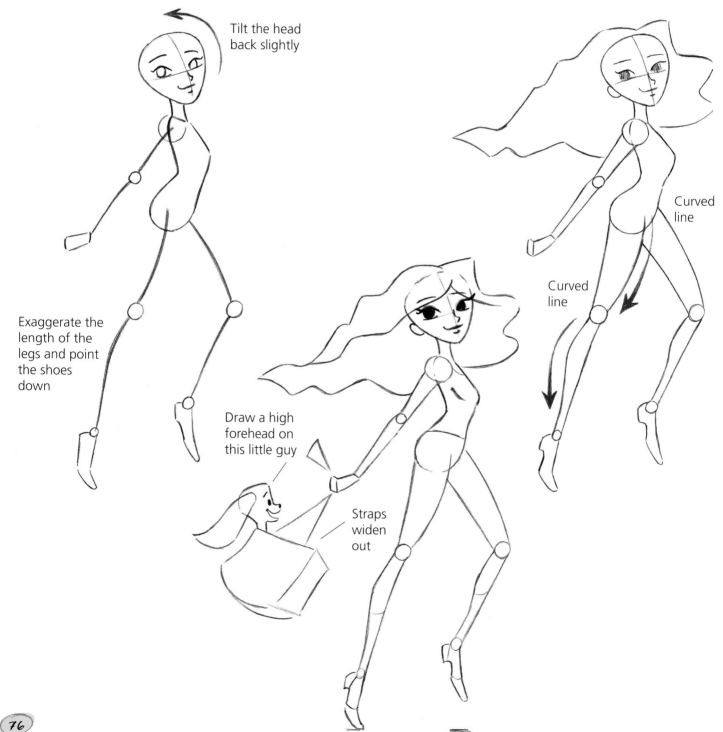

Tilt the head back slightly

Curved line

Curved line

Exaggerate the length of the legs and point the shoes down

Draw a high forehead on this little guy

Straps widen out

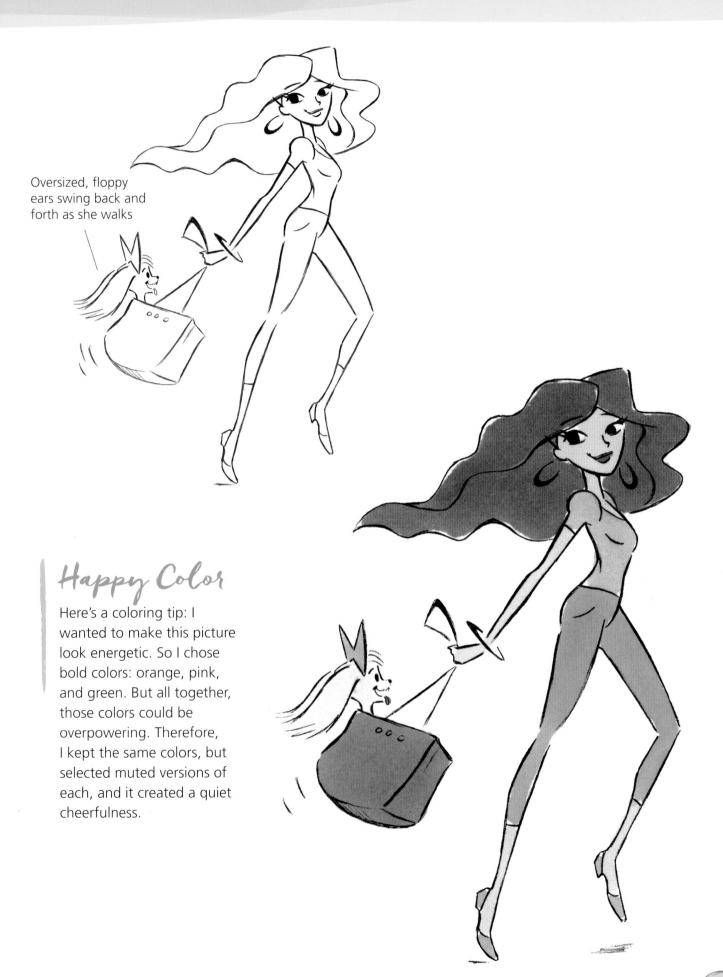

Oversized, floppy ears swing back and forth as she walks

Happy Color

Here's a coloring tip: I wanted to make this picture look energetic. So I chose bold colors: orange, pink, and green. But all together, those colors could be overpowering. Therefore, I kept the same colors, but selected muted versions of each, and it created a quiet cheerfulness.

FAMILY OF DUCKLINGS

When I see a family of animals, such as a mother duck followed by her ducklings, it makes me smile. If one duckling is good, three are three times as much fun!

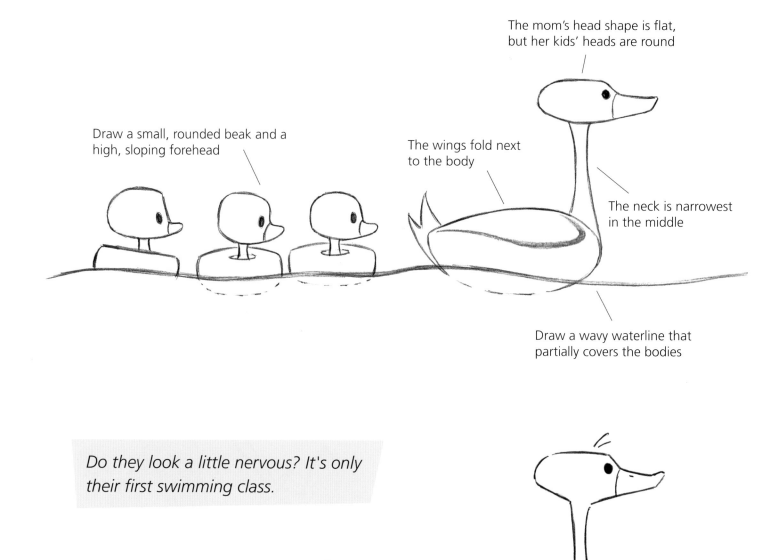

The mom's head shape is flat, but her kids' heads are round

Draw a small, rounded beak and a high, sloping forehead

The wings fold next to the body

The neck is narrowest in the middle

Draw a wavy waterline that partially covers the bodies

Do they look a little nervous? It's only their first swimming class.

SWIMMING WITH DOLPHINS

I could see this dolphin bragging to his friends, "I swam with a human today!" Dolphins make us happy because we feel a kinship with them. They seem to have a friendly disposition. Their mouths are shaped so that they always appear to be smiling. And they are also known to have helped people who were in the ocean—and in real trouble.

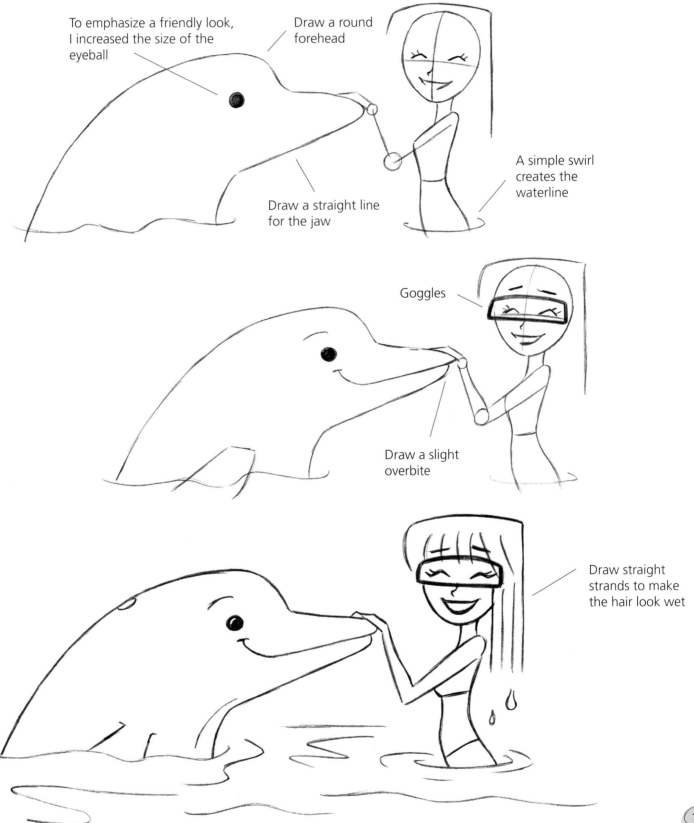

To emphasize a friendly look, I increased the size of the eyeball

Draw a round forehead

A simple swirl creates the waterline

Draw a straight line for the jaw

Goggles

Draw a slight overbite

Draw straight strands to make the hair look wet

FRISBEE FUN

Catching a Frisbee in your mouth, now that's talent. Some dogs don't even need to go on to YouTube to figure it out how it's done. Start by drawing the body with its legs gathered below. Notice, too, that the entire body is drawn on an upward tilt. The mouth opens in anticipation of the catch.

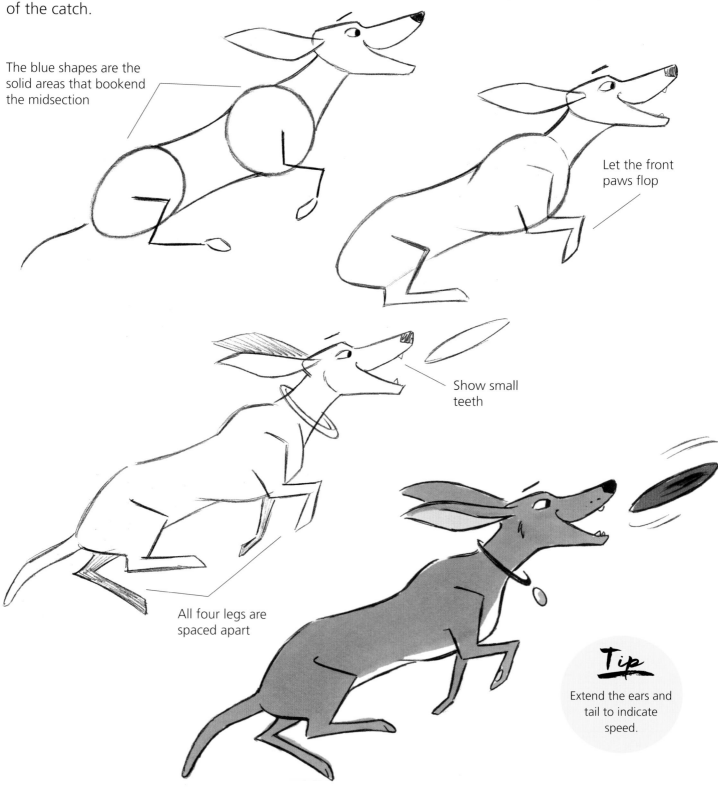

The blue shapes are the solid areas that bookend the midsection

Let the front paws flop

Show small teeth

All four legs are spaced apart

Tip

Extend the ears and tail to indicate speed.

MY WORKOUT BUDDY

He can't spin cycle. And kickboxing confuses him. But this little dog can jog for at least two blocks—before taking off after a squirrel. This little guy's jubilant run makes him the perfect companion for a buddy scene. And for her, it makes jogging somewhat less painful!

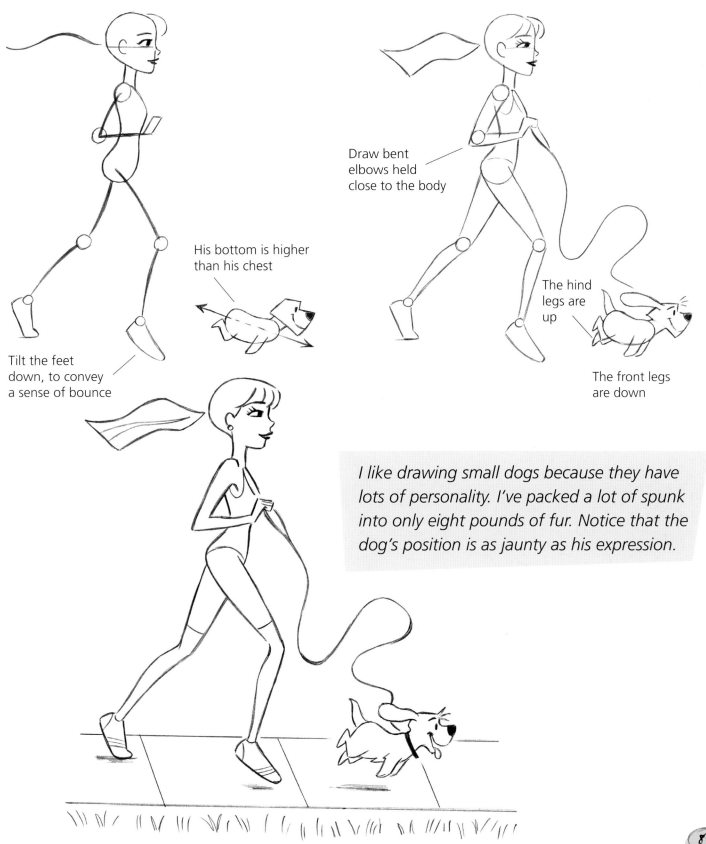

Draw bent elbows held close to the body

His bottom is higher than his chest

Tilt the feet down, to convey a sense of bounce

The hind legs are up

The front legs are down

I like drawing small dogs because they have lots of personality. I've packed a lot of spunk into only eight pounds of fur. Notice that the dog's position is as jaunty as his expression.

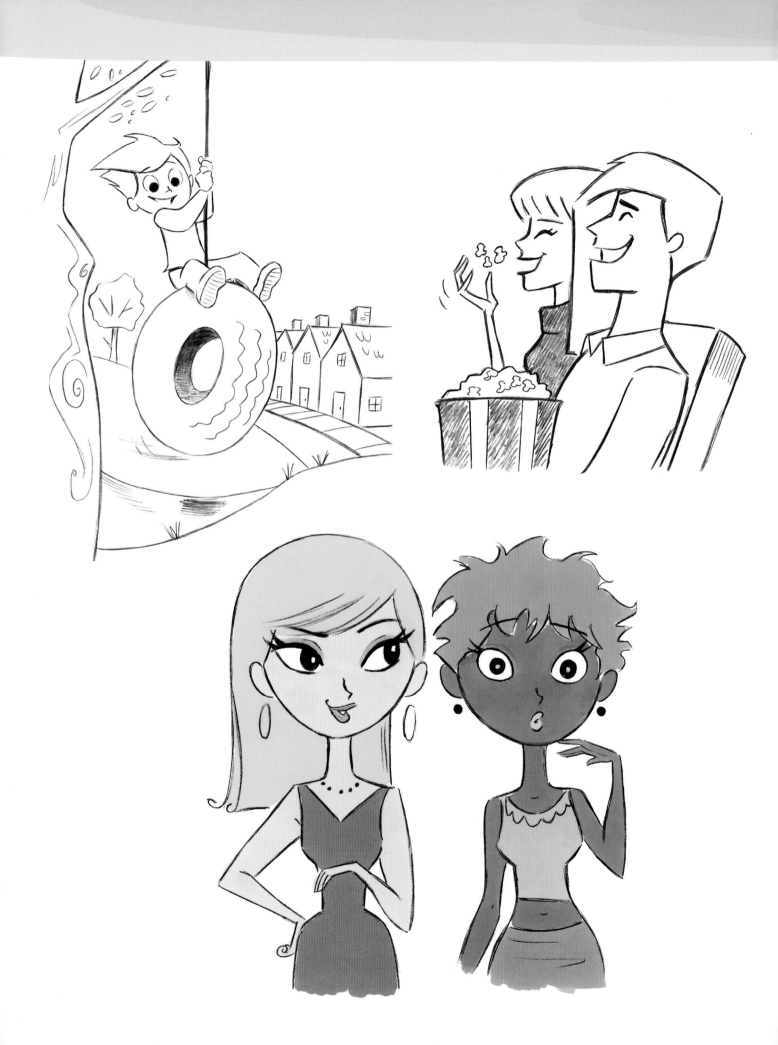

So Much Fun!

Almost everyone loves to draw when they're young. Then you hit high school where they stick a copy of *The Odyssey* by Homer in your hand and mandate that you play the recorder in band. Then it's off to college, then a job. Hit the pause button! It's time to put some fun and excitement back in your life. This chapter will do all of that and more. Pencils ready?

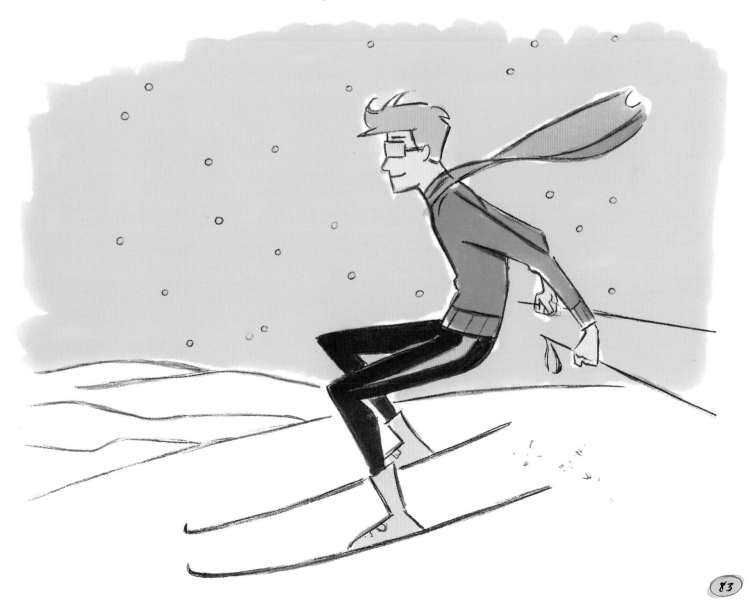

TRAMPOLINE TIME

It's impossible to bounce on a trampoline and stay in a bad mood. I have some relatives who should use a trampoline. And what would summer camp be without them? For some of us, camp may be pretty far in the rearview mirror, but we can re-create the fun with a pencil and paper.

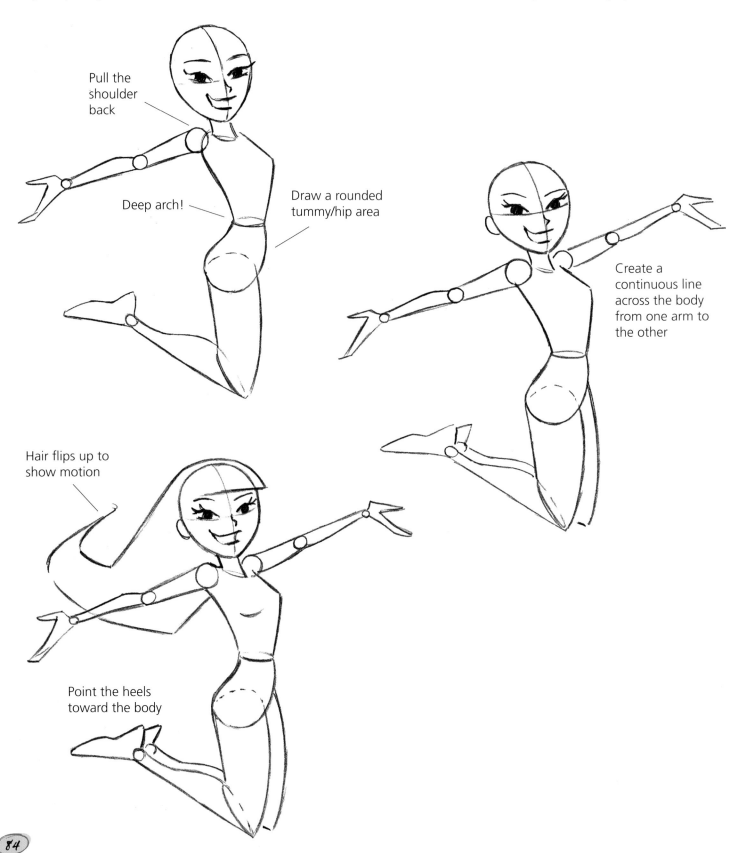

Pull the shoulder back

Deep arch!

Draw a rounded tummy/hip area

Create a continuous line across the body from one arm to the other

Hair flips up to show motion

Point the heels toward the body

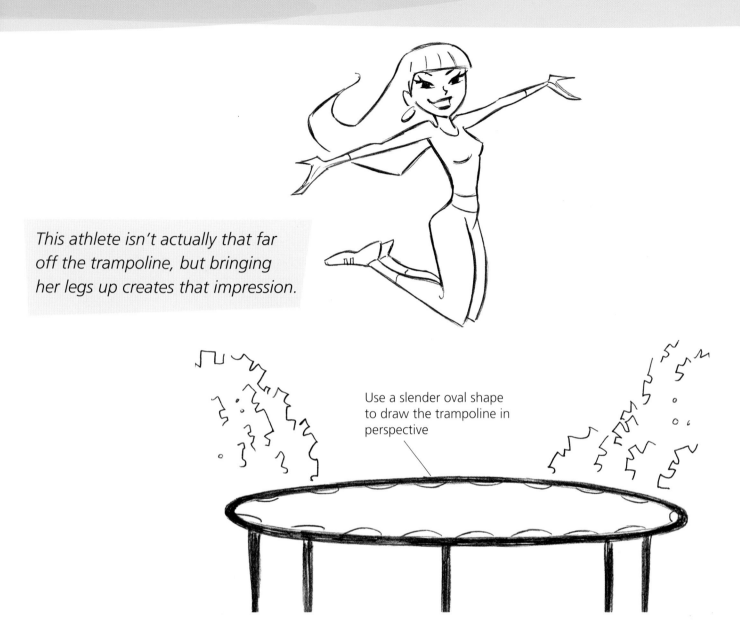

This athlete isn't actually that far off the trampoline, but bringing her legs up creates that impression.

Use a slender oval shape to draw the trampoline in perspective

VARIATION: Classic Pose

Here's a typical pose I think you'll enjoy. The key is to self-check this drawing as you go along to ensure that it's symmetrical. Check to see if you've drawn both hands at the same level, and both sneakers, too.

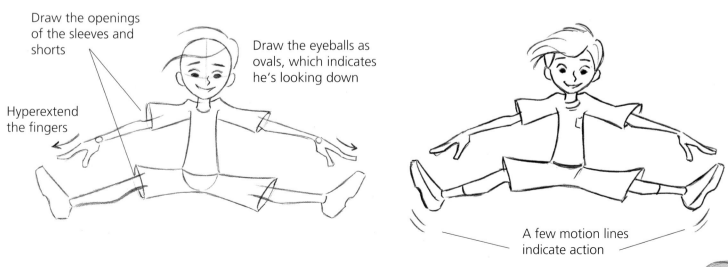

Draw the openings of the sleeves and shorts

Draw the eyeballs as ovals, which indicates he's looking down

Hyperextend the fingers

A few motion lines indicate action

SHARING SECRETS

Sharing secrets is such naughty fun. It's practically irresistible, which begs the question: Why would anyone share a secret? It's like saying to a puppy, "Here, guard this chicken wing." I've included this lighthearted scene for you to draw. But don't tell anyone about it.

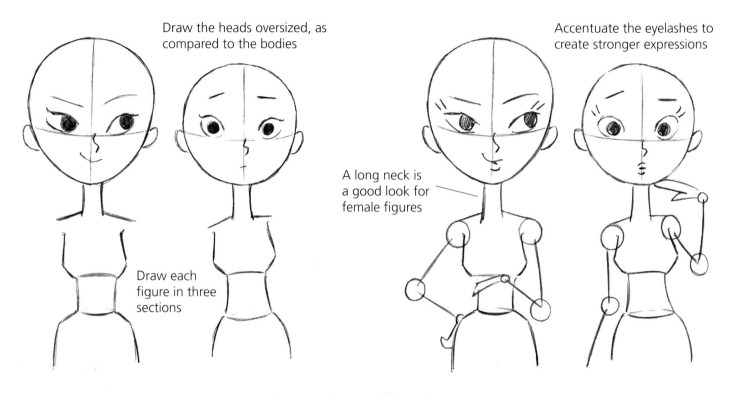

Draw the heads oversized, as compared to the bodies

Accentuate the eyelashes to create stronger expressions

A long neck is a good look for female figures

Draw each figure in three sections

Contrast the two different hairstyles

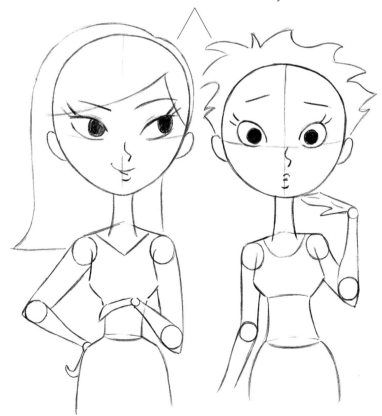

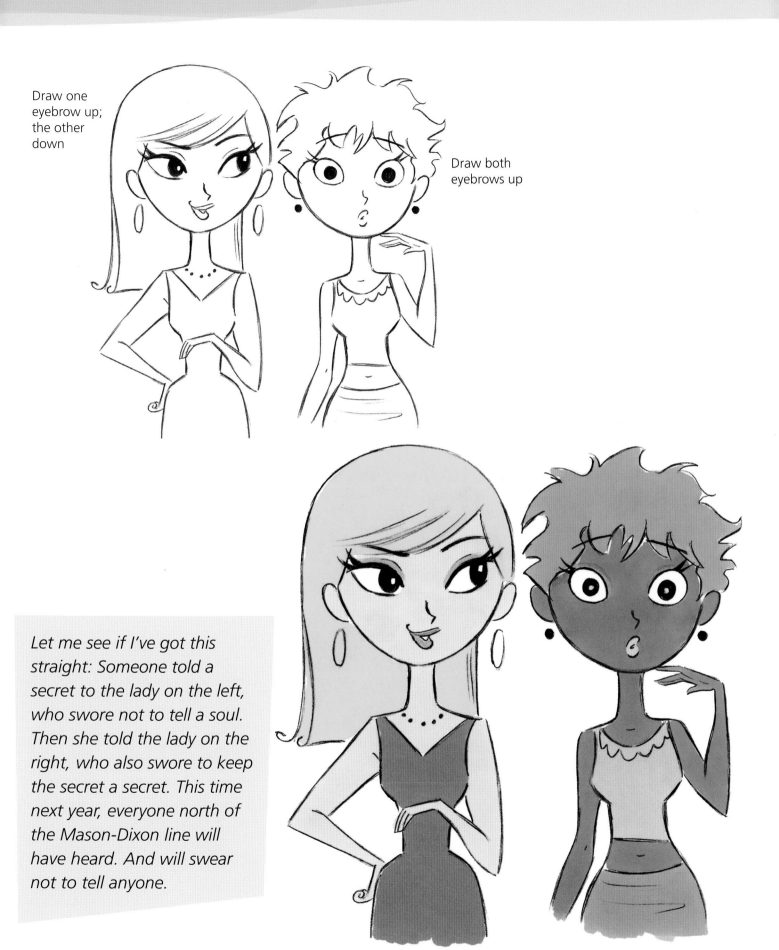

Draw one eyebrow up; the other down

Draw both eyebrows up

Let me see if I've got this straight: Someone told a secret to the lady on the left, who swore not to tell a soul. Then she told the lady on the right, who also swore to keep the secret a secret. This time next year, everyone north of the Mason-Dixon line will have heard. And will swear not to tell anyone.

DANCING THE NIGHT AWAY

Dancing is the body's way of smiling. It's relaxed, spontaneous, and exuberant. Doesn't she look like she's having fun? Follow the steps, and you'll also get your character to move to the beat.

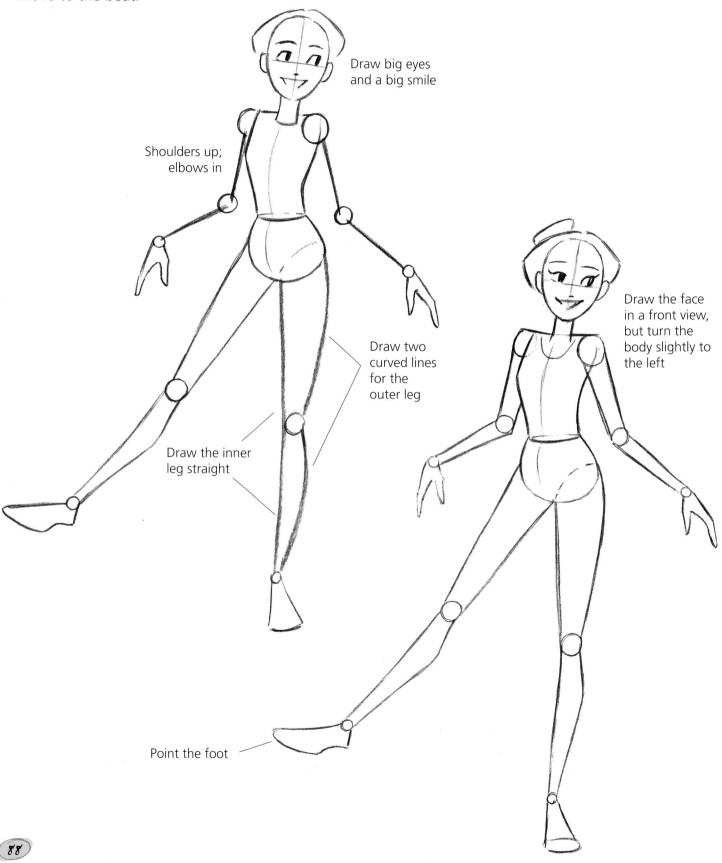

Draw big eyes and a big smile

Shoulders up; elbows in

Draw two curved lines for the outer leg

Draw the inner leg straight

Draw the face in a front view, but turn the body slightly to the left

Point the foot

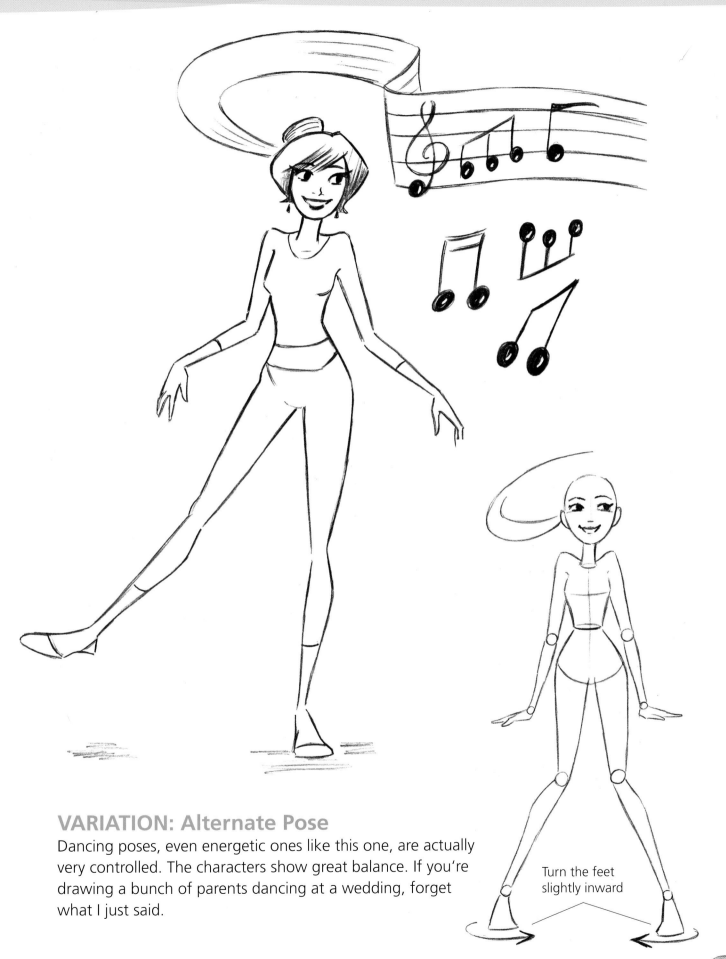

VARIATION: Alternate Pose

Dancing poses, even energetic ones like this one, are actually very controlled. The characters show great balance. If you're drawing a bunch of parents dancing at a wedding, forget what I just said.

Turn the feet slightly inward

TAKING THE SLOPES

If you've got the winter blues, pack your skis and hit the slopes. Gliding down a freshly packed mountain of snow is a fantastic feeling. It makes all of those face-plants worthwhile.

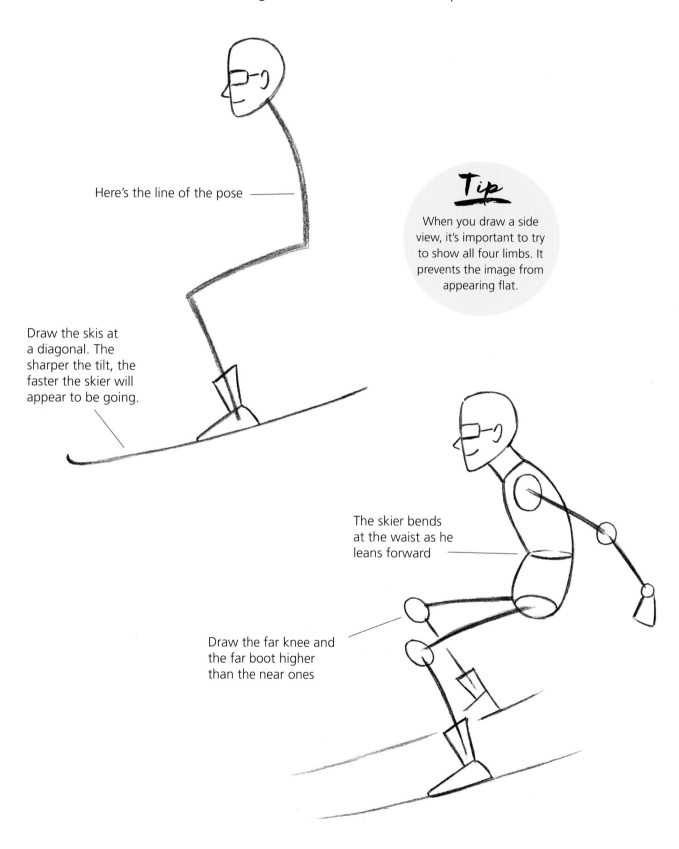

Here's the line of the pose

Draw the skis at a diagonal. The sharper the tilt, the faster the skier will appear to be going.

Tip

When you draw a side view, it's important to try to show all four limbs. It prevents the image from appearing flat.

The skier bends at the waist as he leans forward

Draw the far knee and the far boot higher than the near ones

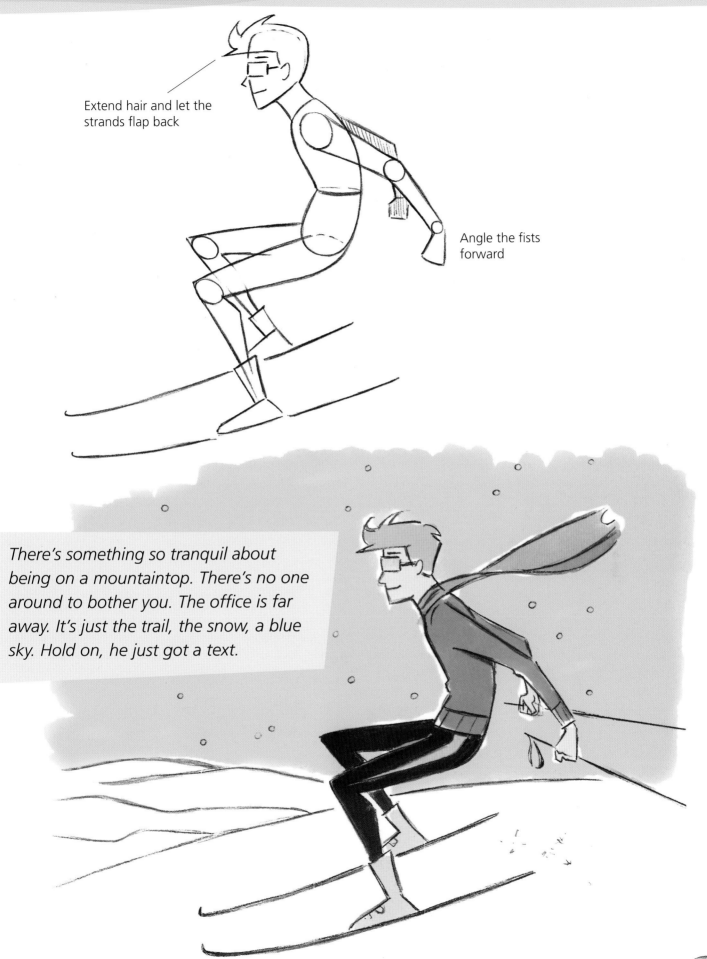

Extend hair and let the strands flap back

Angle the fists forward

There's something so tranquil about being on a mountaintop. There's no one around to bother you. The office is far away. It's just the trail, the snow, a blue sky. Hold on, he just got a text.

HAVING A GOOD LAUGH

They say that laughter is the best medicine. I guess those people never had the flu. Some people believe that the good feelings produced by laughter have real health benefits. Whether that's true or not, laughter is twice as much fun when shared with a friend, especially over a tub of popcorn.

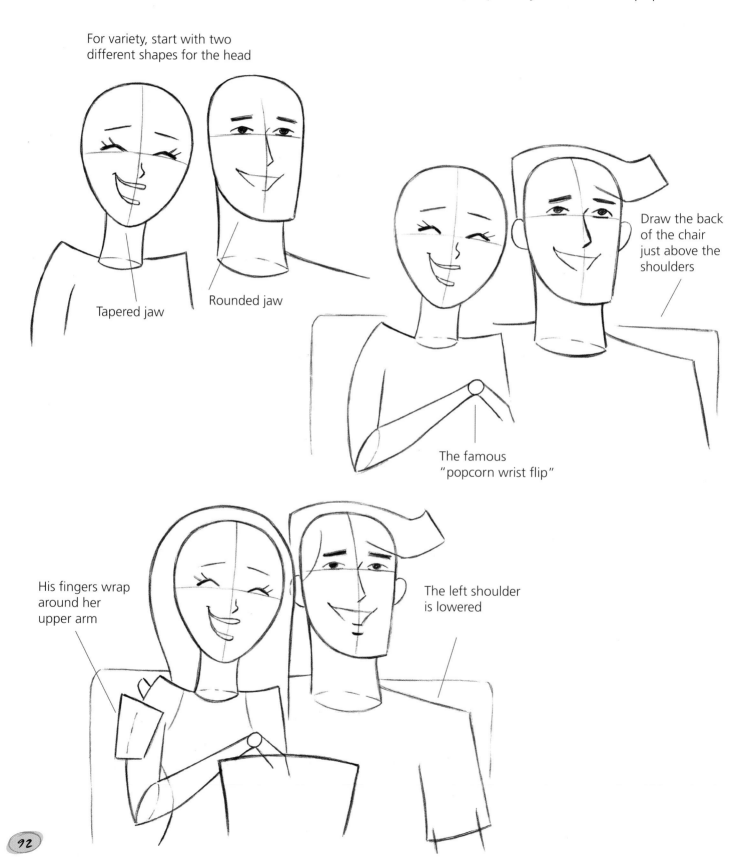

For variety, start with two different shapes for the head

Tapered jaw

Rounded jaw

Draw the back of the chair just above the shoulders

The famous "popcorn wrist flip"

His fingers wrap around her upper arm

The left shoulder is lowered

Draw her hair so that it overlaps his, which gives the appearance of bringing them closer together

Raised shoulders indicate laughter

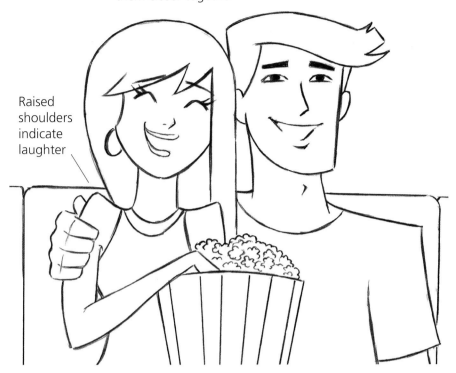

To make it seem like the eyes are looking up at the movie screen, draw the eyes pressed against the upper eyelids.

Looking straight ahead

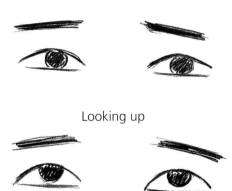

Looking up

VARIATION: Side View

Decisions about composition are best made before starting a drawing. In a strict side view, the man would block our view of the woman. But if we draw him leaning back in his seat, then we can clearly see both of them.

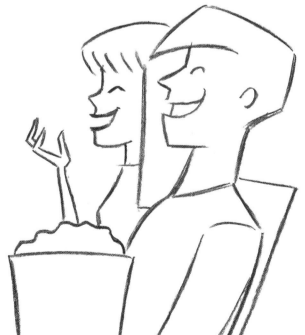

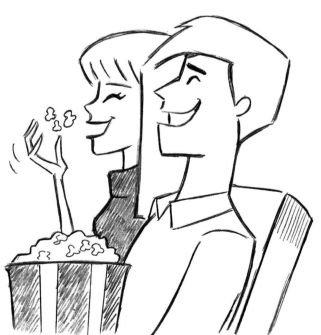

WOO-HOO!

Tell me something that beats swinging from a tire for fun. The only thing missing from this picture is a line of kids yelling, "You're hogging it!" There are a number of interesting dynamics in this scene, which I'll point out so that you can incorporate them into your drawing.

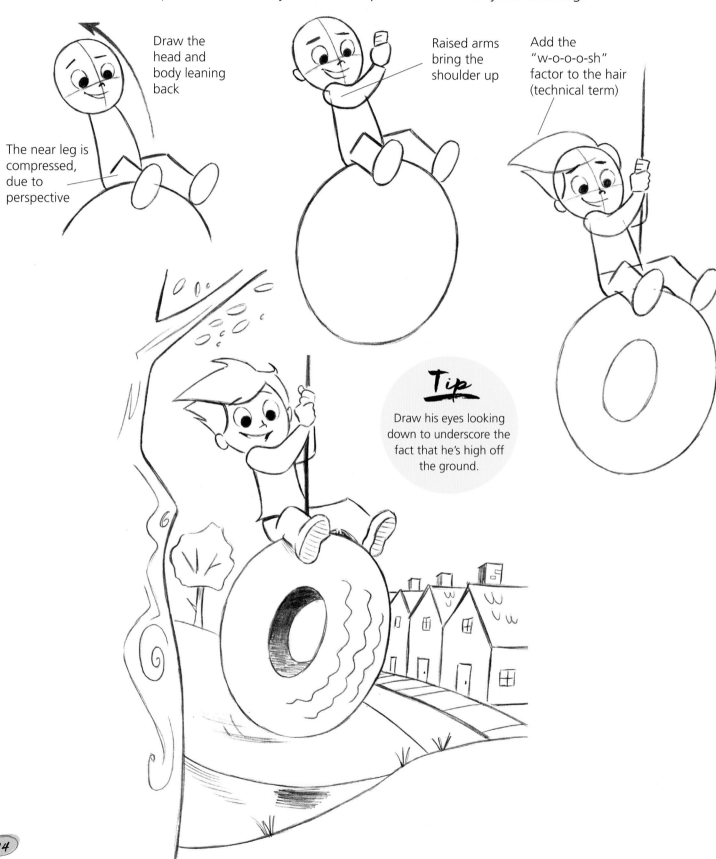

Draw the head and body leaning back

The near leg is compressed, due to perspective

Raised arms bring the shoulder up

Add the "w-o-o-o-sh" factor to the hair (technical term)

Tip

Draw his eyes looking down to underscore the fact that he's high off the ground.

SNOW DAY

When my kids were young, I remember how exciting snow days were. They would gather in my office and I would surround them with drawing and coloring supplies, and we'd create stuff together. The only problem was that I would sometimes get a business call. I found out that, for kids, there's nothing more fun than making kooky sounds when your dad is talking to his publisher.

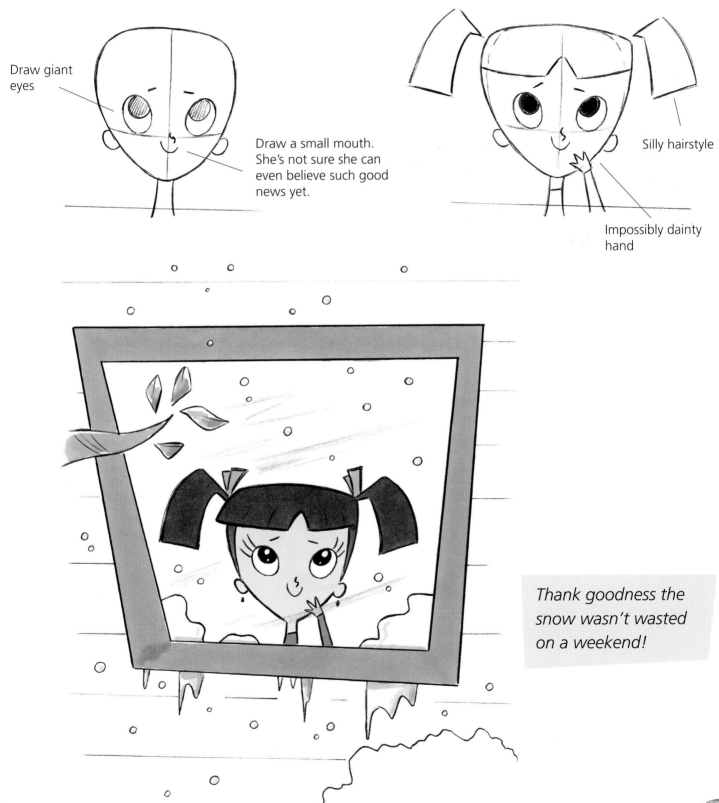

Draw giant eyes

Draw a small mouth. She's not sure she can even believe such good news yet.

Silly hairstyle

Impossibly dainty hand

Thank goodness the snow wasn't wasted on a weekend!

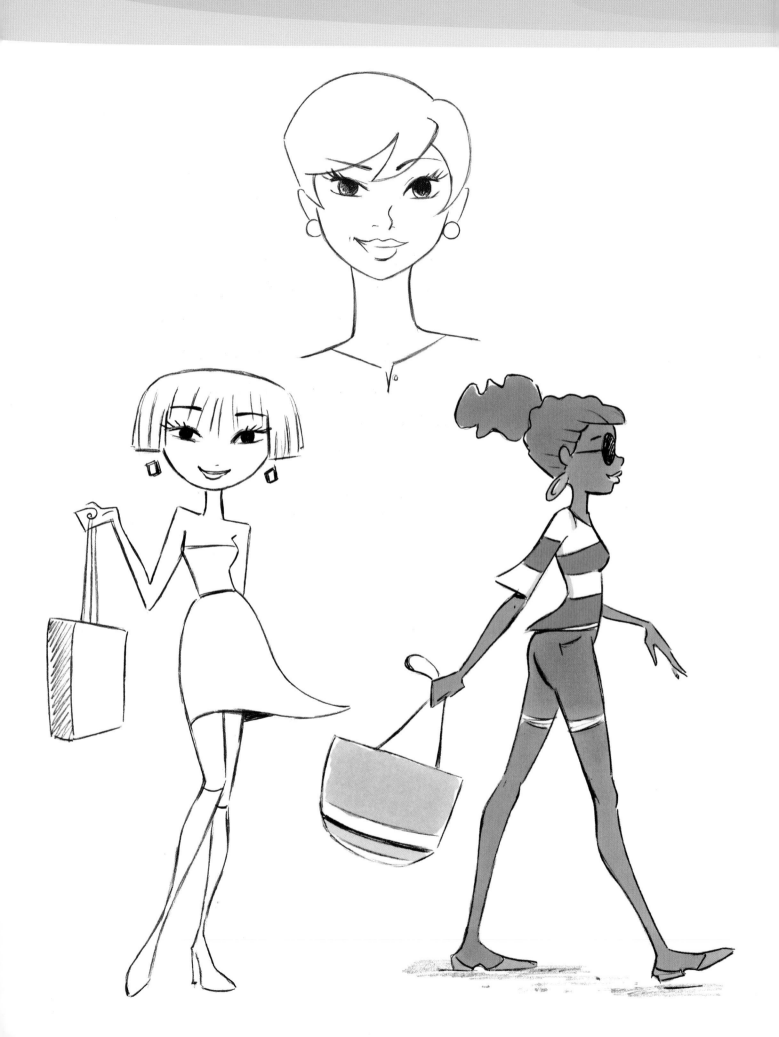

Finding Your Style

Drawing a stylish haircut makes a character look great. It's one of the best ways to create an appealing look. In this chapter, you'll learn how to draw a variety of trendy hairstyles, which you can use whenever you're sketching people. You'll also get a range of attractive clothes to draw, because wearing fashionable outfits is uplifting. So, if drawing fabulous fashions sounds good to you, you're in for more creative fun.

SO CHIC

A chin-length haircut is a popular look. This one is parted down the middle, with the sides falling forward. For the first example in this chapter, I'll use a few extra steps to clearly demonstrate how to draw stylish hair onto the foundation of the head.

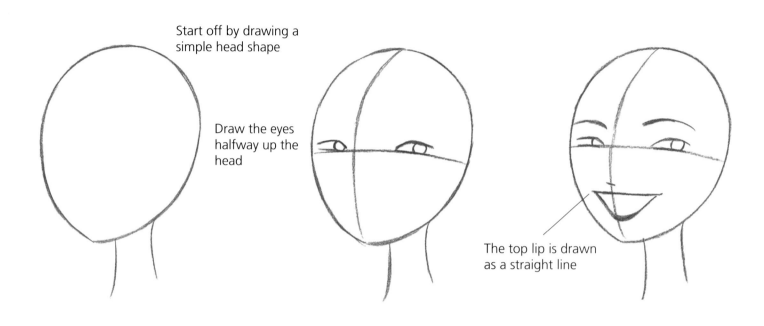

Start off by drawing a simple head shape

Draw the eyes halfway up the head

The top lip is drawn as a straight line

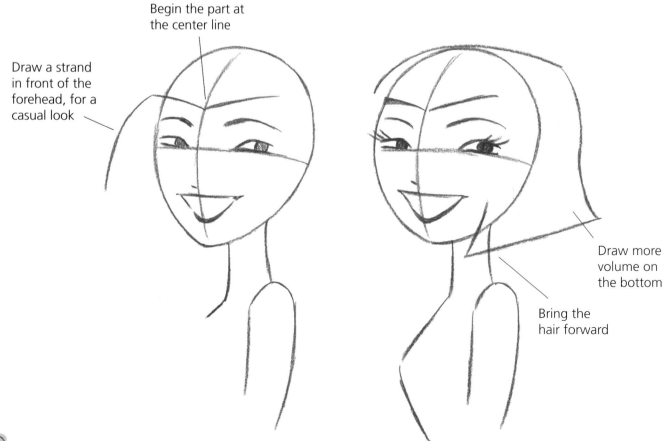

Begin the part at the center line

Draw a strand in front of the forehead, for a casual look

Draw more volume on the bottom

Bring the hair forward

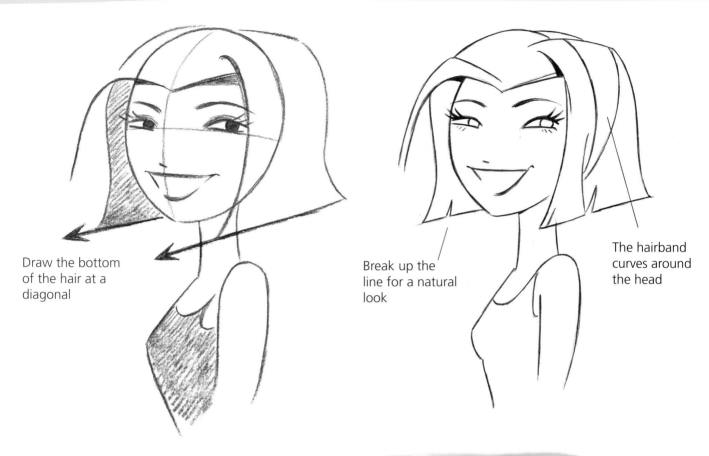

Draw the bottom of the hair at a diagonal

Break up the line for a natural look

The hairband curves around the head

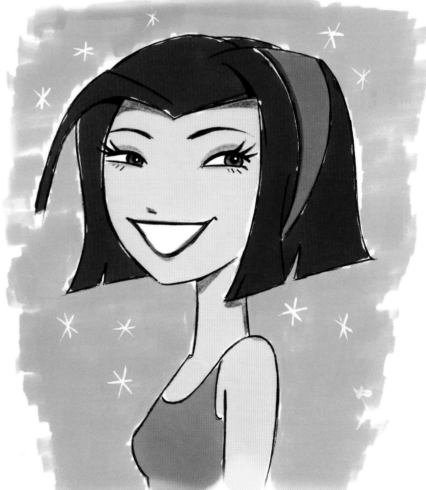

By spending a bit more attention to the hair, you'll end up with a character with a touch of glamour.

DRAMATIC BANGS

Draw an even row of low bangs that almost touches the eyelids. Animators draw eyebrows through the bangs, so the viewer can still see them. This gives the animator more tools to create expressions. You can use this technique, too.

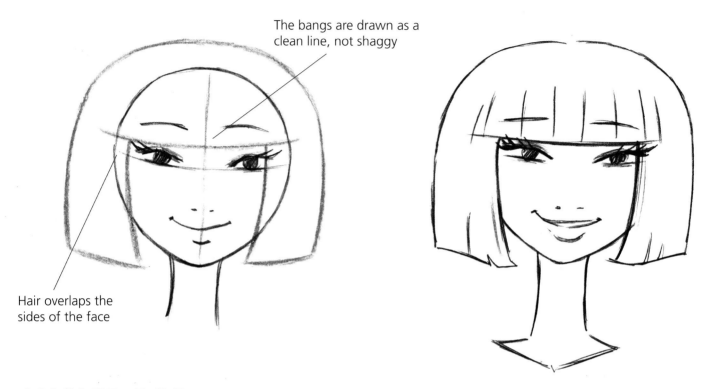

The bangs are drawn as a clean line, not shaggy

Hair overlaps the sides of the face

ANGLED BOB

This style is a controlled look. Everything in place. The angles are sharper, and the curves are curvier. Draw a few light strands running through the hair, to give it a pleasing sweep.

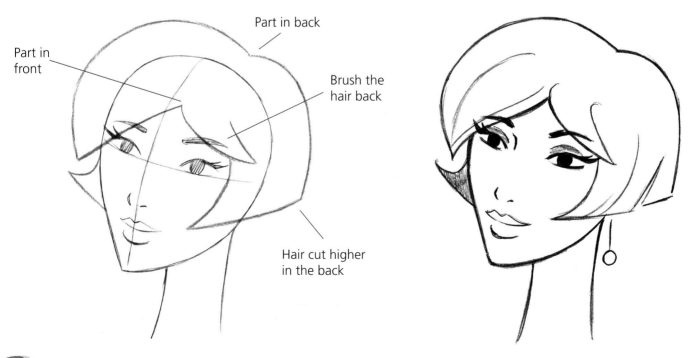

Part in back

Part in front

Brush the hair back

Hair cut higher in the back

FLOWING WAVES

Wavy hair has a happy, bouncy look. Draw large curves to create the outline of the hair. (Small curves are for curly hair.) Use a flowing line to make the hair look soft.

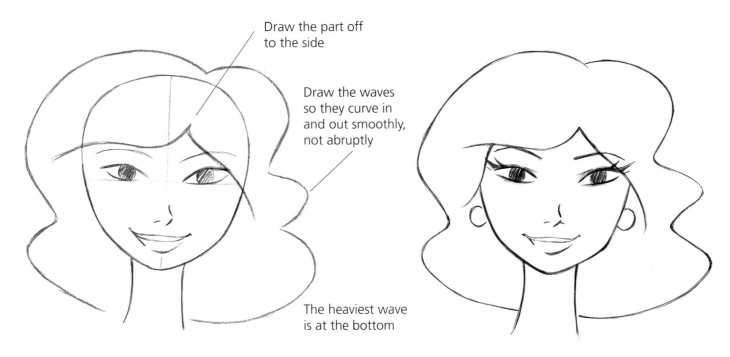

Draw the part off to the side

Draw the waves so they curve in and out smoothly, not abruptly

The heaviest wave is at the bottom

THE "IT GIRL"

If you want to add glamour, you came to the right page. This short European cut is super-chic. It's unique in that the hair is entirely above the ears. It creates an attractive, confident look. She knows she looks good. Who can argue with her?

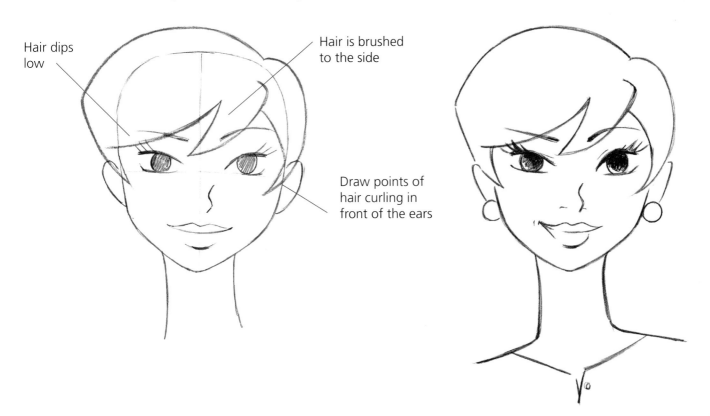

Hair dips low

Hair is brushed to the side

Draw points of hair curling in front of the ears

MODERN FLIP

This lively haircut doesn't just flip, it fans out. The exaggerated points at the ends of the hair give it a stylish appeal. Draw big eyes for a bubbly personality.

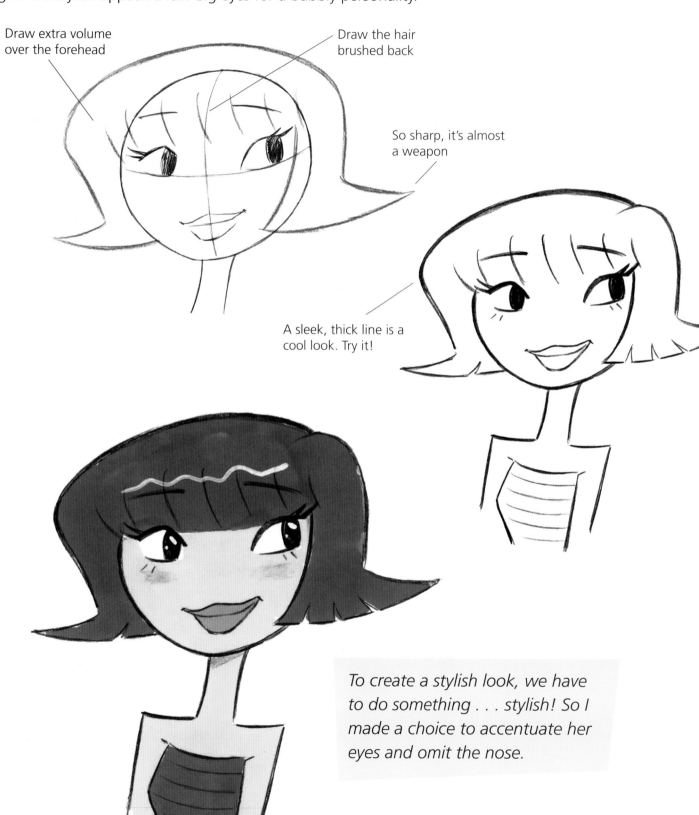

Draw extra volume over the forehead

Draw the hair brushed back

So sharp, it's almost a weapon

A sleek, thick line is a cool look. Try it!

To create a stylish look, we have to do something . . . stylish! So I made a choice to accentuate her eyes and omit the nose.

CASUAL CHIC

The collar is up and the shirttails are out. The look is cool and casual but still put together. Draw oversized bell sleeves and puffed up shoulders to make this casual outfit stand out. The loose areas of the top create a nice contrast to the pants, which are skin tight.

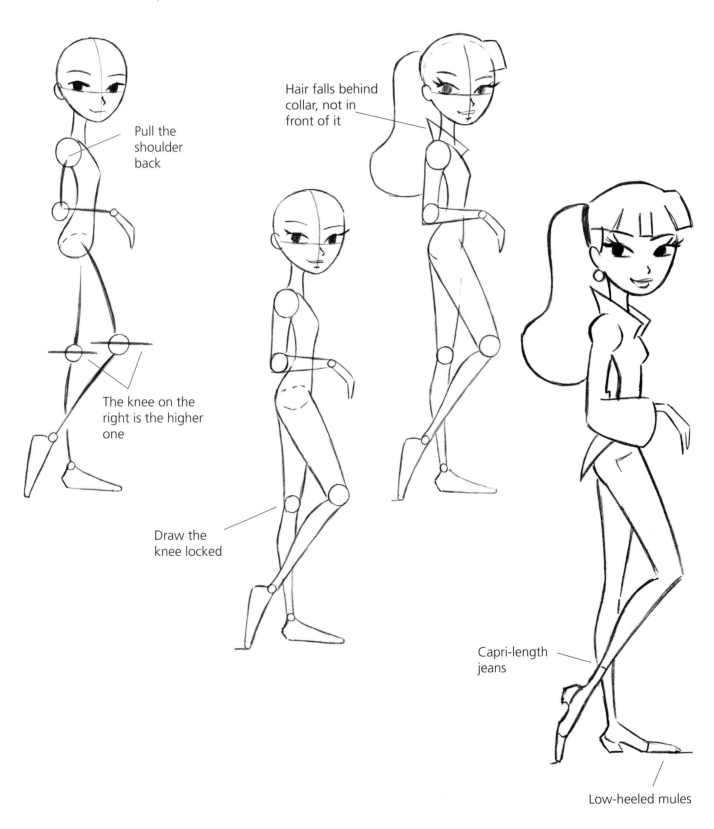

Pull the shoulder back

Hair falls behind collar, not in front of it

The knee on the right is the higher one

Draw the knee locked

Capri-length jeans

Low-heeled mules

BUILDING AN OUTFIT

An outfit can be built around a single article of clothing. It could be a sweater, a cape, a skirt, or a vest, such as the one on the figure, below. The neutral color of the vest works as a transitional tone from the white shirt to the blue pants. I prefer to draw a tailored vest to one that is larger and loose.

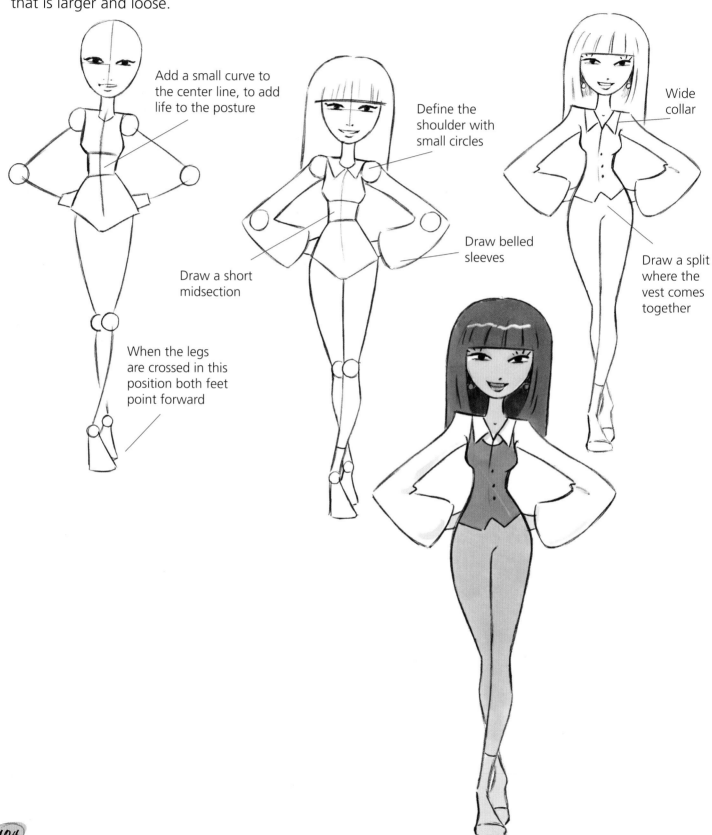

Add a small curve to the center line, to add life to the posture

Draw a short midsection

When the legs are crossed in this position both feet point forward

Define the shoulder with small circles

Draw belled sleeves

Wide collar

Draw a split where the vest comes together

ANIMAL PRINTS

Animal prints have had a strong resurgence in fashion. Popular prints are zebra, leopard, tiger, and even giraffe. I like to use patterns for smaller areas, such as a top, a short skirt, or accessories, because too much of a pattern can be overwhelming to the eye.

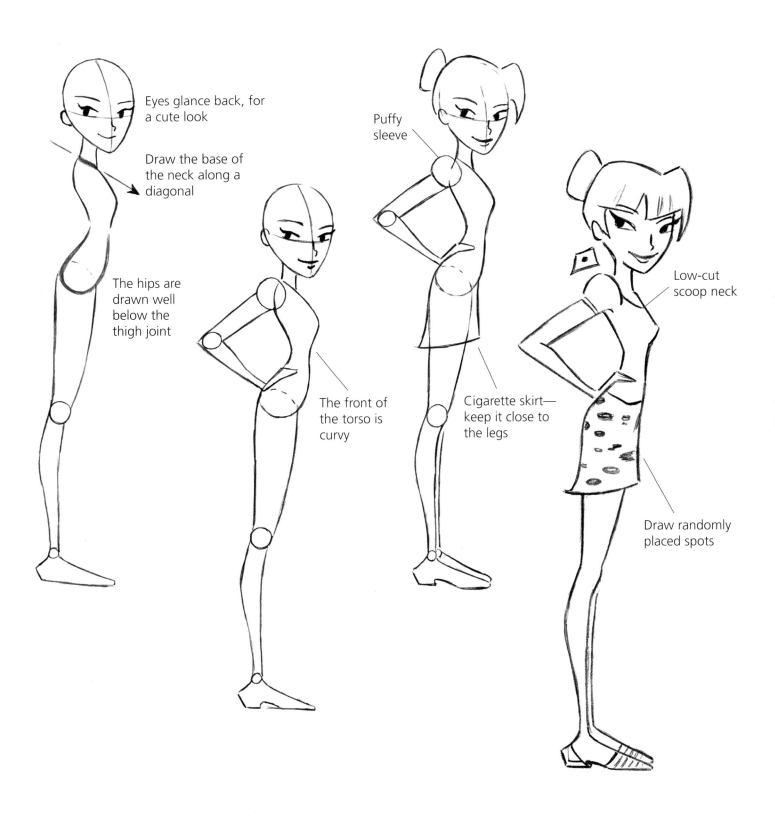

Eyes glance back, for a cute look

Draw the base of the neck along a diagonal

The hips are drawn well below the thigh joint

The front of the torso is curvy

Puffy sleeve

Cigarette skirt— keep it close to the legs

Low-cut scoop neck

Draw randomly placed spots

OUT AND ABOUT

A piece from this drawer, a piece from that drawer, and pretty soon, you've got an outfit. But it's not quite as extemporaneous as it appears. It's actually well coordinated for a walk along the promenade. Colorful, casual-chic clothes, sunglasses, and a designer tote. Nice.

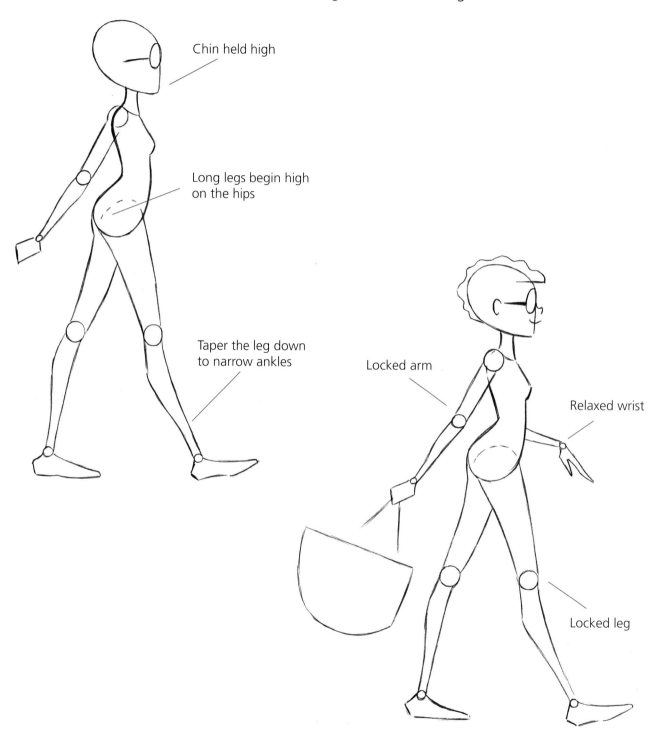

Chin held high

Long legs begin high on the hips

Taper the leg down to narrow ankles

Locked arm

Relaxed wrist

Locked leg

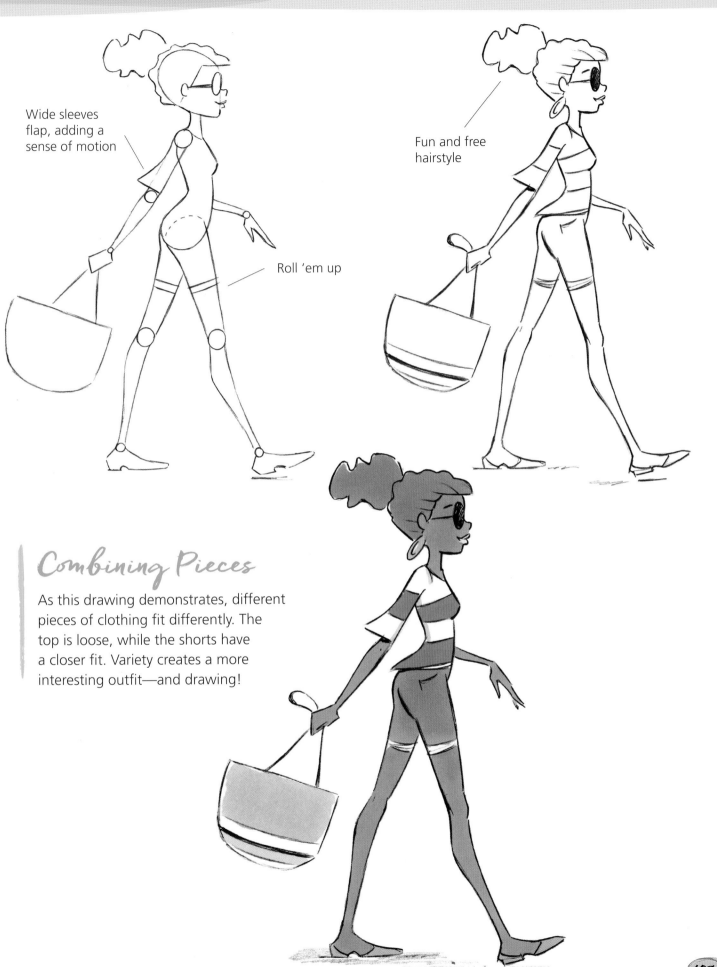

Wide sleeves flap, adding a sense of motion

Fun and free hairstyle

Roll 'em up

Combining Pieces

As this drawing demonstrates, different pieces of clothing fit differently. The top is loose, while the shorts have a closer fit. Variety creates a more interesting outfit—and drawing!

DESIGNER STYLE

This fearlessly chic style is seen on many designer clothes. Because of the strapless cut, you don't need to do much with the rest of the outfit. But a small lift of the hem is a welcome touch. Cue the breeze.

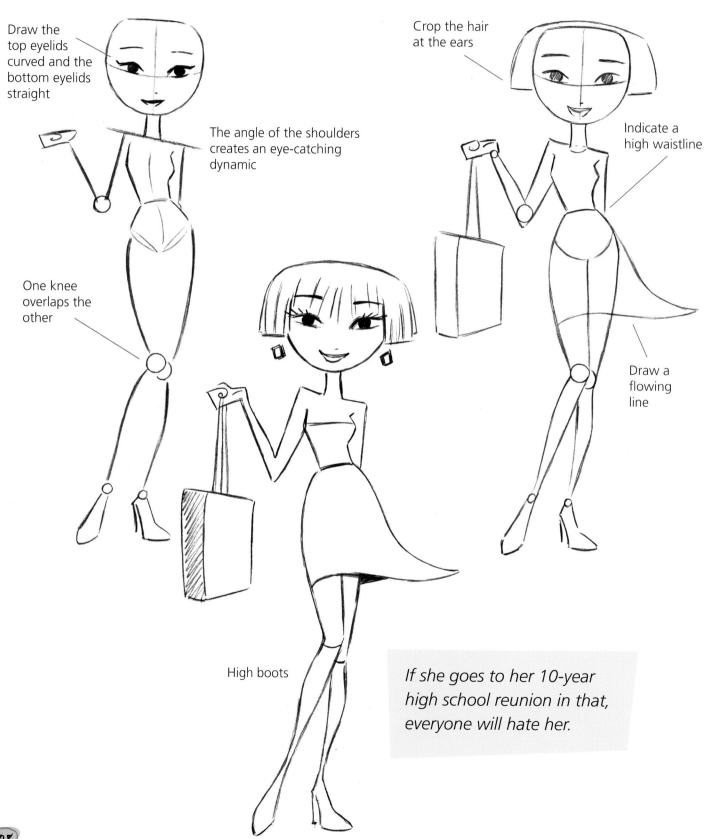

Draw the top eyelids curved and the bottom eyelids straight

The angle of the shoulders creates an eye-catching dynamic

One knee overlaps the other

Crop the hair at the ears

Indicate a high waistline

Draw a flowing line

High boots

If she goes to her 10-year high school reunion in that, everyone will hate her.

RESORT STYLE

Most shorts end at mid-thigh. A fashionable alternative is capris. They are drawn narrowest at the knees and cropped just below them. Draw a flare at the bottom for added style.

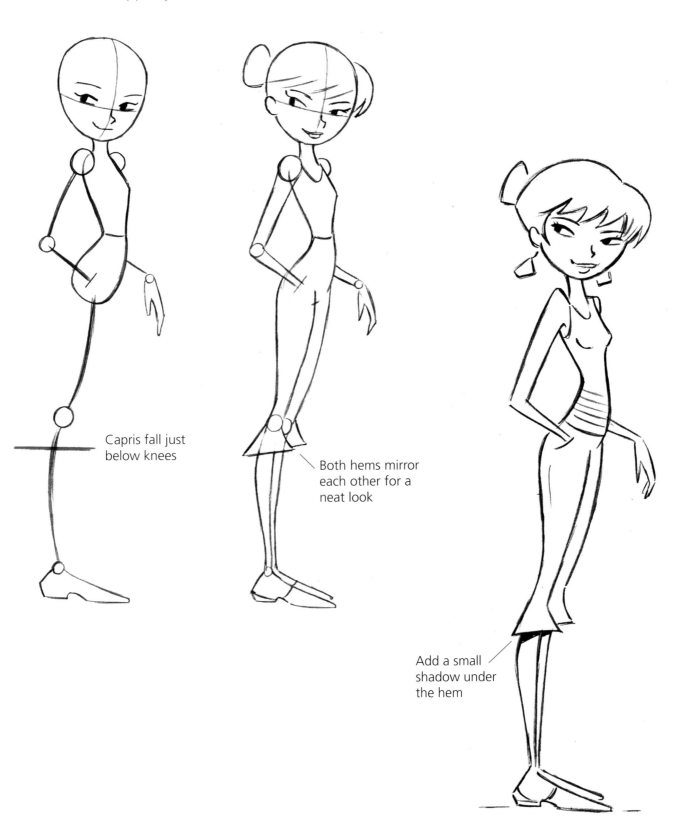

Capris fall just below knees

Both hems mirror each other for a neat look

Add a small shadow under the hem

SUMMERTIME IS FINE

Summer clothes are casual, although I suspect that the sunglasses are imported from Italy. The bag is probably imported from Italy, too. And the shoes, Italy. I never realized how expensive an inexpensive outfit could be!

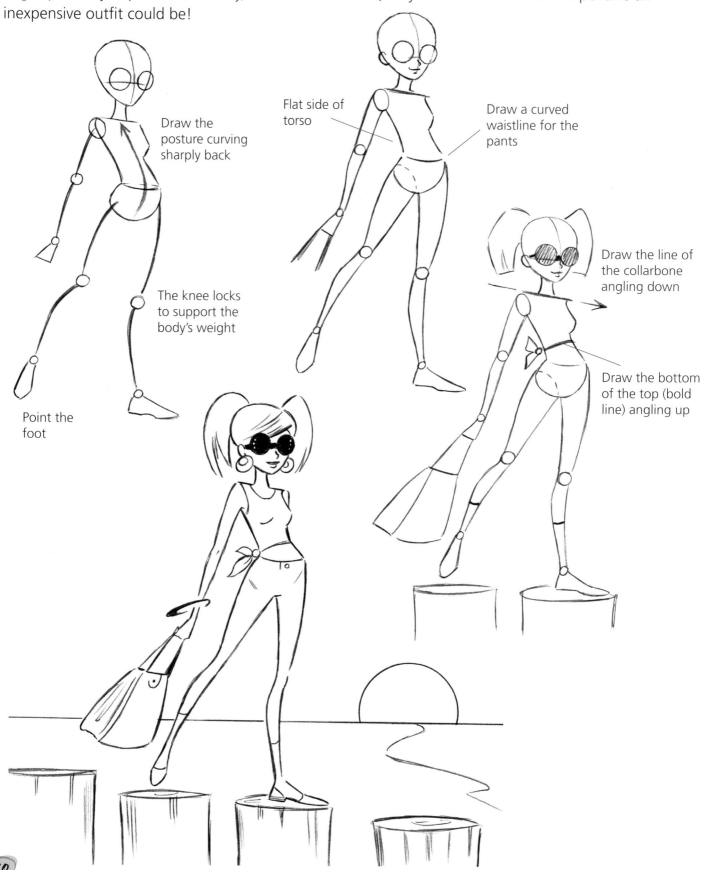

Draw the posture curving sharply back

The knee locks to support the body's weight

Point the foot

Flat side of torso

Draw a curved waistline for the pants

Draw the line of the collarbone angling down

Draw the bottom of the top (bold line) angling up

THE PERFECT HAT

The sizeable brim serves two purposes: to make a breezy fashion statement and to block the light from a supernova. The bigger the brim, the more the eye is drawn to it. But a hat can make a head shot look flat. The way to counter that is to show the underside of the brim.

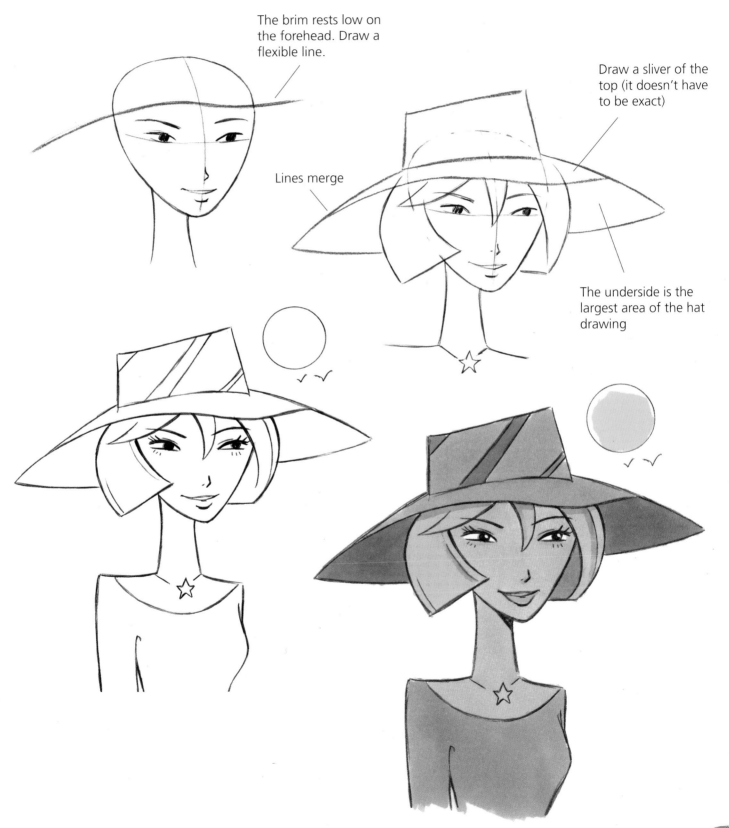

The brim rests low on the forehead. Draw a flexible line.

Draw a sliver of the top (it doesn't have to be exact)

Lines merge

The underside is the largest area of the hat drawing

PERFECTLY PUT TOGETHER

You can give a jacket a high-end look if you keep it fitted and add a luxurious collar. This collar is an eye-catcher because of its size, pattern, and the sumptuous way it surrounds her neck. The jacket flares at the bottom, and the skirt is smartly cut at the knees. Erase the price tag before you finish the drawing.

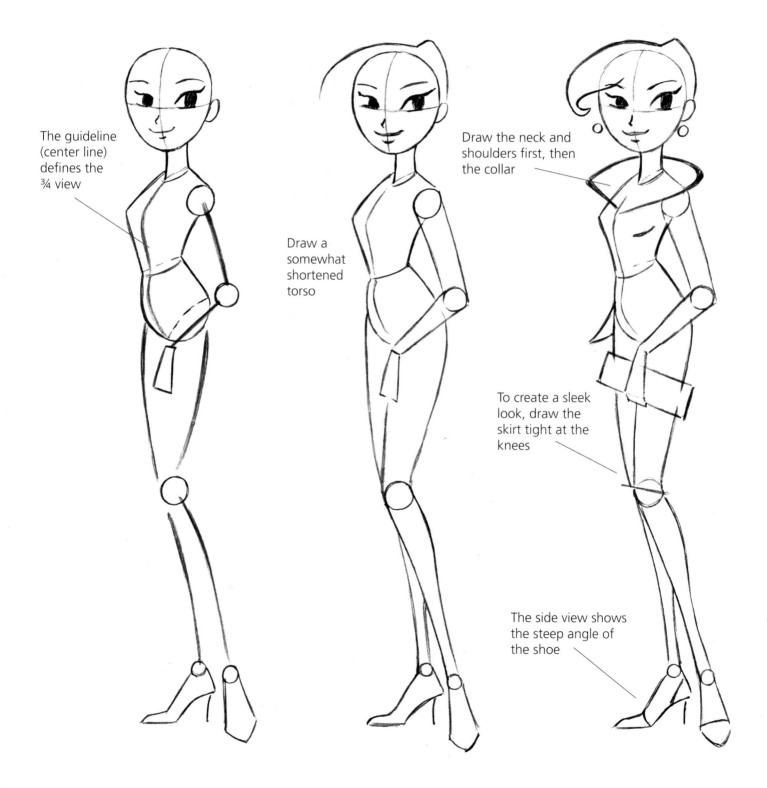

The guideline (center line) defines the ¾ view

Draw a somewhat shortened torso

Draw the neck and shoulders first, then the collar

To create a sleek look, draw the skirt tight at the knees

The side view shows the steep angle of the shoe

Personalize It

You can customize your fashion drawings by adding or changing jewelry and other accessories. Here are a few ideas to change up this outfit.

Bracelets

A popular look is to stack bracelets with clashing patterns. I must be ahead of the curve. My clothes have been clashing for years.

Purses

The shape of the bag creates the basic look. The brackets, snaps, and straps add the glitter.

Tip

Add length to the legs for a glamorous look.

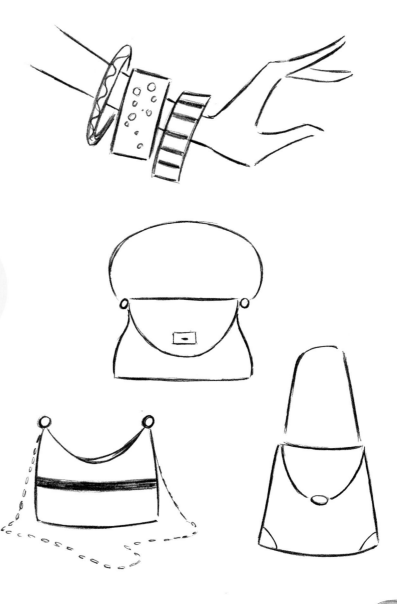

SUNGLASS STYLE

Clinical trials have recently shown that wearing sunglasses increases a cool look. They also discovered that wearing a baseball cap backward diminishes a cool look. The lesson is that if you wear sunglasses and a baseball cap turned back, you've gone to a lot of effort to get nowhere. Sunglasses are drawn with the following principles in mind.

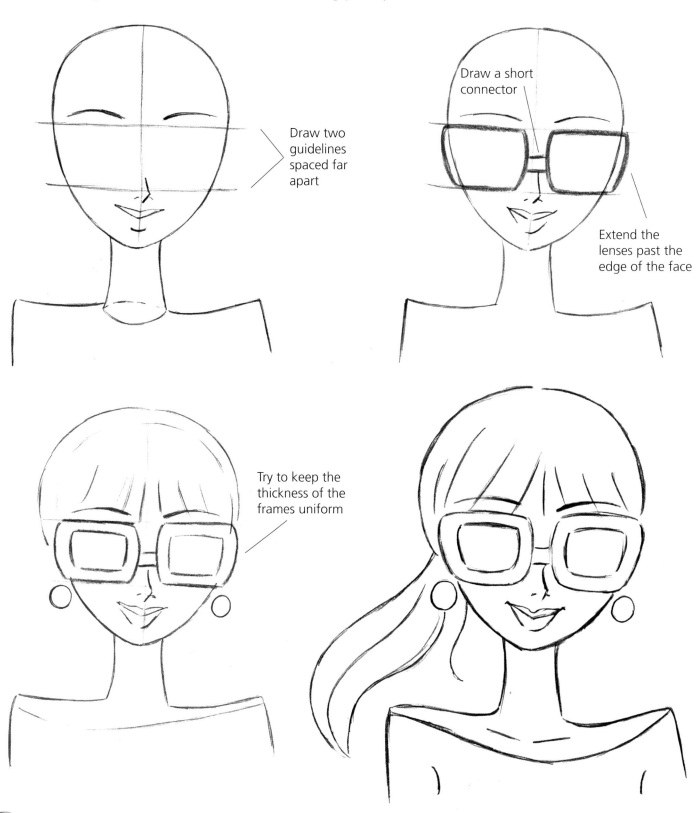

Draw two guidelines spaced far apart

Draw a short connector

Extend the lenses past the edge of the face

Try to keep the thickness of the frames uniform

VARIATIONS: Other Styles

Now let's try a couple styles that are more angular. The key is to be consistent in drawing the same angles for both lenses, as shown in the drawing below. You can also add a little flash to your shades by drawing a decorative accent across the top of the lenses.

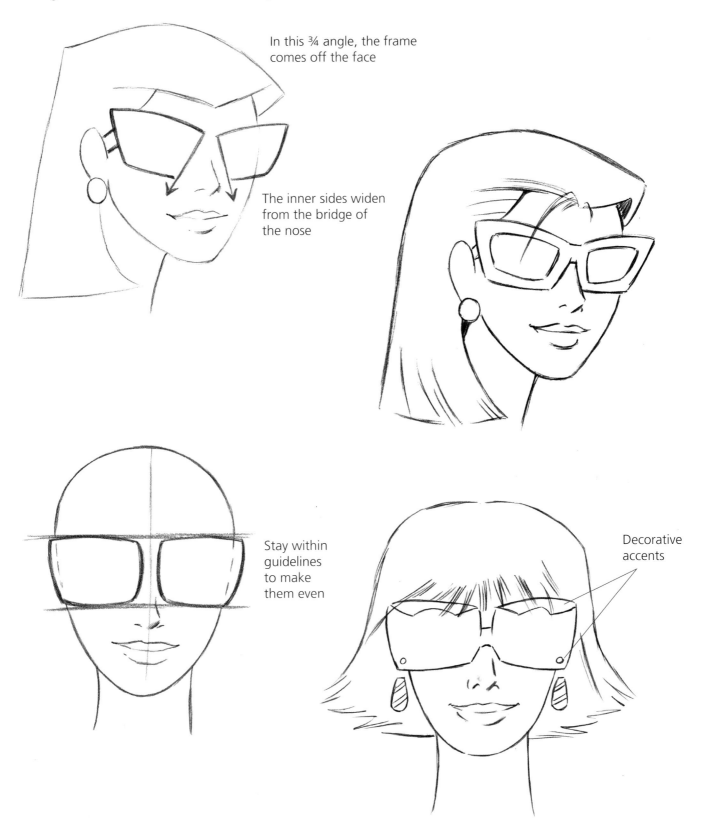

In this ¾ angle, the frame comes off the face

The inner sides widen from the bridge of the nose

Stay within guidelines to make them even

Decorative accents

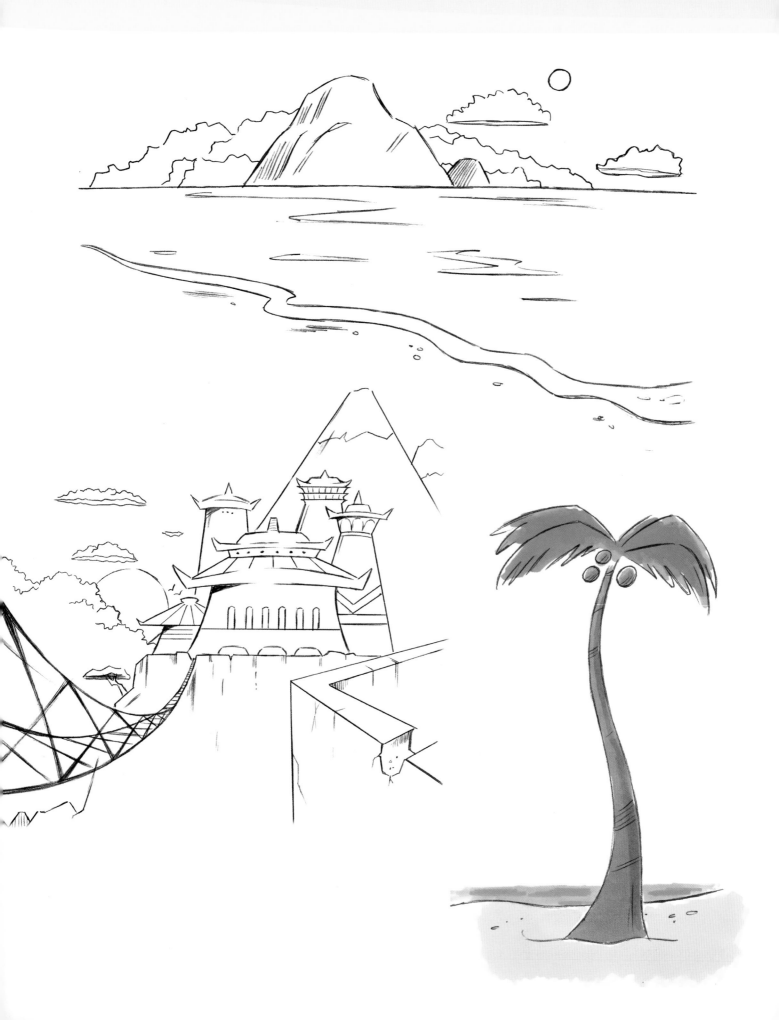

Fantastic Destinations

Let's travel to some of the world's most desirable destinations. In this chapter, we'll draw a variety of appealing scenes—each one different. Some drawing instructors make it quite complicated to draw scenes. They break it down into complex grids and multiple vanishing lines. But drawing doesn't have to be a struggle. We can achieve the same results—and often better ones—by using basic principles to create visually appealing scenes. The concepts I'll show you are effective and make drawing fun.

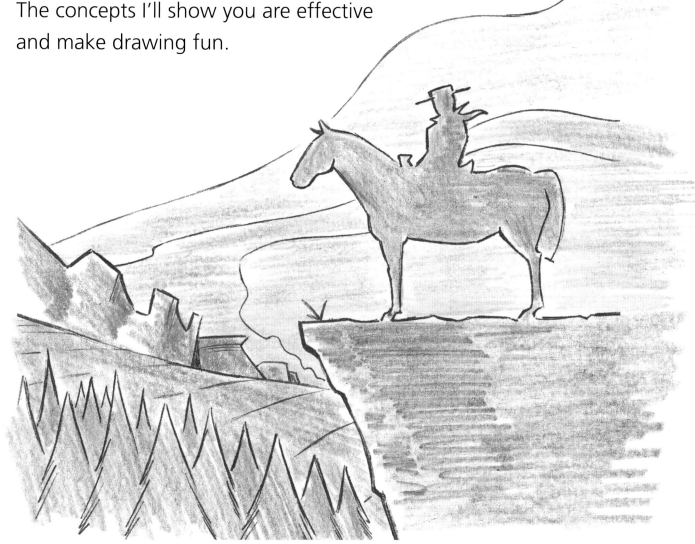

STARRY LAKE

I was recently hiking at Lake Mohonk in upstate New York. It's a spectacular lake, ringed by rocky mountains. A magnificent resort hotel overlooks the water, where sailboats glide. Rather than draw it literally, I used it as the springboard for an imagined scene. I hope you have fun drawing it, too.

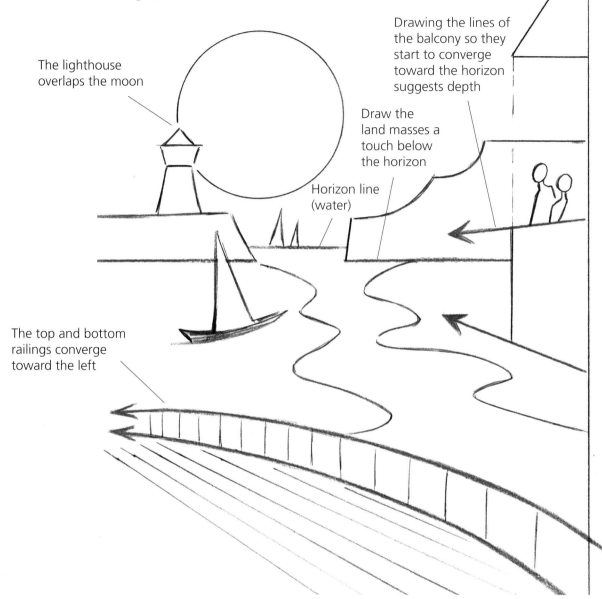

The lighthouse overlaps the moon

Drawing the lines of the balcony so they start to converge toward the horizon suggests depth

Draw the land masses a touch below the horizon

Horizon line (water)

The top and bottom railings converge toward the left

Stars and Moons

Changing the style of the moon and stars will give your drawing a fanciful feeling. Here are a few more options.

Storybook-style moons and stars

Moon overlapped by clouds

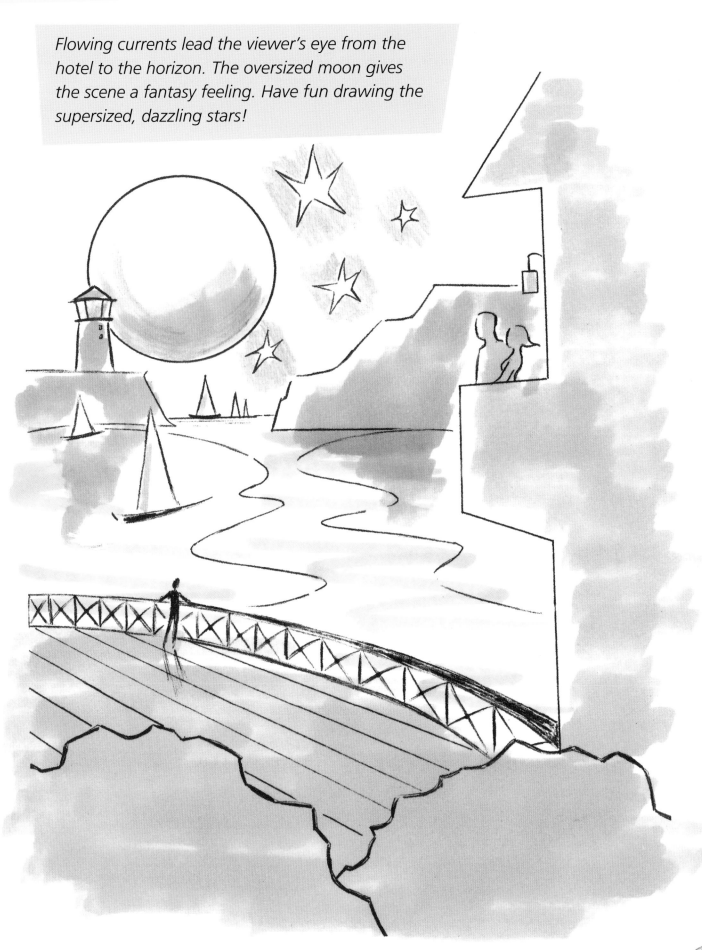

Flowing currents lead the viewer's eye from the hotel to the horizon. The oversized moon gives the scene a fantasy feeling. Have fun drawing the supersized, dazzling stars!

KINGDOM IN THE CLOUDS

Bhutan is famously called the "Kingdom in the Clouds." Perched in the Himalayas, it's one of the most beautiful places on Earth. It's 8,000 feet above sea level, which means you have to either take a plane or walk up 8 million steps to get there. To create the vertical look of this village, draw the temples close together. In this interpretation of Bhutan, I added a long rope bridge to underscore its remoteness.

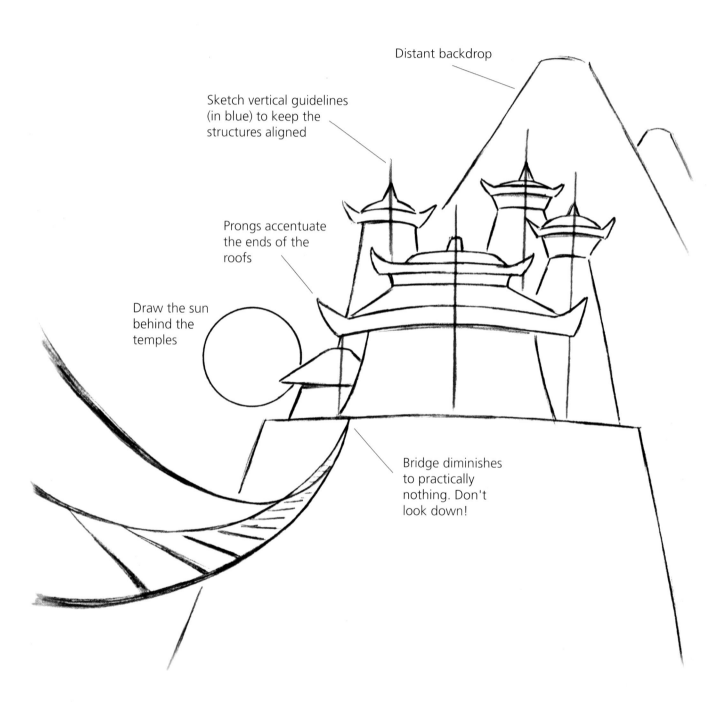

Distant backdrop

Sketch vertical guidelines (in blue) to keep the structures aligned

Prongs accentuate the ends of the roofs

Draw the sun behind the temples

Bridge diminishes to practically nothing. Don't look down!

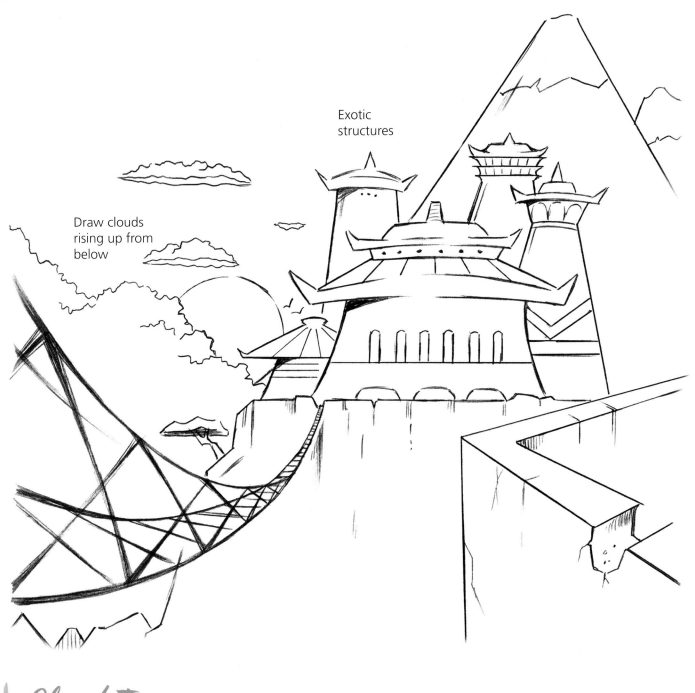

Exotic structures

Draw clouds rising up from below

Cloud Types

Clouds are an essential element in drawing any place that's perched at high altitudes. By showing land above the clouds, you create a magical look.

Bumpy on top, with a flat underside

Wispy slivers

Random groupings

VARIATION: Alternate View

I'm sure Bhutan would get many more visitors each year if they would only install a guardrail around the perimeter. A "No Skateboarding" sign would also help.

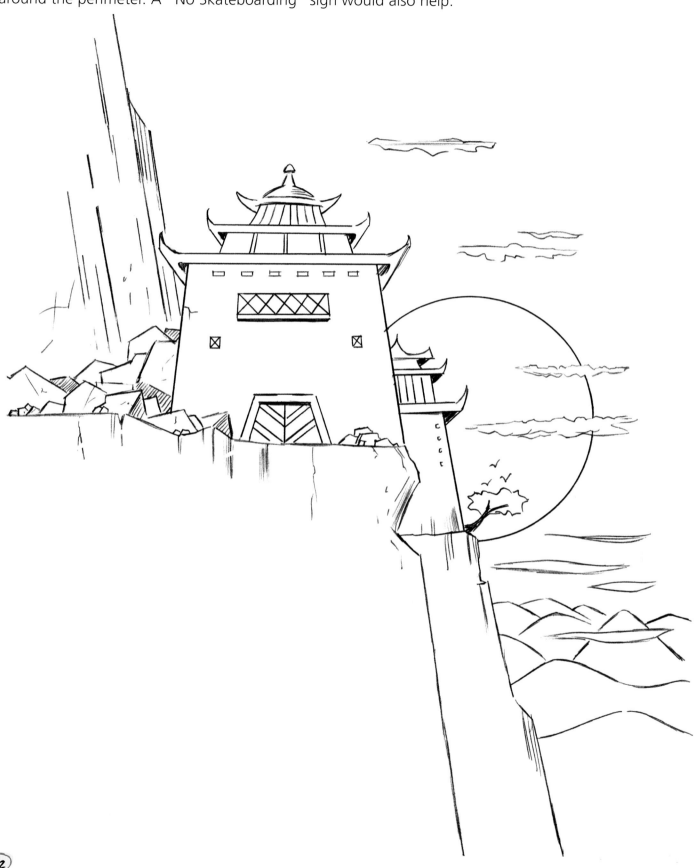

BIG SKY COUNTRY

A big Western sky is an amazing thing. You can experience its grandeur, while at the same time feel humbled by its enormity. An expansive sky can make you believe in endless possibilities. Creating this environment requires only a few key elements.

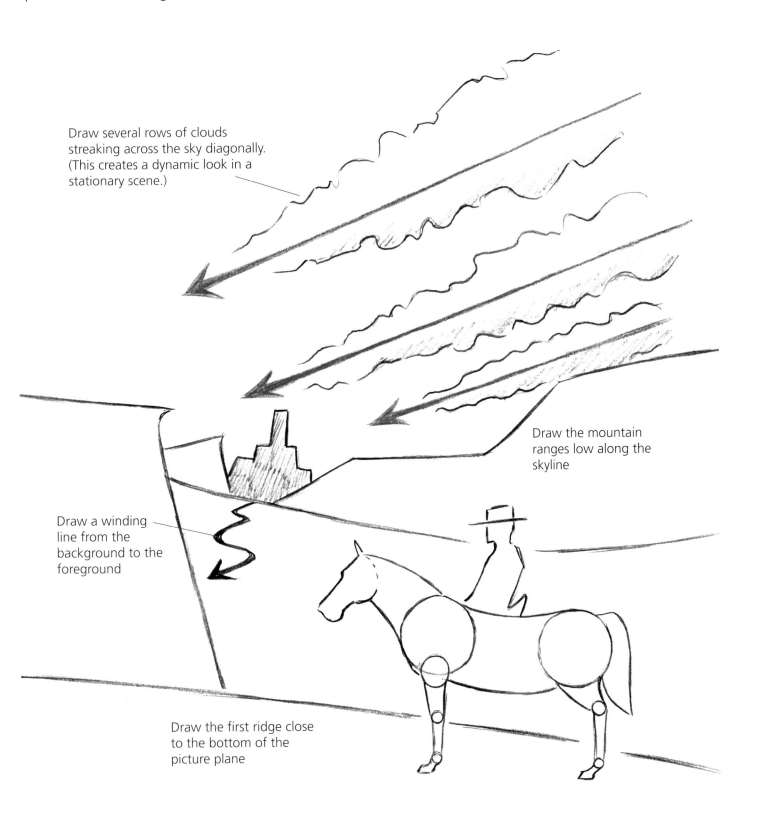

Draw several rows of clouds streaking across the sky diagonally. (This creates a dynamic look in a stationary scene.)

Draw the mountain ranges low along the skyline

Draw a winding line from the background to the foreground

Draw the first ridge close to the bottom of the picture plane

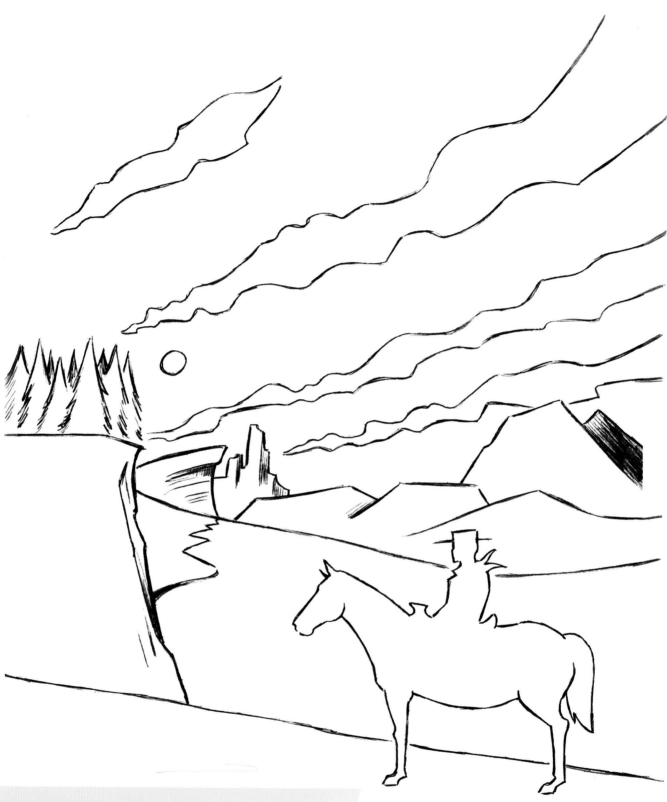

The silhouette is effectively used to weight the visual elements in favor of the landscape.

VARIATION: Semi-abstract Landscape

In this less literal approach, I've chosen to create a swirling design for the sky. You can do the same or invent your own design.

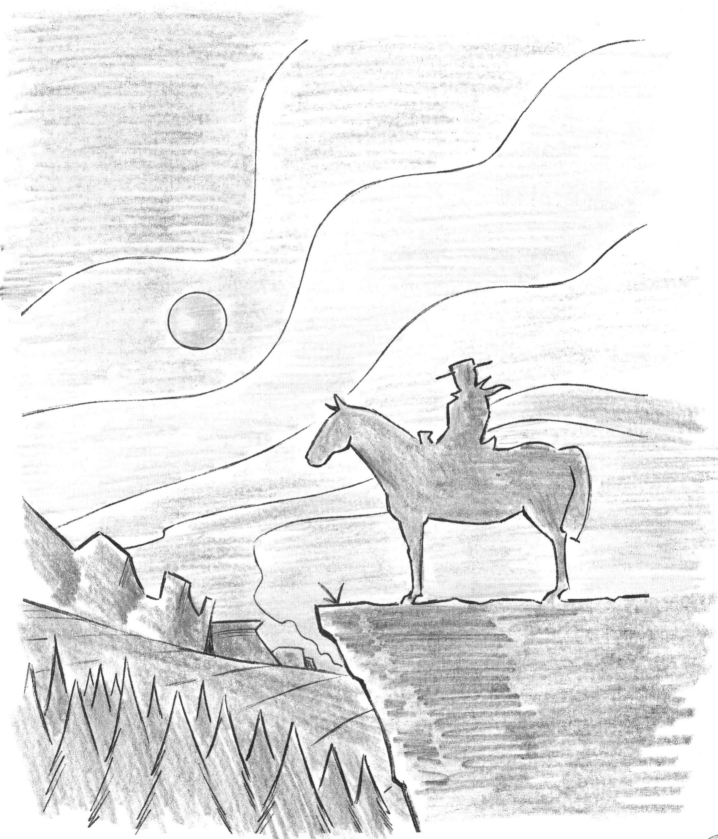

CITY SCENE

Washington Square Park is located in New York City's Greenwich Village. It's the "campus" of my alma mater, New York University. It's full of life and has an eclectic look that's fun to draw. Depth is suggested by the different heights of the figures. More variety is demonstrated by the overlapping archways and buildings.

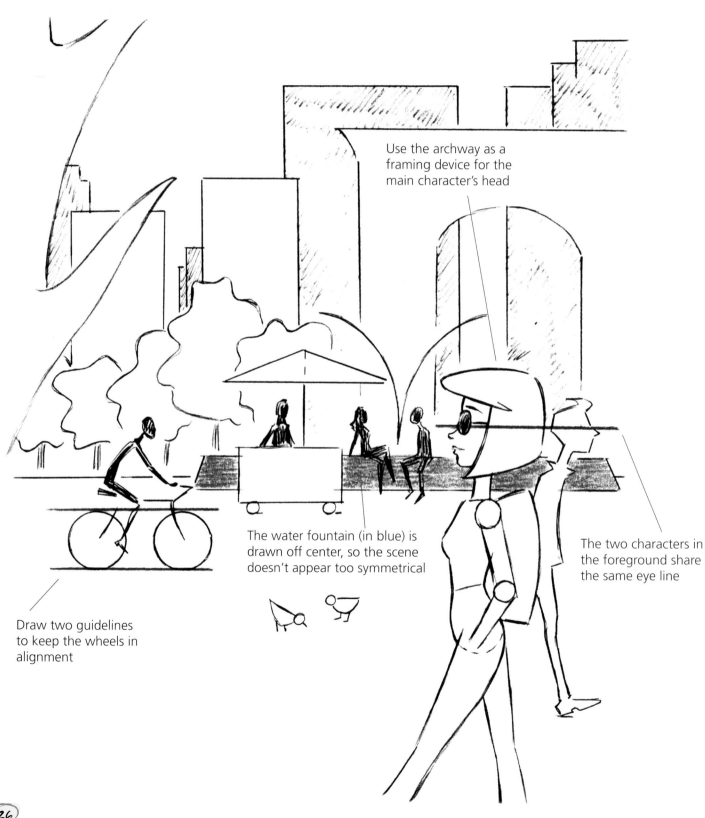

Use the archway as a framing device for the main character's head

The water fountain (in blue) is drawn off center, so the scene doesn't appear too symmetrical

The two characters in the foreground share the same eye line

Draw two guidelines to keep the wheels in alignment

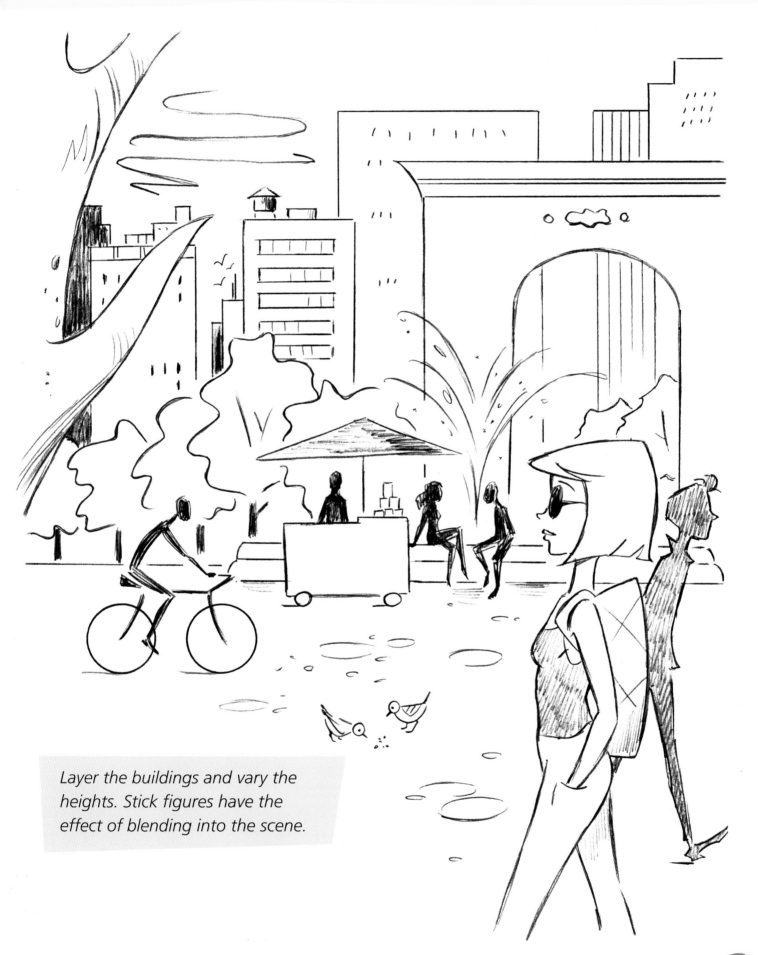

Layer the buildings and vary the heights. Stick figures have the effect of blending into the scene.

TROPICAL PARADISE

You probably daydream about a place like this. I wonder if the people on the island daydream about office cubicles. This scene is very open. Then why does it look so pleasing, rather than simply empty? Because the foundation of the scene is laid out aesthetically.

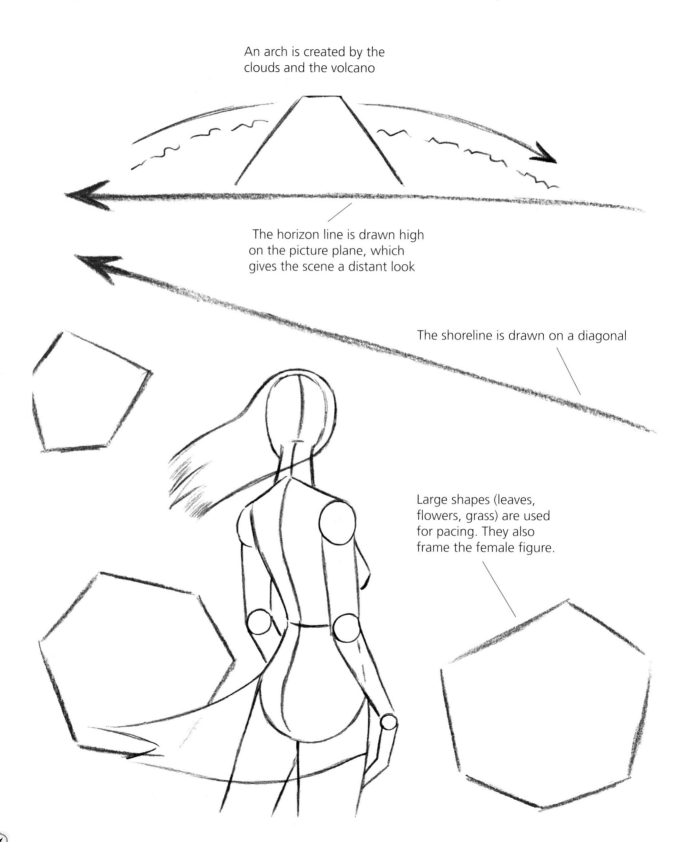

An arch is created by the clouds and the volcano

The horizon line is drawn high on the picture plane, which gives the scene a distant look

The shoreline is drawn on a diagonal

Large shapes (leaves, flowers, grass) are used for pacing. They also frame the female figure.

Big, clumpy clouds, filled with moisture, hover over the water.

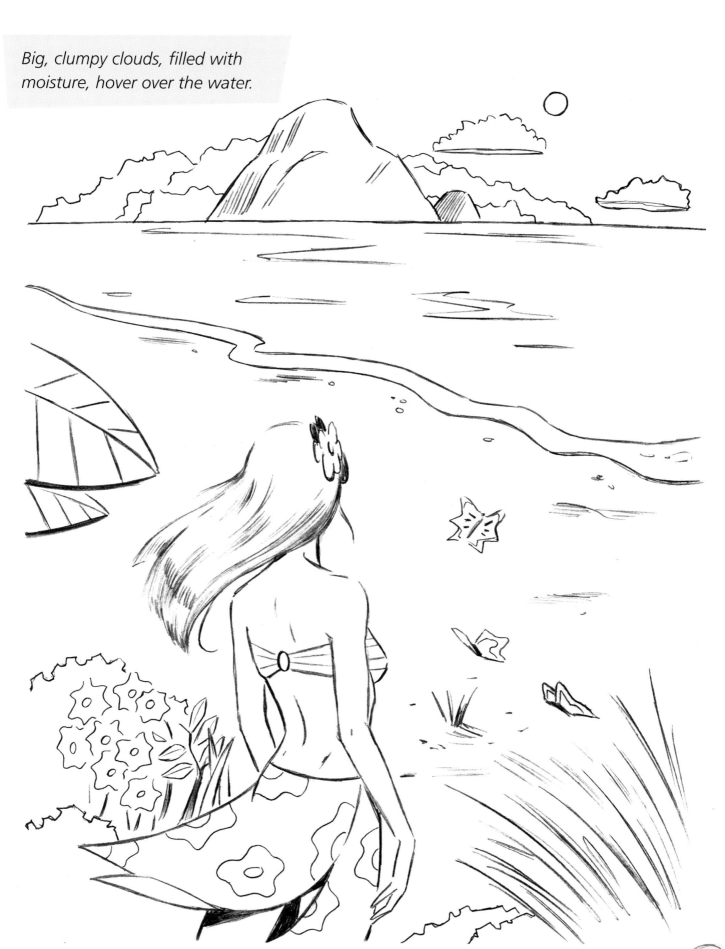

VARIATION: Palm Tree

If your version of a tropical paradise includes palm trees, here's how to draw them.

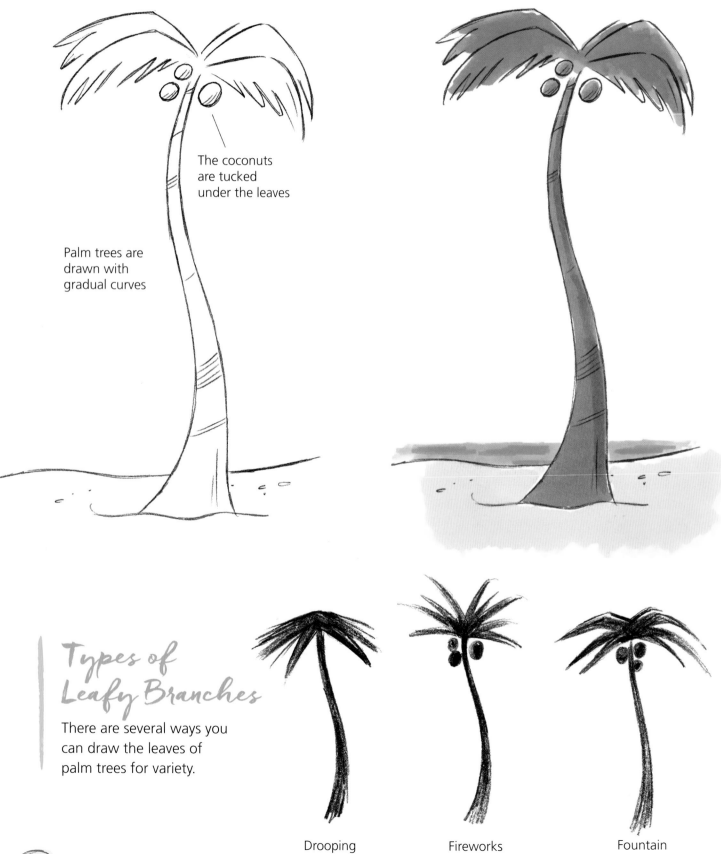

The coconuts are tucked under the leaves

Palm trees are drawn with gradual curves

Types of Leafy Branches

There are several ways you can draw the leaves of palm trees for variety.

Drooping Fireworks Fountain

CITY OF WATER

In Venice, Italy, the major "roads" are canals. Up until now in this chapter, we've been drawing wide-open spaces. But "wide open" the Grand Canal of Venice is not. Don't be intimidated by its narrow look. It's as easy to draw as the other scenes. But we have to frame it first. Let's start by positioning the walls. Next, draw the winding path of the water. Last, place the gondolier in the foreground.

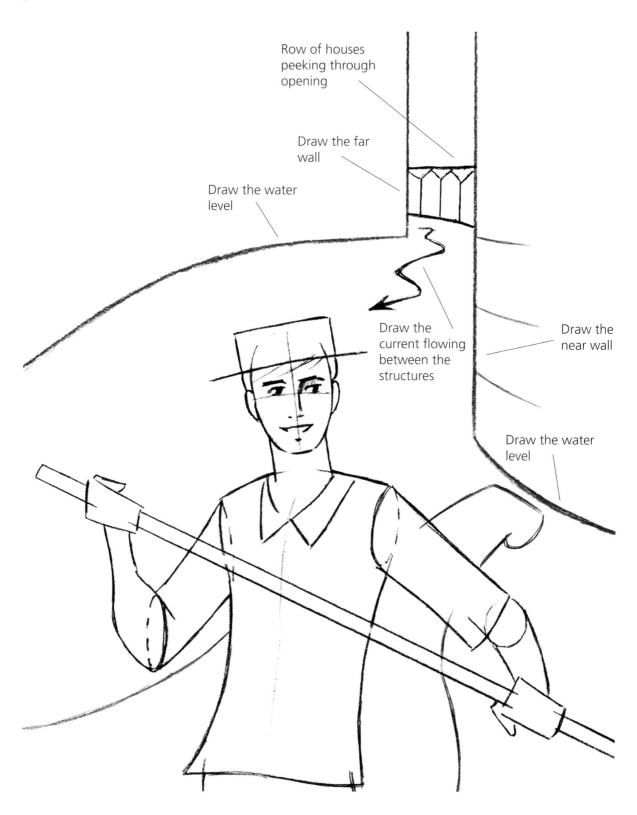

Row of houses peeking through opening

Draw the far wall

Draw the water level

Draw the current flowing between the structures

Draw the near wall

Draw the water level

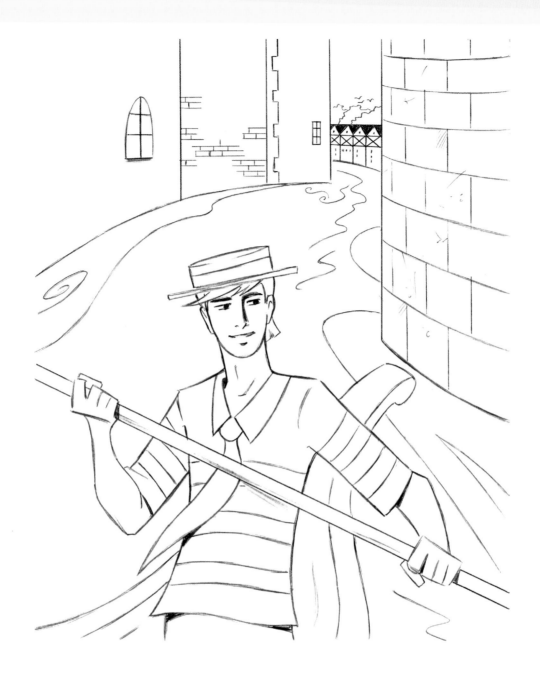

VARIATION: Full Figure

Here's a full-figure variation of the gondolier. To place him in the previous scene, draw the boat higher on the picture plane (moved farther up the page).

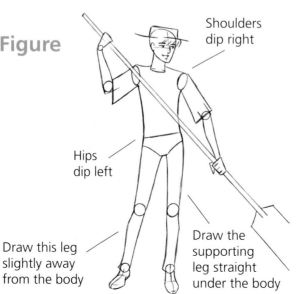

Shoulders dip right

Hips dip left

Draw this leg slightly away from the body

Draw the supporting leg straight under the body

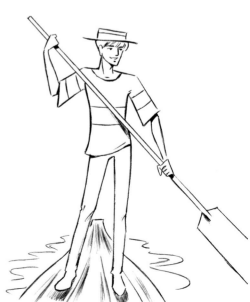

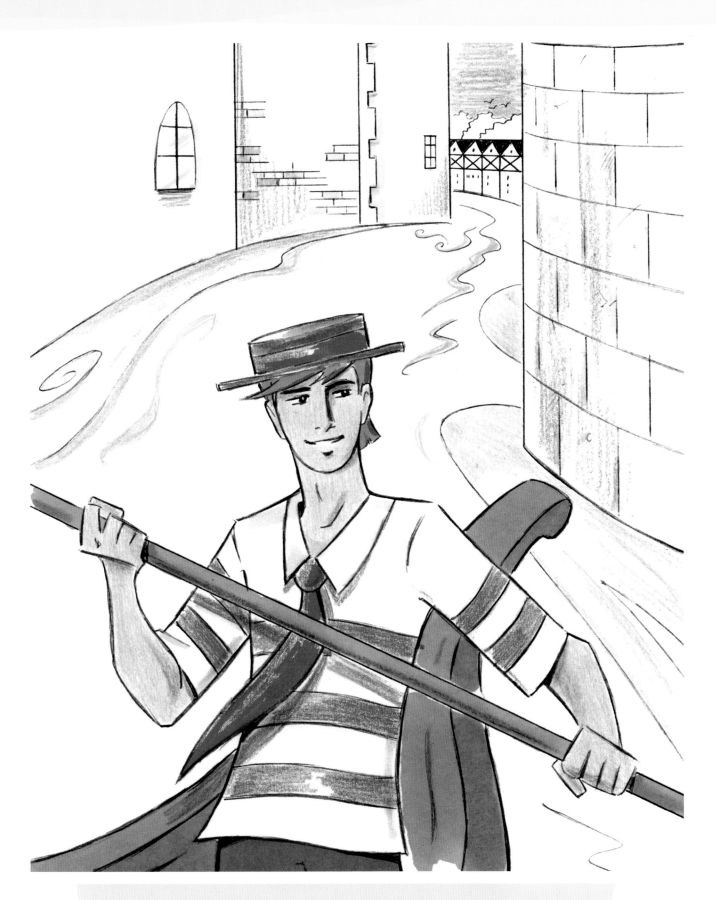

The classic gondolier wears a shirt with black-and-white stripes.
But when you're the artist, you can dress him any way you want!

ENDLESS ROLLING HILLS

When you gaze out at rolling hills, your eye wants to follow the landscape all the way to the horizon. To recreate that look, we have to direct the reader's eye. This simplified diagram will give you the tips to do it.

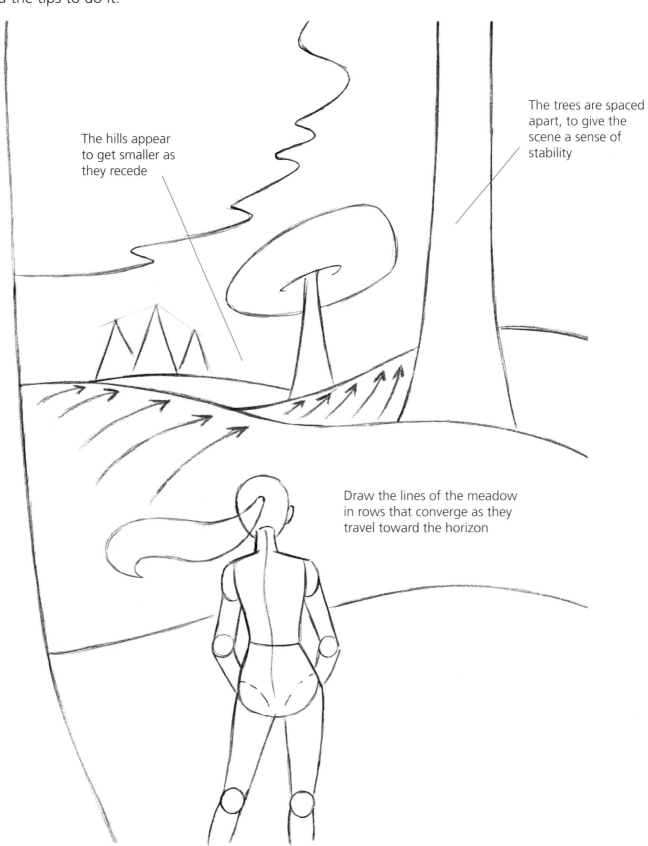

The hills appear to get smaller as they recede

The trees are spaced apart, to give the scene a sense of stability

Draw the lines of the meadow in rows that converge as they travel toward the horizon

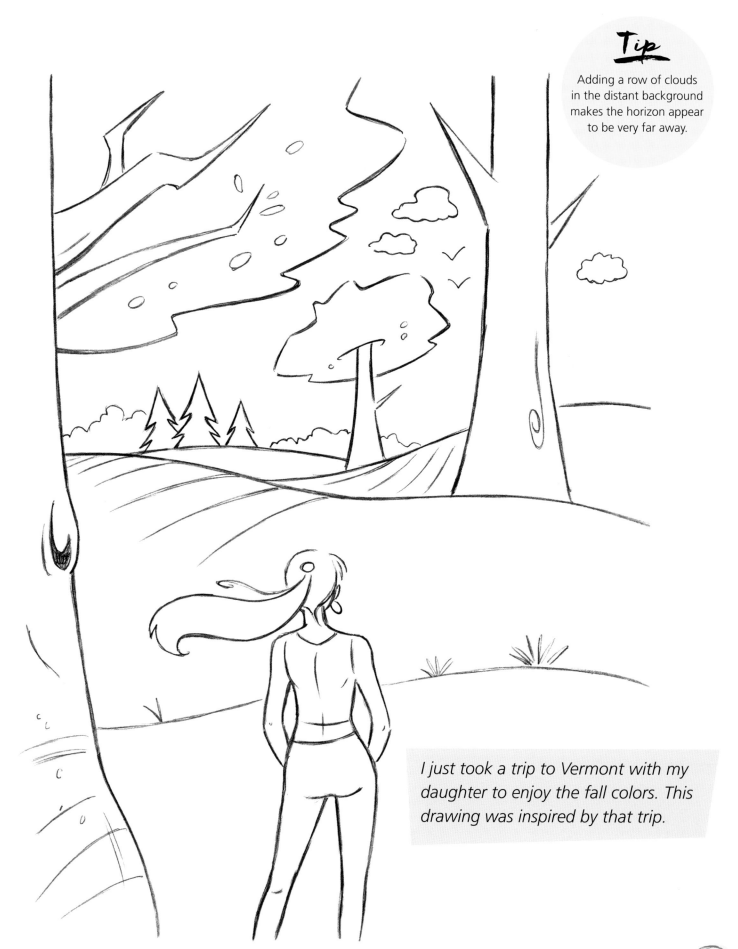

Tip

Adding a row of clouds in the distant background makes the horizon appear to be very far away.

I just took a trip to Vermont with my daughter to enjoy the fall colors. This drawing was inspired by that trip.

This & That

You can find things that make you happy everywhere you look. A slice of delicious homemade pie, a super-cute teddy bear, or something big, like a rollercoaster. Here are a few fun drawings to provide you with good cheer.

HAPPY FACES

It's hard for me to draw a smile without mimicking it as I sketch. It's not even a conscious thing. It just puts me in a good mood. Try it, and see if it doesn't do the same for you.

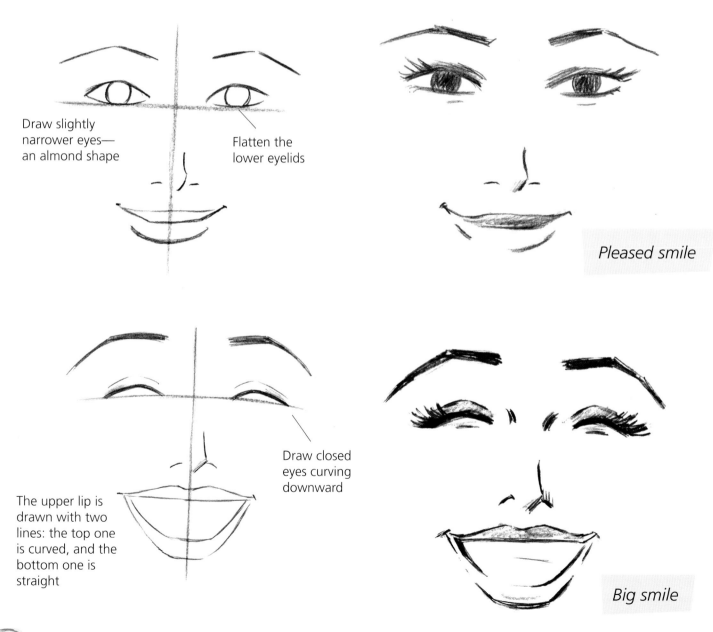

Draw slightly narrower eyes—an almond shape

Flatten the lower eyelids

Pleased smile

Draw closed eyes curving downward

The upper lip is drawn with two lines: the top one is curved, and the bottom one is straight

Big smile

HI, MY NAME IS TEDDY

Teddy bears are popular gifts for Valentine's Day, when someone needs cheering up, and when someone is in the "doghouse."

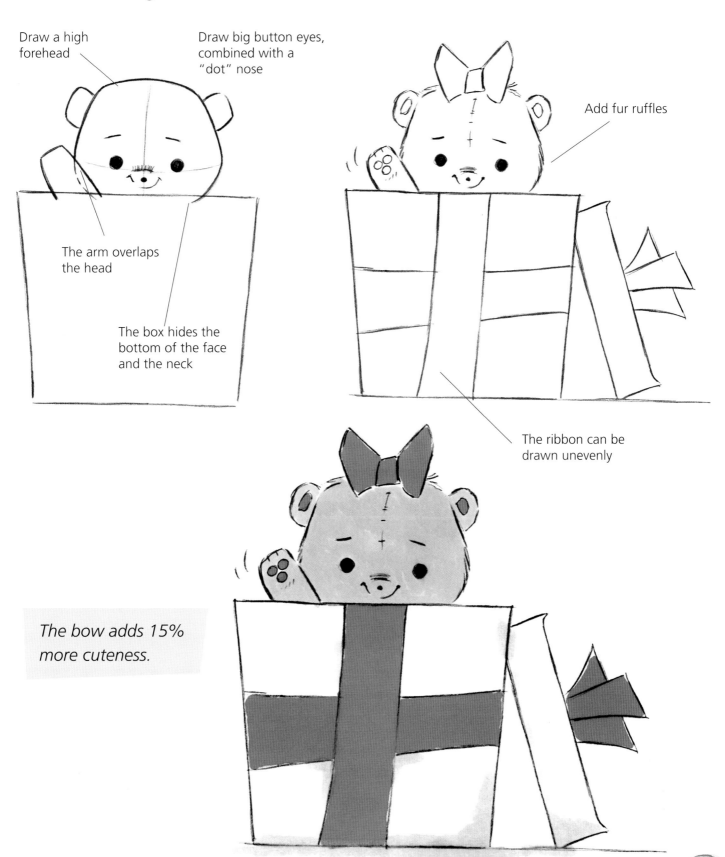

Draw a high forehead

Draw big button eyes, combined with a "dot" nose

The arm overlaps the head

The box hides the bottom of the face and the neck

Add fur ruffles

The ribbon can be drawn unevenly

The bow adds 15% more cuteness.

KNICKKNACKS

By drawing simple faces on ordinary household objects, you'll transform them into charming collectables. You can do the same on a pitcher, a purse, a toaster, and whatever else you spot around the house. This process is what cartoonists and animators call "personification."

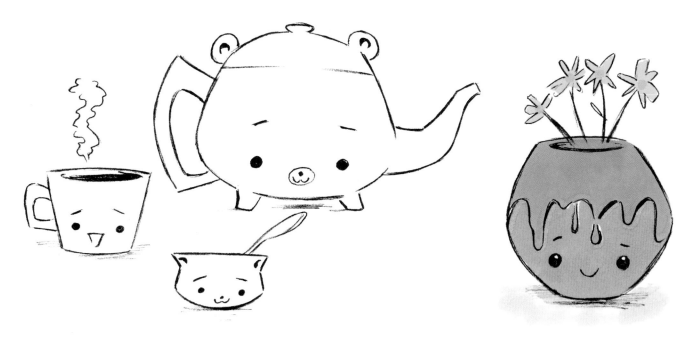

HOMEMADE PIE

Simple objects sometimes aren't so simple. A number of shapes converge to create this pie wedge.

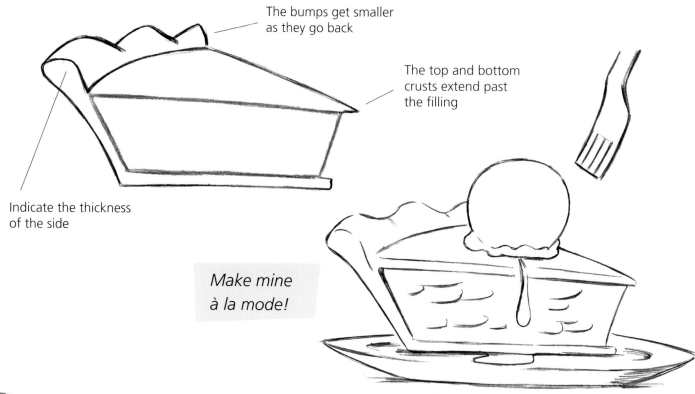

The bumps get smaller as they go back

The top and bottom crusts extend past the filling

Indicate the thickness of the side

Make mine à la mode!

BIRDHOUSE

This robin is going to flip this house and sell it to a family of blue jays.

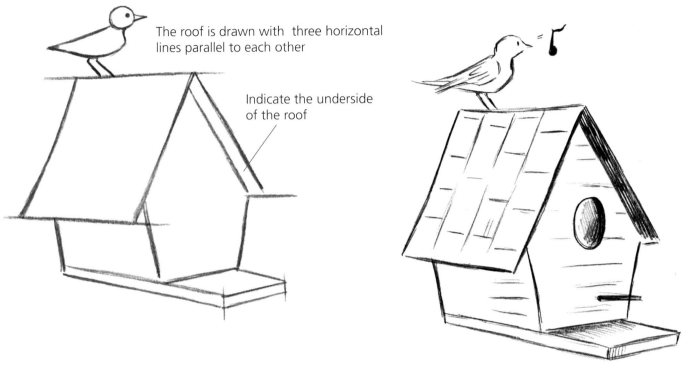

The roof is drawn with three horizontal lines parallel to each other

Indicate the underside of the roof

FUN CAP

Zoning laws in many cities make it mandatory to wear this when you're roller-skating.

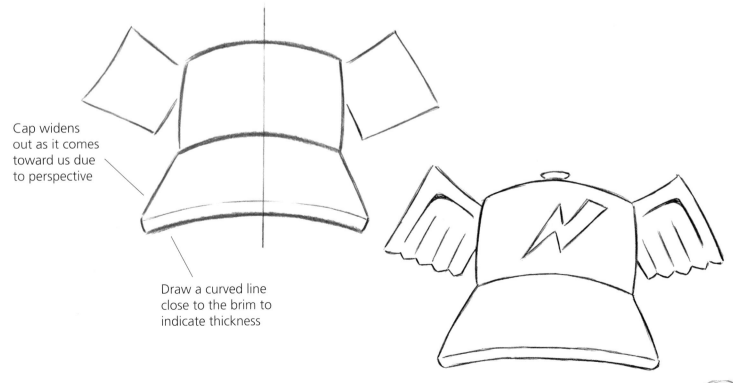

Cap widens out as it comes toward us due to perspective

Draw a curved line close to the brim to indicate thickness

ROLLERCOASTERRR!!!

I love amusement parks. Everything but the getting sick after spinning part. As a kid, I never wanted to leave the amusement park, so I became a cartoonist—a close second!

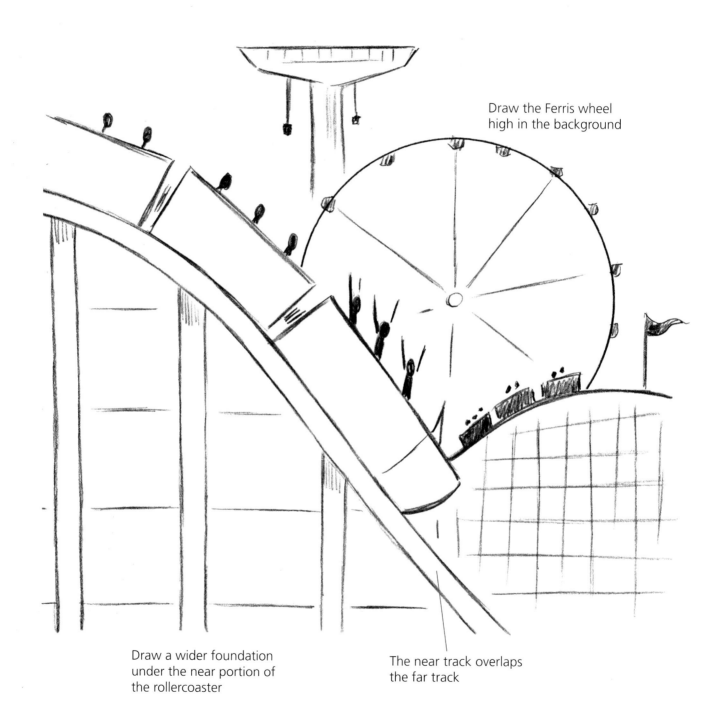

Draw the Ferris wheel high in the background

Draw a wider foundation under the near portion of the rollercoaster

The near track overlaps the far track

Do not ride this after eating pizza. I know what I'm talking about.

GO FLY A KITE!

Here's one more fun scene to induce happy feelings. Draw the figure in silhouette so she's melded with the background and keep some space between her feet and the ground to show that she's bounding off into the sunset!

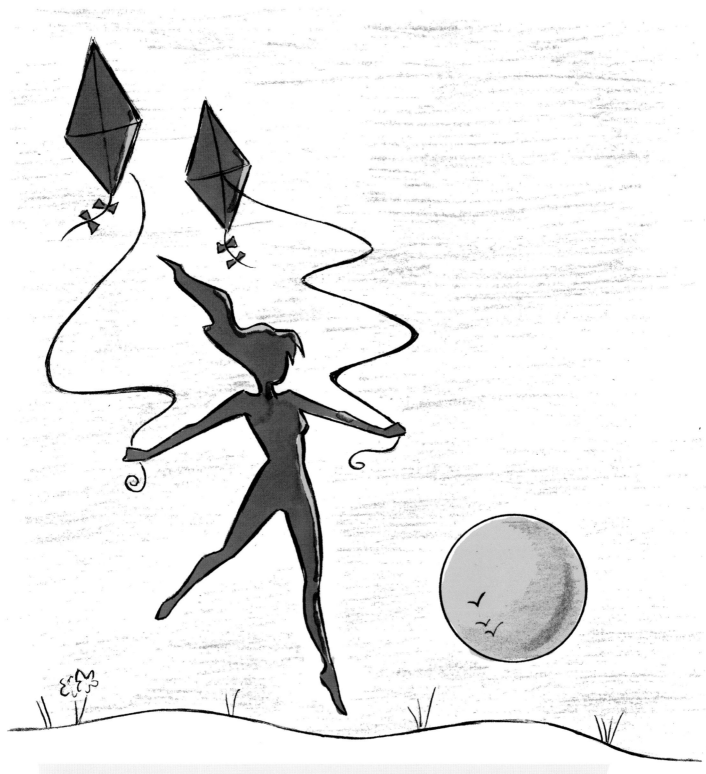

And thanks to you, my readers, for giving me the opportunity to enjoy the happiness of drawing with you.
 — *Christopher Hart*

Index

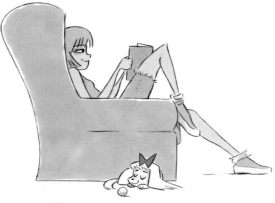

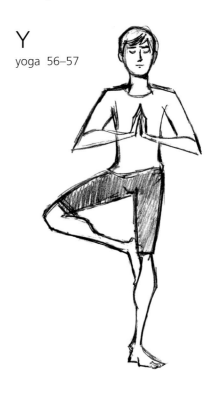

Don't miss these other great titles from
Christopher Hart!